STAR WARS®

The
MAGIC
of
MYTH

This book is a companion to the *Star Wars: The Magic of Myth* exhibition at the Smithsonian Institution's National Air and Space Museum in Washington, D.C.

This exhibition is made possible through the generous support of Bantam Books, a division of Bantam Doubleday Dell Publishing Group, Inc.

Designed by Alexander Isley Inc.

Bantam Books
NEW YORK · TORONTO ·
LONDON · SYDNEY · AUCKLAND

STARS

The MAGIC of MYTH

Mary Henderson

EXHIBITION CURATOR

The MAGIC of MYTH

A Bantam Spectra Hardcover / December 1997
A Bantam Spectra Trade Paperback / December 1997

See pages 211 to 214 for permissions and illustration credits.

Book and cover design by Alexander Isley Inc.

Library of Congress Cataloging-in-Publication Data
Henderson, Mary S.
Star wars: the magic of myth / by Mary Henderson.
p. cm.
"Companion to the Star Wars exhibition at the National Air and Space Museum."
Includes bibliographical references.
ISBN 0-553-10206-0 (hc). — ISBN 0-553-37810-4 (pbk.)
1. Star Wars films—History and criticism. I. Title.
PN1995.9.S695H46 1997
791.43'75—dc21 97-13039 CIP

Published simultaneously in the United States and Canada

Bantam Books are published by Bantam Books,
a division of Bantam Doubleday Dell Publishing Group, Inc.
Its trademark, consisting of the words "Bantam Books"
and the portrayal of a rooster, is Registered
in U.S. Patent and Trademark Office and in other countries.
Marca Registrada. Bantam Books,
1540 Broadway, New York, New York 10036.

Printed in the United States of America

1 3 5 7 9 10 8 6 4 2

Special thanks to Howard Roffman, who has
provided so much support for this project;
Steve Sansweet, who helped to get it going; and
David Spencer, who believed in it.

This book is dedicated to my hero—my daughter Mary.

A very special thank-you to Nancy Palmer Jones,
whose editorial expertise brought this to fruition.

NATIONAL AIR AND SPACE MUSEUM

Director of Publications: Patricia Graboske

Photo Editor: Walton Ferrell

Research Intern: Pamela Feltus

Photographers: Eric Long, Mark Avino

Registrar for Loans: Ellen Folkama

Textile Conservator: Anahid Akasheh

Assistant Dressers: Jean Rostron, Walter Rostron

Conservation Intern: Laura Badger

Research Assistance: Dana Bell, Tim Cronen,
Dan Hagedorn, Allan Janus, Kristine Kaske,
Melissa N. Keiser, Brian Nicklas,
Paul Silbermann, Patricia Williams, Paul Wood

Exhibits Division

General Counsel: James Wilson

Contracting: Ronald Cuffe

Elinchrom equipment courtesy of Bogen Photo Corporation

BANTAM BOOKS

President and Publisher: Irwyn Applebaum

Senior Editor: Emily Heckman

Project Manager: Chris Pike

Managing Editor: Gina Healy

Design Supervisor: Glen Edelstein

Production Manager: Gabriel Ashkenazi

LUCASFILM LTD.

Director of Publishing: Lucy Autrey Wilson

Continuity Editor: Allan Kausch

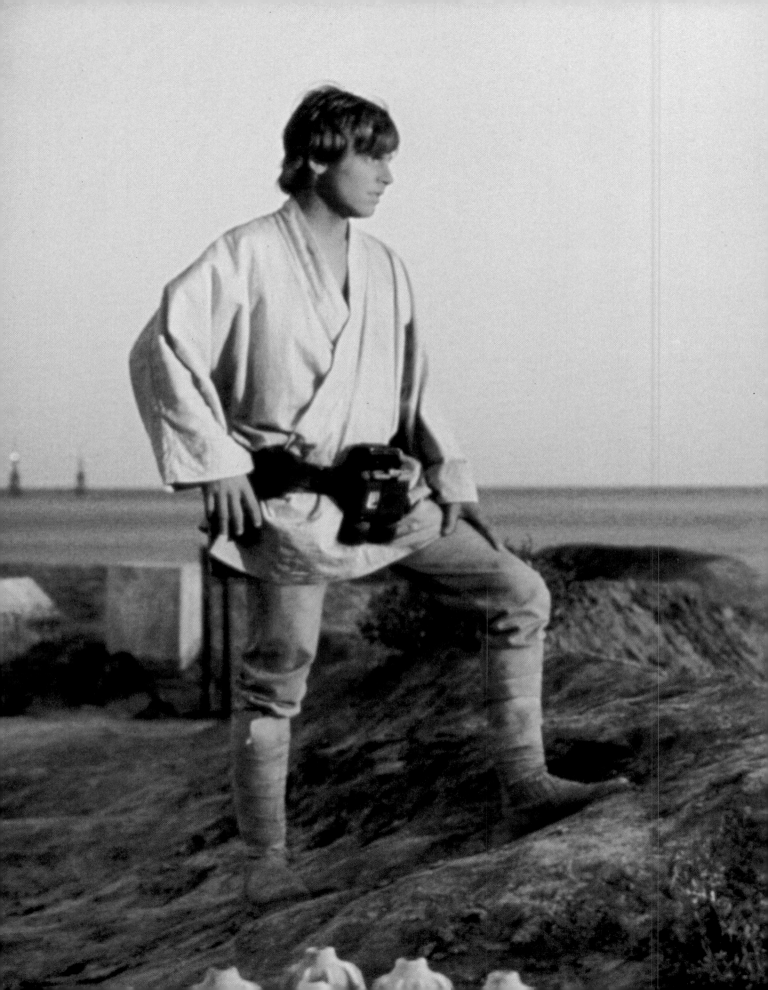

CONTENTS

INTRODUCTION

1

CHAPTER ONE

STAR WARS AND CLASSIC MYTHOLOGY:
The Hero's Journey and the Conflict of Good Versus Evil

15

CHAPTER TWO

THE MAKINGS OF MODERN MYTH:
Cultural and Historical Influences

123

CHAPTER THREE

MYTHIC IMAGES:
The Look of STAR WARS

161

CONCLUSION

195

ENDNOTES	BIBLIOGRAPHY	INDEX
201	**203**	**205**

Introduction

Throughout the inhabited world, in all times
and under every circumstance, the myths of man have flourished;
and they have been the living inspiration
of whatever else may have appeared out of the activities
of the human body and mind.

JOSEPH CAMPBELL, *The Hero with a Thousand Faces*

A long time ago in a galaxy far, far away

GEORGE LUCAS, *Star Wars*

Throughout history, humans have told each other stories —to share their experiences of the world, to explore ways of dealing with life's problems and adventures, and to try to fathom the deeper meanings that underlie daily life. Some of these stories have become myths, with the potential to guide and inspire generation after generation of those who see and hear them. · But what is a myth? What is magical about it? And how has STAR WARS come to represent one of the great myths of our time?

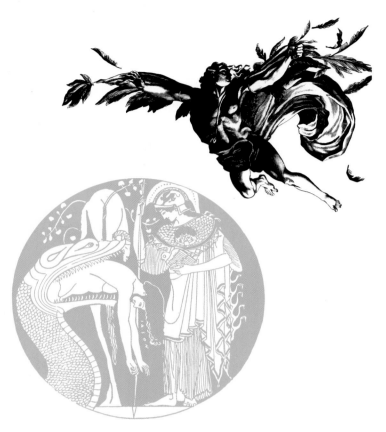

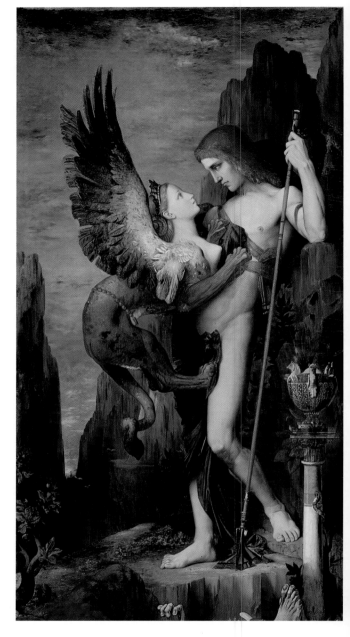

Many of us had our first contact with mythological stories in school; we studied, with more or less enthusiasm, the Greek, Roman, Norse, African, or Asian myths about the creation of the world, the workings of nature, and the jealousies, wars, loves, and misadventures of a wide range of gods and goddesses, heroes and heroines. These stories arose as ancient peoples struggled to answer the most fundamental questions about their humanity, such as why are we here? How can we live up to our highest potential? Is there a force that exists within and beyond us that we may call God? What is our relationship to this God, and how can this relationship guide us on life's journey? In attempting to address these larger issues, certain archetypal stories, in which some elements of plot, character types, and locale all remain basically the same, have described the human experience with such universality that they have become lasting myths. The sense of a deep and abiding truth that such myths offer is part of their magic.

But a myth does not exist in a vacuum; rather, it captures the spirit and concerns of the particular time and place out of which it has sprung—yet it manages to do so in a timeless fashion.

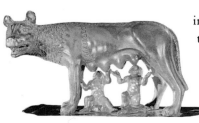

THIS PAGE: **Heroes from Classic Myths**

LEFT, FROM TOP: **The Fall of Icarus,**
Bernard Brussel-Smith.

The Return of Jason, c. 475 B.C.

Twins Romulus and Remus,
She-Wolf of the Capitol, 500 B.C.

ABOVE: **Oedipus and the Sphinx,**
Gustave Moreau, 1864.

OPPOSITE: **Star Wars poster,**
1978 rerelease, art by Drew Struzan and Charles Whilt III.

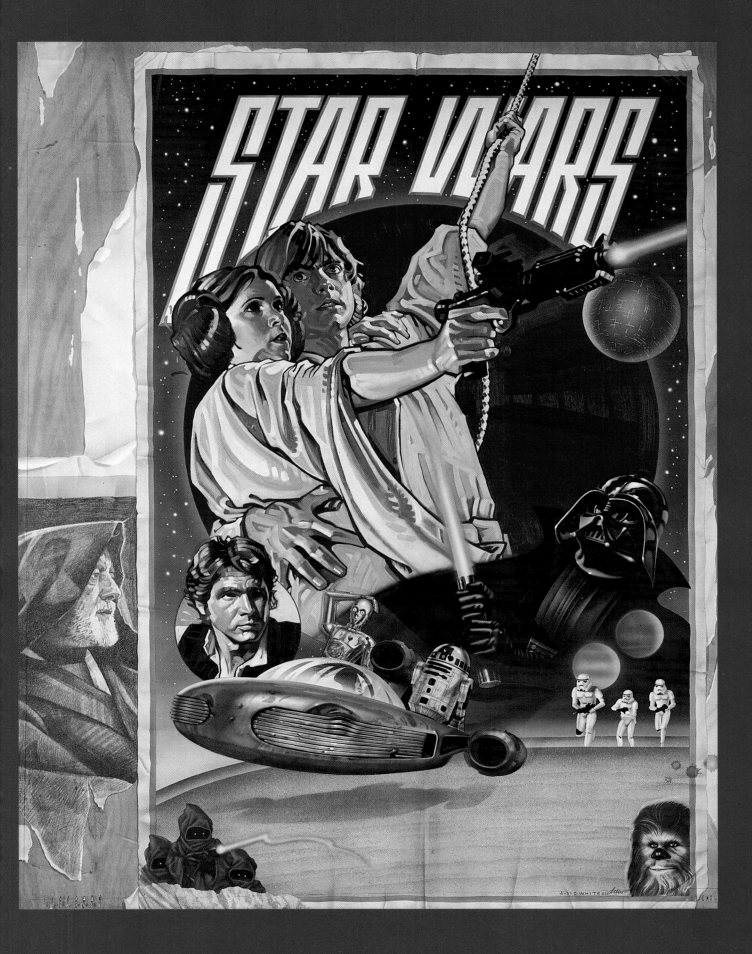

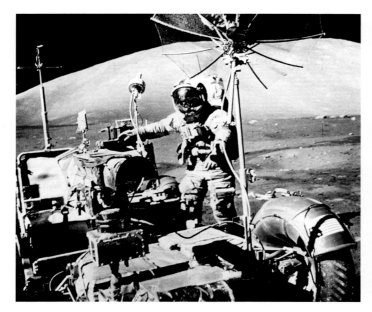

Perhaps this apparent contradiction is possible because at heart, we are all asking the same questions. Certainly this mixture of elements—the universal in conjunction with the specific, the story rooted within a particular culture combined with the timeless tale for all humankind—is another magical aspect of myth.

"It has always been the prime function of mythology," wrote Joseph Campbell in *The Hero with a Thousand Faces*, ". . . to supply the symbols that carry the human spirit forward, in counteraction to those other constant human fantasies that tend to tie it back."[1] A myth shows us what we're up against; it identifies the "bad guys"—who often turn out to be within us, the part of ourselves that would hold us back—and it helps us find a way to defeat them. And that, finally, is part of the myth's magic too: it offers hope.

When the first film in the *Star Wars* trilogy appeared in 1977, the ancient myths no longer seemed relevant for many people in this culture; pressing present-day problems absorbed our attention, and hope itself seemed in short supply. The economy was on the downswing, the recently ended Vietnam conflict had left no clear victor and many troubling issues in its wake, the Cold War continued, and Watergate had instilled a profound disillusionment with government in the minds of many Americans. Even the space program, which had symbolized the American spirit of discovery and adventure when President John F. Kennedy announced it in the early 1960s, had stalled. Here was a culture that needed new stories to inspire and instruct it—stories that would speak to modern concerns and at the same time offer some timeless wisdom.

The first film of the *Star Wars* trilogy, subtitled *A New Hope,* blasted across movie screens as a fast-paced action-

LEFT: **Apollo 17 commander Eugene Cernan on the moon.**

ABOVE: **George Lucas, creator of Star Wars.**

FROM TOP: **Robert Duvall in a scene from Lucas' film THX 1138.**

Lucas directing Ron Howard in American Graffiti.

adventure movie set in a new and exciting universe. Even in the midst of this disillusioned decade audiences frequently interrupted the film with spontaneous applause. Joined by *The Empire Strikes Back* in 1980 and *Return of the Jedi* in 1983, the *Star Wars* trilogy captured the imaginations of millions of viewers, and the three films remain among the top box-office hits of all time. George Lucas, *Star Wars'* creator, author, and the director of the first film, combined the universal story of the hero's journey with specific concerns and images from our own times. He dramatized the eternal battle of good versus evil and, by suggesting a way to emerge victorious from that battle, fashioned a tale that has all the elements of myth.

In the chapters to come, we will look at these elements in detail. But the story of how *Star Wars* came to be is a journey in itself.

George Lucas was born in Modesto, California, in 1944. His first love was car racing, but just before graduating from high school, he was involved in a near-fatal automobile accident. After this brush with his own mortality, he became interested in anthropology, sociology, and psychology, and studied these subjects at Modesto Junior College, along with creative writing. He was particularly fascinated with indigenous folktales and their cultural context. While working on a college project, Lucas discovered a book with a "wonderful life force":[2] Joseph Campbell's *The Hero with a Thousand Faces*, which examined some of the universal themes of myths and fairy tales from a variety of ages and cultures. This discovery began a lifelong interest in mythology for Lucas.

In 1964 he entered the University of Southern California as a film student. His first professional film, *THX 1138*, the story of a man accidentally granted free will in a robotic society, was released in 1971. In 1973, the release of *American Graffiti*, a look at growing up in the 1950s and early 1960s, established Lucas as a blockbuster filmmaker.

Until the hero of *THX 1138* developed a will of his own, he was more machine than human, while the teenagers of *American Graffiti* were adrift, searching for a meaningful future. Lucas' fascination with Campbell's work, a concern for the preservation of the human spirit in an increasingly technological world, and his interest in the process of growing up would all go into the mix that became the *Star Wars* films.

As Lucas began work on the script for *Star Wars* in the early 1970s, he realized that it would take a number of films to tell the complex story. The *Star Wars* trilogy represents the middle part of the saga; *Star Wars: A New Hope, The Empire Strikes Back,* and *Return of the Jedi* are episodes four, five, and six of an intended nine-part tale. The back story "about where Darth Vader came from, how the kids evolved, his wife, how

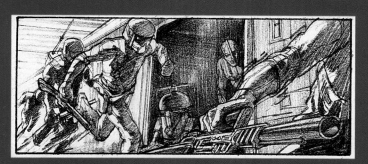
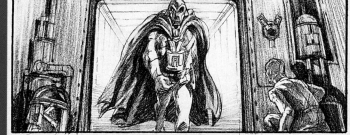

ABOVE AND LEFT: Storyboards for opening scenes of <u>Star Wars</u> by Alex Tavoularis.

RIGHT: Darth Vader and Imperial stormtroopers in the Rebel Blockade Runner.

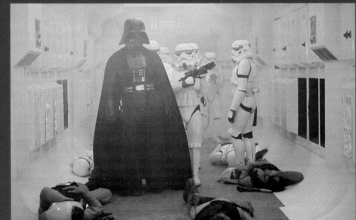

Ben related to all that, how the Emperor came to power"[3] was always in Lucas' mind as he built the trilogy around the coming of age of Vader's son, Luke Skywalker.

Lucas describes the process of writing the *Star Wars* trilogy in this way:

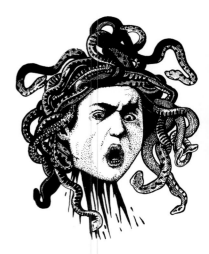

> *I was trying to take certain mythological principles and apply them to a story. Ultimately, I had to abandon that and just simply write the story. I found that when I went back and read it, then started applying it against the sort of principles that I was trying to work with originally, they were all there. It's just that I didn't put them in there consciously. I'd sort of immersed myself in the principles that I was trying to put into the script. . . . [And] these things were just indelibly infused into the script. Then I went back and honed that a little bit. I would find something where I'd sort of gotten slightly off the track, and I would then make it more, let's say, universal, in its mythological application. . . .*
>
> *I'm very much of the painting school of filmmaking, which is you put a layer on, and you put another layer on, and you put another layer on. You look at it, see how it is, redo it. It doesn't evolve linearly.*[4]

The result is indeed a multilayered story. Charles Champlin, in his book *George Lucas: The Creative Impulse*, summarizes it well:

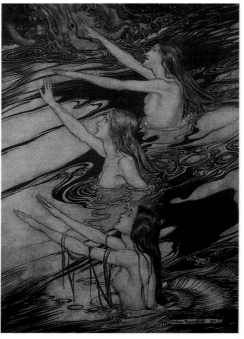

> *From early folklore writings from many different cultures, Lucas devoured the great themes: epic struggles between good and evil, heroes and villains, magical princes and ogres, heroines and evil princesses, the transmission from fathers to sons of the powers of both good and evil. What the myths revealed to Lucas, among other things, was the capacity of the human imagination to conceive alternate realities to cope with reality: figures and places and events that were before now or beyond now but were rich with meaning to our present.*[5]

The "alternate reality" that helps to place the *Star Wars* saga in the realm of myth is certainly part of its magic. But Lucas didn't just settle for creating a new universe, whose every culture comes complete with its own laws, landscapes, and history; he also set his adventure in an alternate time. "A long time ago in a galaxy far, far away" begins the first episode of the trilogy. Space stations and androids usually belong to narratives set in the future, but the *Star Wars* story, we are told, takes place "a long time ago." Lucas has taken a highly advanced technological society and portrayed it as existing in the past. And although the characters may be

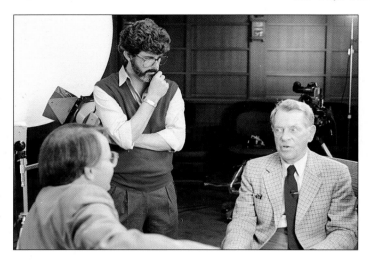

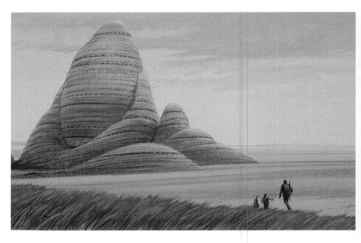

space travelers, they enact an ancient drama. Swords, sorcery, and chivalry combine with space flight, laser weapons, and droids. A traditional dark lord zooms around the galaxy in his futuristic Star Destroyer; a damsel in distress sends a message to her "gentle perfect knight" via a droid; a young man starts on a quest armed with his father's lightsaber—a laser sword—and he rides to a joust-to-the-death mounted on an X-wing fighter. It is as if medieval legend had been sent into deep space. This timelessness and spacelessness move the story into the realm of myth and fairy tale—it is in *illo tempore*,[6] a timeless eternity, both now and forever.

"The artist is the one who communicates myth for today," Joseph Campbell said.[7] In volume four of his multi-volume work *The Masks of God*, Campbell coined the phrase "creative mythology" to describe the process by which an artist takes the signs and symbols gathered from his or her own experience of the world and transforms them into a metaphor that reveals something about the mysteries of human existence. If the artist's experience has been profound enough and if the story that he or she creates is able to communicate some part of that deeper mystery, then the resulting work can have the value and force of traditional myth. In just this way, the *Star Wars* trilogy has become part of our contemporary "creative mythology," and in the years following its release, Campbell himself became interested in how this story captured certain mythological themes. In 1985 and 1986, Campbell discussed mythology, as well as his thoughts about *Star Wars*, with journalist Bill Moyers in a series of interviews. Filmed for the most part at Lucas' Skywalker Ranch in northern California, these interviews became the book and video series *The Power of Myth*. In this book, we will draw on *The Power of Myth* and the story of the "hero's journey," as described in Campbell's *The Hero with a Thousand Faces*, in order to trace the sources of the magic that has transformed *Star Wars* itself into myth.

CLOCKWISE FROM TOP LEFT:

(FROM LEFT TO RIGHT) **Bill Moyers, George Lucas, and Joseph Campbell at Skywalker Ranch,** © Douglas P. Sinsel.

Early concept painting for Rebel headquarters in the grasslands by Ralph McQuarrie.

Prince and princess with a "wise and helpful guide," The Fox Gives Advice, Donn P. Crane, 1936.

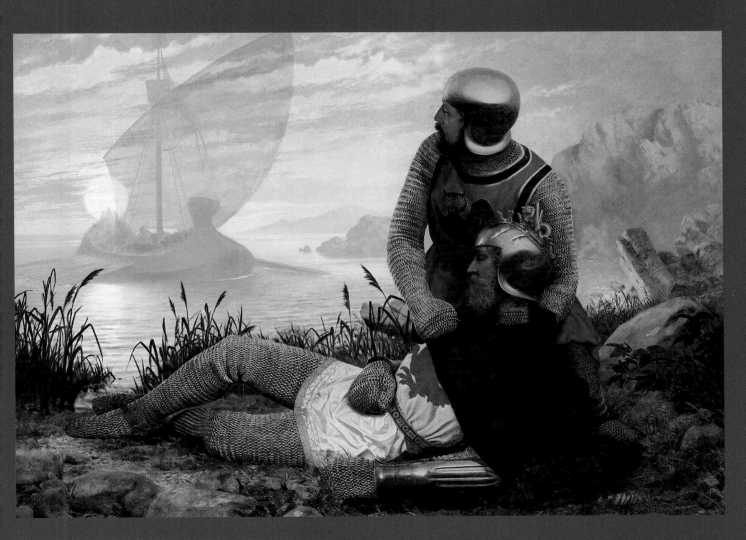

The knights of King Arthur's court
made the classic hero's journey,

John Mulcaster Carrick, <u>Morte d'Arthur</u>, 1862, private collection.

Chapter One

STAR WARS AND CLASSIC MYTHOLOGY:

The Hero's Journey and the Conflict of Good Versus Evil

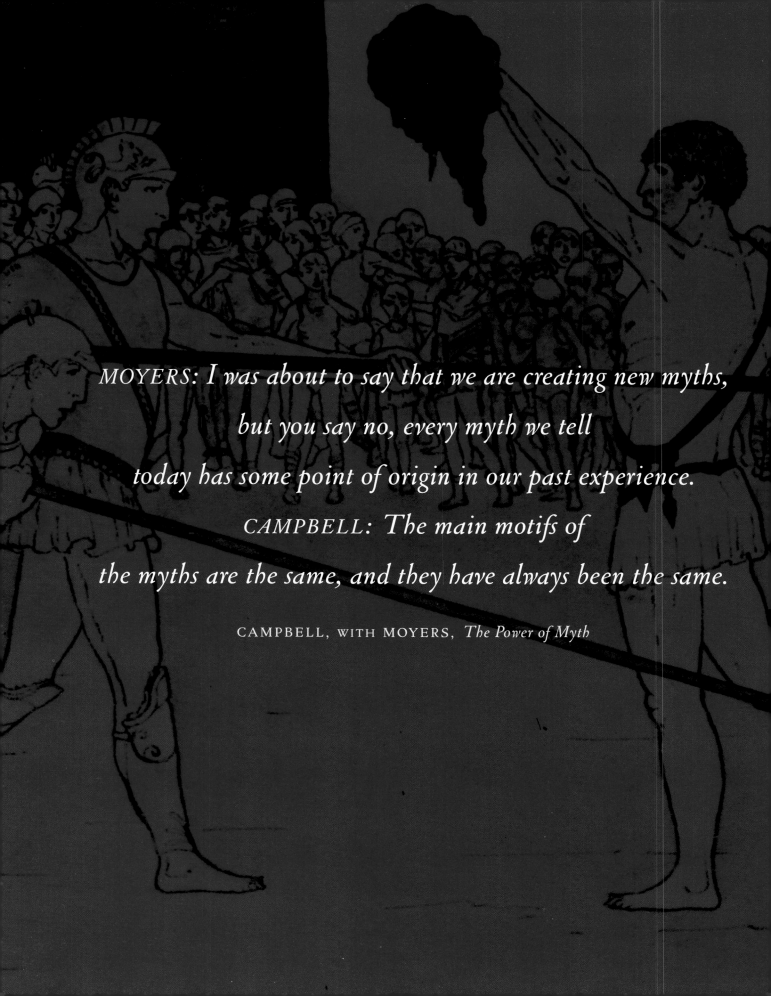

MOYERS: *I was about to say that we are creating new myths,*

but you say no, every myth we tell

today has some point of origin in our past experience.

CAMPBELL: *The main motifs of*

the myths are the same, and they have always been the same.

CAMPBELL, WITH MOYERS, *The Power of Myth*

When Joseph

Campbell maintained that all mythic stories draw on a common store of images and symbols, he was, in part, referring to the work of psychiatrist Carl Jung and his theory of archetypes. He believed that certain psychological urges and instincts manifest themselves in fantasies and reveal their presence through symbolic motifs. These "forms or images…occur practically all over the world as constituents of myths."[1] As the forms rise out of the unconscious mind in dreams and myths, archetypes appear as characters—princesses, knights, dragons,

wizards, and fools—who help or hinder the hero on the path to enlightenment. Or they may show up as archetypal images—a sequence of events, a certain kind of place, or a talismanic object. In the stories that speak to us most deeply, these elements remain remarkably constant. The activities, communications, and adventures in which the mythic hero participates; the places the hero visits, from the enchanted castle to the magic mountain to the darkest cavern; all these appear over and over in myths from around the world. At the heart of these stories there often lies a central conflict between some pair of opposites: good versus evil, light versus dark, even male versus female. As we watch this conflict unfold, we find the germ of meaning that can help us make sense of our own lives.

The *Star Wars* trilogy incorporates many of these classic mythic elements. In this chapter we will trace the appearance of two of them—the story pattern that Campbell called the "hero's journey" and the conflict of good versus evil—through the three *Star Wars* films of the trilogy.

BELOW: **Luke's home planet of Tatooine.**
Matte painting by Ralph McQuarrie.

The Hero's Journey

As Campbell and other scholars have noted, there is a certain typical hero sequence of actions that can be found in most myths. First, the hero must *separate* from the ordinary world of his or her life up to the point at which the story begins; then, in the new world through which the journey takes place, the hero must undergo a series of trials and must overcome many obstacles in order to achieve an *initiation* into ways of being hitherto unknown; finally, the hero *returns* to share what he or she has learned with others.[2]

ABOVE: Theseus, like Luke, gains his father's sword for his heroic deeds.
Theseus Moving the Rock to Reveal the Sword of Aegeus.

This story pattern can be found throughout classical mythology. Campbell himself cites the examples of Jason—who left the cave in which he was brought up in order to search for the Golden Fleece and then returned with this prize to recapture his homeland—and Prometheus, who traveled to Mount Olympus, stole fire from the gods, and brought it back to earth.[3] The knights of King Arthur's

Round Table set off to seek the Holy Grail, and the great figures of every major religion have each gone on a "vision quest," from Moses' journey to the mountain, to Jesus' time in the desert, Muhammad's meditations in the mountain cave, and Buddha's search for enlightenment that ended under the bodhi tree.[4]

As these last examples show, the journey is often not just a physical adventure that takes the hero from one place to another but it is also a spiritual one, as the hero moves from ignorance and innocence to experience and enlightenment. This is one reason why the middle leg of the journey is called "initiation"; as in the initiation rites of primitive cultures, the hero must give up the "childhood" that innocence and dependence represent and "come back as a responsible adult."[5] In a psychological sense, then, this is a voyage of self-discovery, an expedition whose true destination is the realm within each of us, where we must find our own unique center with all its strengths and weaknesses. Joseph Campbell puts it this way:

> *All the life-potentialities that we never managed to bring to adult realization, those other portions of ourself, are there [in the internal world]; for such golden seeds do not die. If only a portion of that lost totality could be dredged up into the light of day, we should experience a marvelous expansion of our powers, a vivid renewal of life. We should tower in stature. Moreover, if we could dredge up something forgotten not only by ourselves but by our whole generation or our entire civilization, we should become indeed the boon-bringer, the culture hero of the day— a personage of not only local but world historical moment.*[6]

If we look at Luke Skywalker's story in this light, its meaning begins to glow. Luke's journey through the three films transforms him from a rebellious and impatient teenager, itching for adventure, into a grown-up hero who has confronted his strengths and weaknesses and found the power to help save the world. Along the way, he encounters ogres and wizards, mazes and traps—the archetypal symbols of the hero's journey. In tracking his voyage, we will identify all the classical elements that help to make a myth of *Star Wars*.

But Luke's is not the only journey, the only transformation, that the *Star Wars* trilogy describes. Part of the joy and fascination of this particular myth is that it is full of heroes, sometimes found in the most unlikely places. Several of the main characters set off on a journey, encounter trials, and return profoundly changed. We will also see how Han Solo, the princess Leia Organa, and even Darth Vader and See-Threepio go through their own transformations and discover their deeper natures.

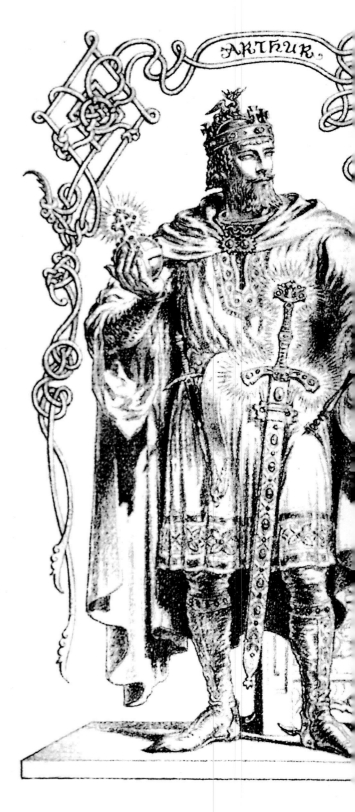

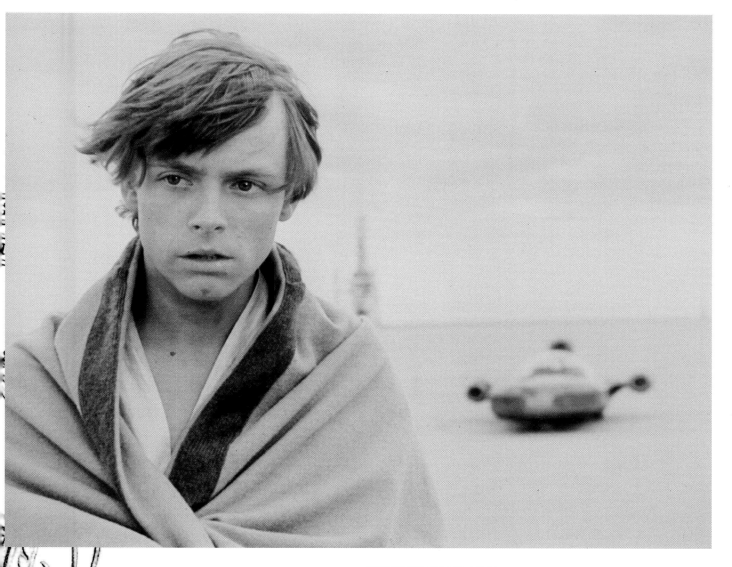

LEFT: **King Arthur,**
Robert Ball, 1939.

ABOVE: **Luke before his
journey begins.**

RIGHT: **Ancient
initiation rite.**
View of the frescoes from
Villa of the Mysteries, c. 50 B.C.

THE CALL TO ADVENTURE

N MYTH, HEROES ARE ALMOST ALWAYS DRAWN from the extremes of life; they are often either princes or paupers. Sometimes the hero is the child of distinguished parents—the father is, say, a king or a lord—but because of some difficulty surrounding the child's birth, such as a prophecy or a curse, he or she is sent far away into the wilderness or wasteland to be reared in humble circumstances. For example, the royal twins Romulus and Remus, the eventual founders of Rome, were suckled by a wolf and reared by a shepherd. Perseus, son of the great god Zeus and the princess Danaë, was brought up in a fisherman's hut until he was old enough to set out on his adventures, which included slaying the evil monster Medusa. Similarly, at the beginning of *Star Wars: A New Hope,*[7] Luke Skywalker is a poor farm boy, living with his foster parents, Uncle Owen and Aunt Beru Lars, on the remote desert planet of Tatooine. It will be quite some time before he discovers his royal heritage.

As the trilogy opens, Luke is like the Fool, the first card in the Tarot deck, which is an ancient fortune-telling tool. This card shows an inexperienced youth setting out on a journey; the way ahead is unknown, and the youth is completely unaware of the dangers that await him. In some decks, the youth may even be shown unwittingly on the verge of stepping off a high cliff.[8] Like this archetype, Luke's character as the story begins is unformed and untested, innocent of a wider experience of the world and unaware of what lies ahead.

The hero's journey actually begins with the call to adventure, the first occurrence in a chain of events that will separate the hero from home and family. Sometimes that call comes from within the hero's own nature, and the hero will set out of his or her own accord, but usually fate brings the call, often sending a herald—a person or animal who literally carries a message that causes the journey to begin. In the Arthurian cycle, the herald appears as an old hermit, who visits the court of Arthur and the Knights of the Round Table and tells them that he who will succeed in the quest for the Holy Grail is yet unborn, but will be born before the year has passed. Lancelot, after hearing this, leaves the court to continue on his adventure. He comes upon an imprisoned princess, the fair Elaine, whom he frees and marries. They beget a son, Sir Galahad, who eventually embarks on the successful quest for the Holy Grail. And so unbeknownst to Lancelot at the time (and to the other knights at the Round Table), the old hermit had indeed set him on his inevitable life's course. Usually the hero does not initially recognize the hand of fate at work; the precipitating crisis appears

THE FOOL.

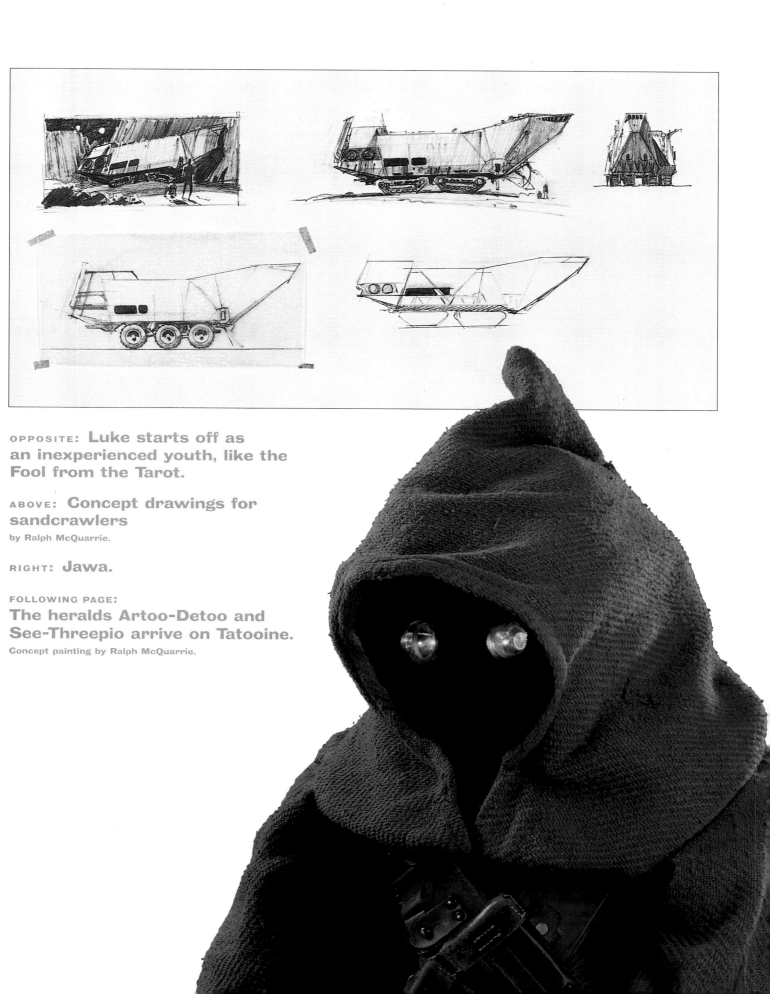

OPPOSITE: **Luke starts off as an inexperienced youth, like the Fool from the Tarot.**

ABOVE: **Concept drawings for sandcrawlers** by Ralph McQuarrie.

RIGHT: **Jawa.**

FOLLOWING PAGE:
The heralds Artoo-Detoo and See-Threepio arrive on Tatooine. Concept painting by Ralph McQuarrie.

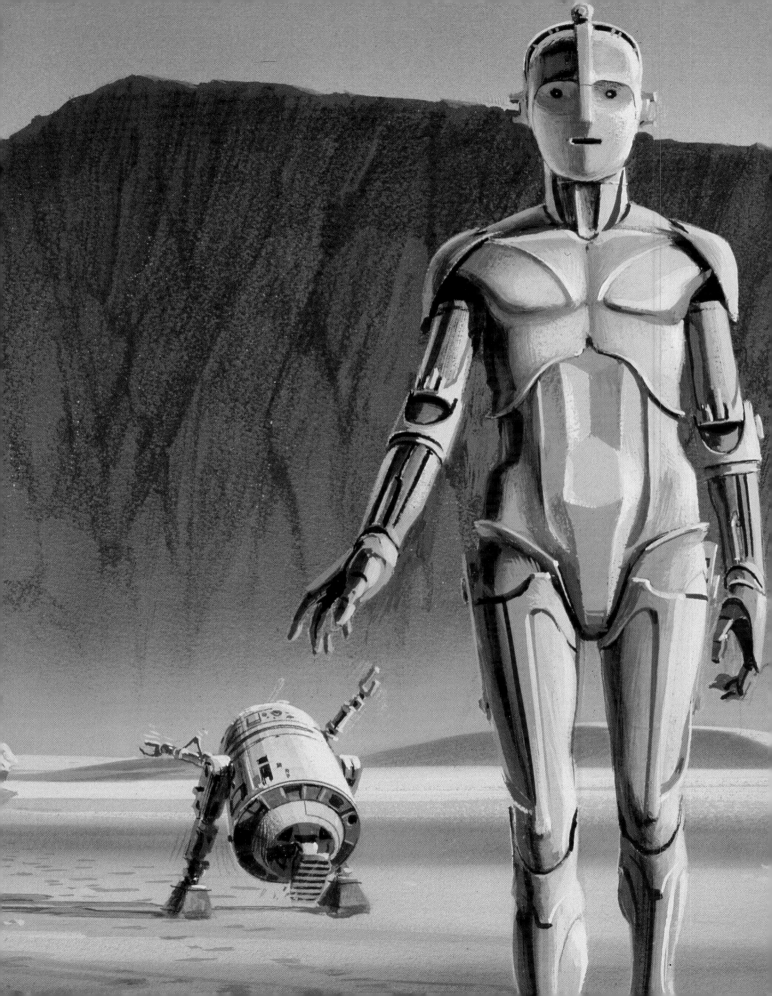

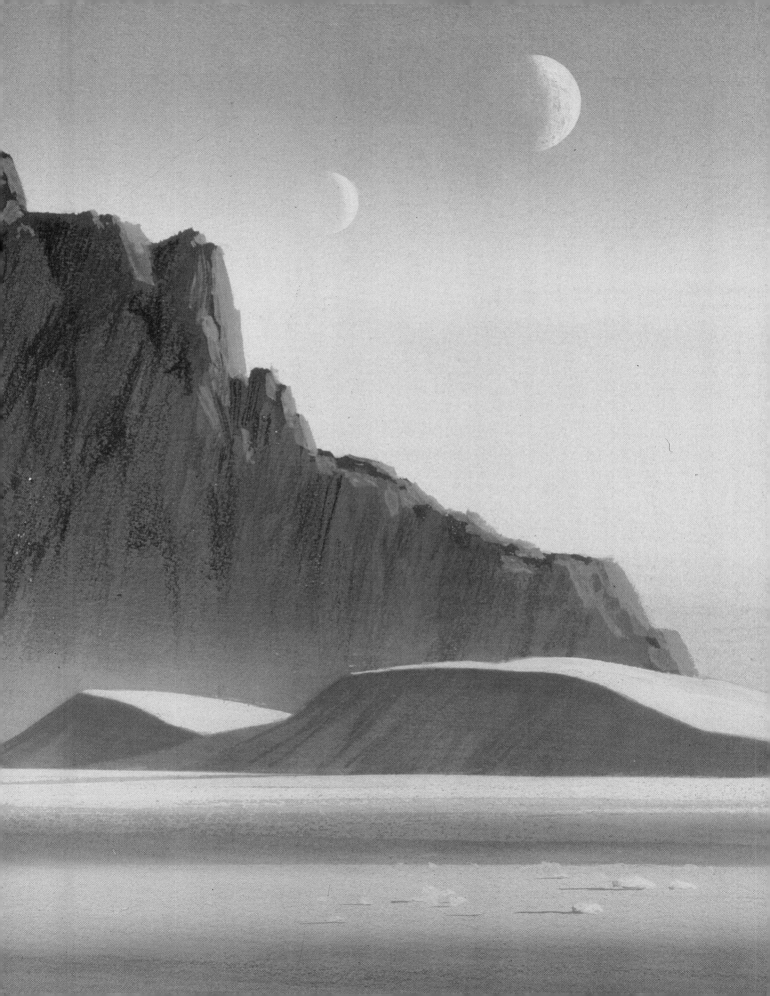

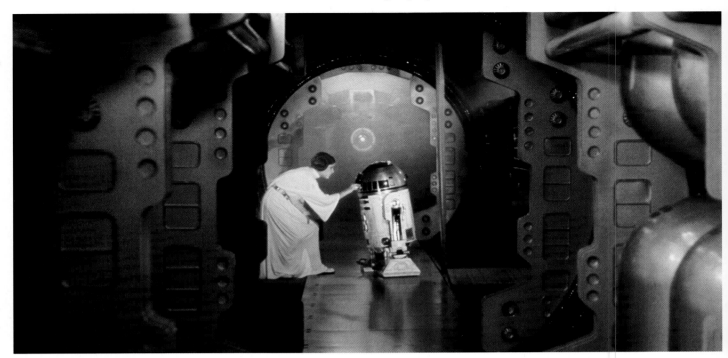

accidental or even commonplace, even though it represents
the opening of the hero's life into a world of unsuspected
power and danger.

In *Star Wars* the story begins with a damsel in distress
and a message gone astray: Artoo-Detoo and See-Threepio
set out to carry Leia's plea for help to Jedi Knight Obi-Wan
(Ben) Kenobi on the planet of Tatooine, but they are waylaid
by Jawa scavengers who roam the planet searching for junk
to sell. The Jawas take the droids to the Lars homestead,
unintentionally becoming the hand of fate that brings the
princess's message—and the call to adventure—to young Luke.

Traditionally a herald was the messenger of a royal
personage; now we use the word to mean not only someone
who brings news but also someone "who precedes or fore-
shadows," a presage or harbinger.[9] Artoo-Detoo satisfies both
these definitions, for he will not only make known to Luke
the existence of the princess but is also an omen of events to
come. While he is humble and unremarkable, the little droid
carries within his "rusty innards" the plans for the Galactic
Empire's battle station, the Death Star. In the myth of
Perseus and Medusa, the hero receives a magic shield, a cap
of invisibility, Hermes' sword, and a pair of winged shoes
with which to conquer the Gorgon. Here Luke acquires the
plans of the Death Star as the first step toward demolishing
the forces of darkness.

As archetypes, the droids can be compared to aspects of
the psyche. See-Threepio seems to be all ego and no insight.
He is fluent in over six million forms of communication, but
while he hears everything, he seems to understand nothing.

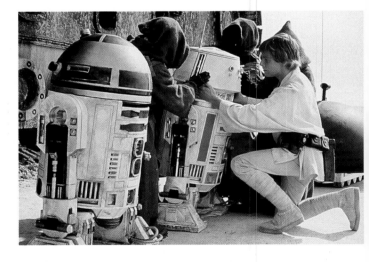

TOP: **Princess Leia gives the
herald Artoo the message for
Obi-Wan Kenobi.**

ABOVE: **The hand of fate guides
Luke to Artoo-Detoo.**

OPPOSITE: **Artoo-Detoo.**

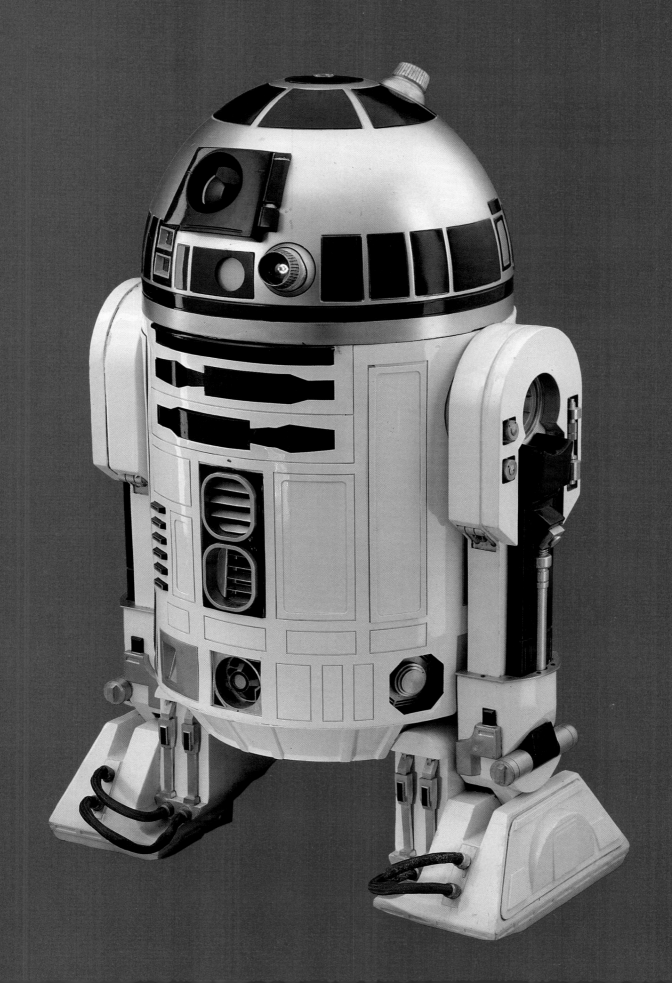

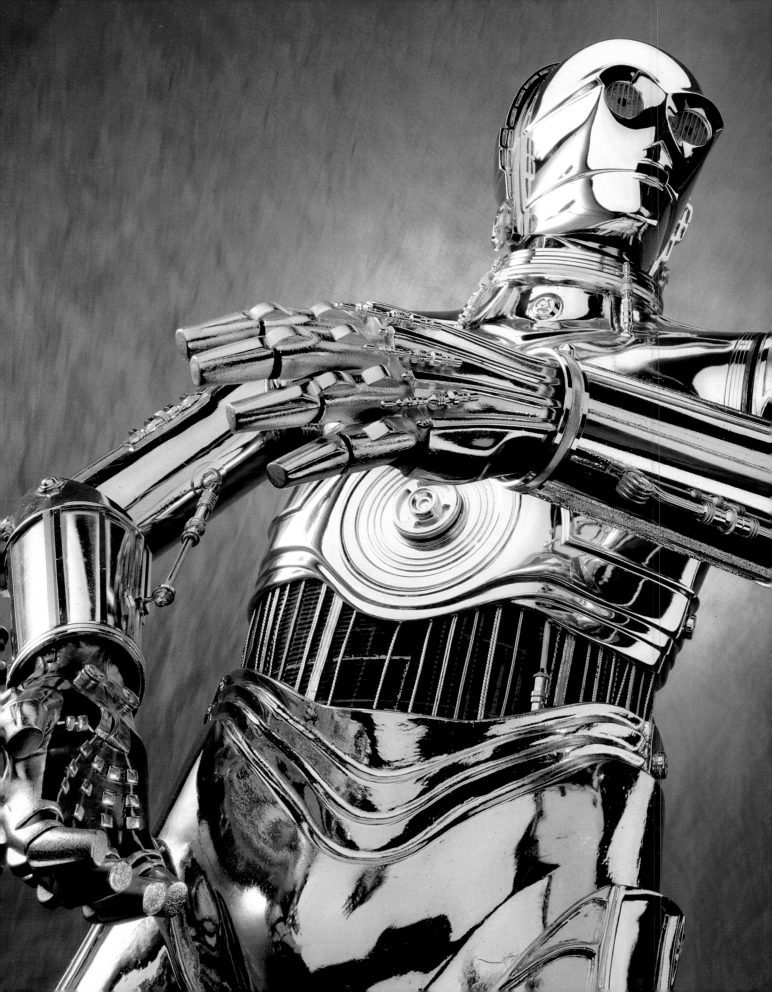

OPPOSITE: **See-Threepio.**

BELOW: **Luke and the two Suns.**

Artoo-Detoo is more like the subconscious mind—all his power resides deep within. He can take in massive amounts of data and process them instantly, but he can only communicate with humans through signs and symbols and often relies on See-Threepio's translations. Artoo seems made to keep secrets, yet he is the one who draws Luke into the quest.

See-Threepio, too, acts as an unwitting herald; his first conversation with Luke is fraught with prophecy. When Luke laments that he will never get off the farm, See-Threepio asks if he can help. Luke responds, "Not unless you can alter time, speed up the harvest, or teleport me off this rock!" It will indeed be the appearance of the droids that precipitates Luke's journey, catapulting him into a starship on his way to other planets. In this conversation, See-Threepio calls Luke "Sir Luke," and although Luke, still the innocent, laughs, by the end of the trilogy he will have matured and symbolically earned this title. Finally, See-Threepio says that he can tell Luke nothing of the Rebellion against the Empire because "I'm not much more than an interpreter and not very good at telling stories." This too will change, as we will see, near the end of *Return of the Jedi*. Luke's very name, Skywalker, reveals his destiny. While Luke's uncle wants to keep him on the farm, the young hero's name indicates that he is fated to travel in space.

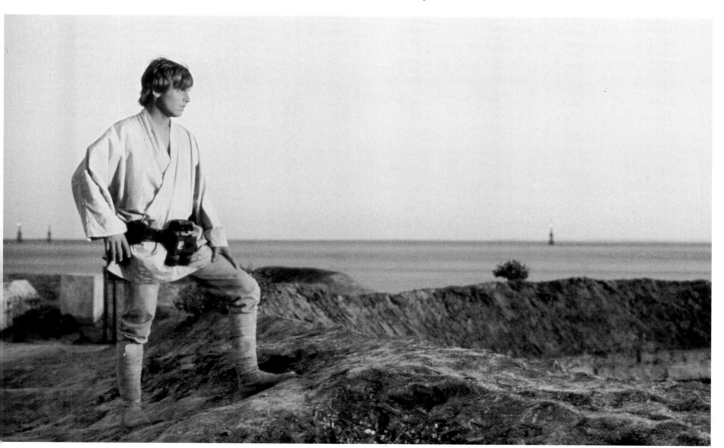

THRESHOLD GUARDIANS

EVEN BEFORE LUKE HAS COMMITTED himself to the journey, he faces obstacles, for entry into the realm of the spirit is always guarded. The way into the biblical Garden of Eden is blocked by an angel with a flaming sword; on their quest for the Golden Fleece, Jason and his Argonauts have to sail between the Clashing Rocks that can easily crush their ships.

To break through the boundaries that define daily life and so achieve the first step on his journey, the hero must get past such threshold guardians. Some are benign and protective, but this type can be restrictive too, for they will try to discourage the hero from setting foot on his path. Uncle Owen and Aunt Beru represent this type of guardian for Luke, and their mild reprimands when he insists that he would like to get away from the farm are the first obstacle that he must overcome.

In myths from the Middle Ages, the knight might begin his quest by following a mysterious white hart into a dark, unknown part of the forest. In *Star Wars* mythology, Luke sets off almost accidentally, hoping to find the escaped Artoo-Detoo and return before Uncle Owen notices that they are missing. Luke's path leads into the unmapped Dune Sea; he will, however, never really be able to return home again.

There is another, more dangerous type of threshold guardian that appears in the ancient myths, ready to stop the hero from entering the unknown realms that lie beyond the borders of homestead and village. The fearsome Cerberus guards the entrance to Hades, for example. Theseus is attacked by thugs as he sets off from his childhood home in Troezen on his way to Athens. Similarly, Luke, having stepped beyond the authority of his foster parents, is quickly overwhelmed by the Tusken Raiders, also known as the Sand People. He cannot pass this second barrier unaided; his hero quest, and his life, are about to end abruptly when a mysterious figure chases the marauders away.

THE WISE AND HELPFUL GUIDE AND THE MAGIC TALISMAN

OFTEN THE YOUNG AND INEXPERI-enced hero finds that in the early stages of the adventure, he cannot proceed without supernatural aid. As Joseph Campbell describes it, in fairy tales this helper "may be some little fellow of the wood, some wizard, hermit, shepherd, or smith, who appears, to supply the amulets and

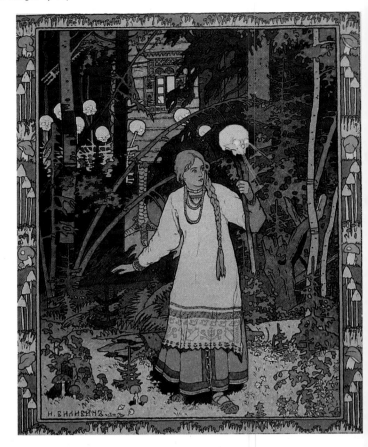

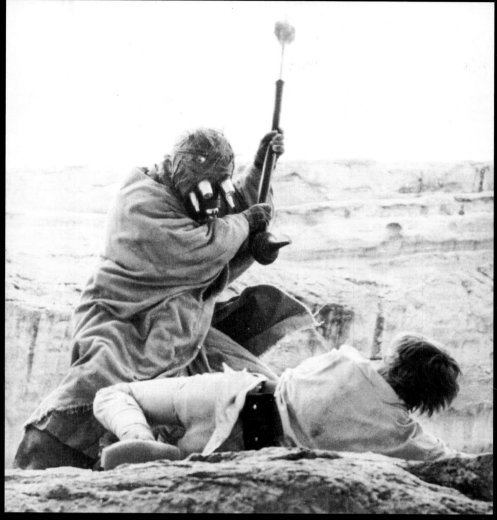

OPPOSITE, FROM TOP:
Vassilisa sets out from Baba Yaga's house.

Luke leaves the farm to look for Artoo.

ABOVE: **This Tusken Raider serves as a ferocious threshold guardian.**

RIGHT:
Guardian figure, 13th c.

advice that the hero will require. The higher mythologies develop the role in the great figure of the guide, the teacher."[10] In the Arthurian legends, for example, the wizard Merlin plays the role of the "wise and helpful guide," not only arranging for Arthur's conception and upbringing but also helping him achieve the throne and instructing him in the early days of his kingship. Frequently depicted with a white beard and deep, penetrating eyes, Merlin personifies the guide who holds the magical powers and foreknowledge of events that will guard and assist the young hero until he is able to continue the journey alone.

In *Star Wars,* Obi-Wan (Ben) Kenobi (who looks strikingly like Merlin) is a Jedi Knight who has retired from the world to live in solitude. Now he appears to save Luke's life and to offer the advice, amulets, and training that Luke will need in his quest. To begin his hero's journey, Luke needs a sense of direction, a goal. Ben's story of Luke's father, Anakin Skywalker, is rather different from the one that Luke has heard from Uncle Owen. Luke believes that his father was a navigator on a spice freighter; Ben tells him that his father was a starpilot and a Jedi Knight. Now Luke has his goal: he aspires to become a Jedi Knight like his father.

The talisman that Ben offers is a magic sword, the lightsaber—and not just any lightsaber but the one that belonged to Luke's father. In myth, the magic sword is

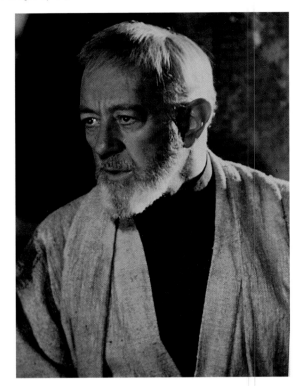

LEFT: <u>Siegfried Reforges His Father's Sword,</u>

Donn P. Crane, 1936.

ABOVE: Merlin is King Arthur's "wise and helpful guide," just as Obi-Wan Kenobi is Luke's.

<u>Merlin</u>, illustration by Robert Ball for <u>Idylls of the King</u>, 1939.

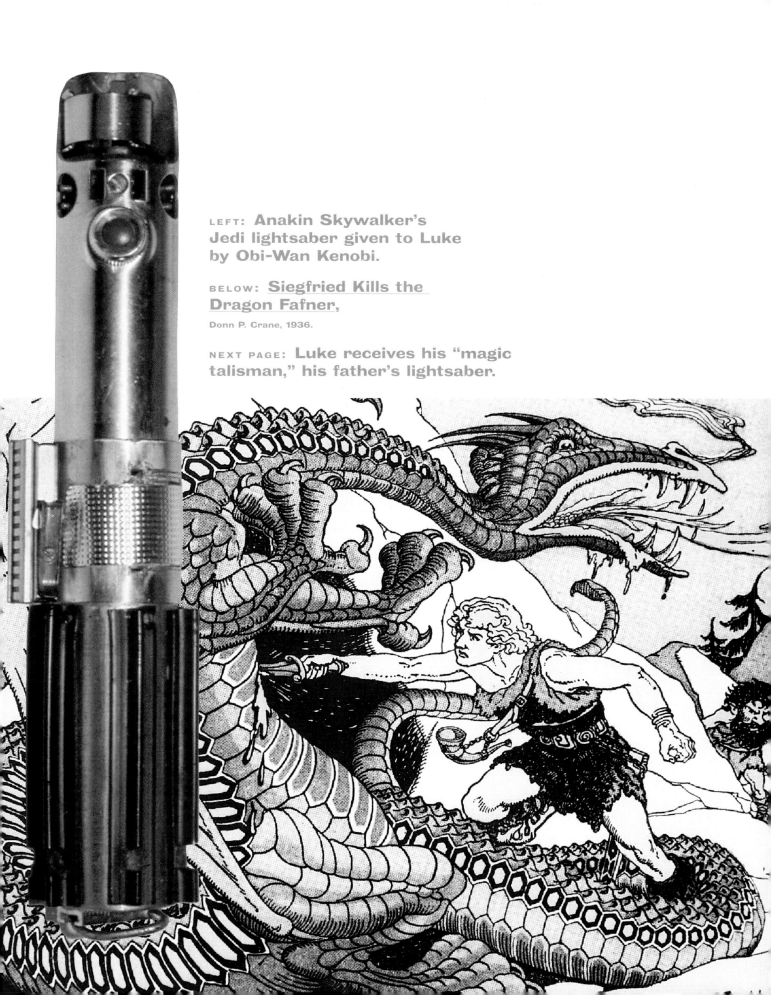

LEFT: Anakin Skywalker's Jedi lightsaber given to Luke by Obi-Wan Kenobi.

BELOW: Siegfried Kills the Dragon Fafner,

Donn P. Crane, 1936.

NEXT PAGE: Luke receives his "magic talisman," his father's lightsaber.

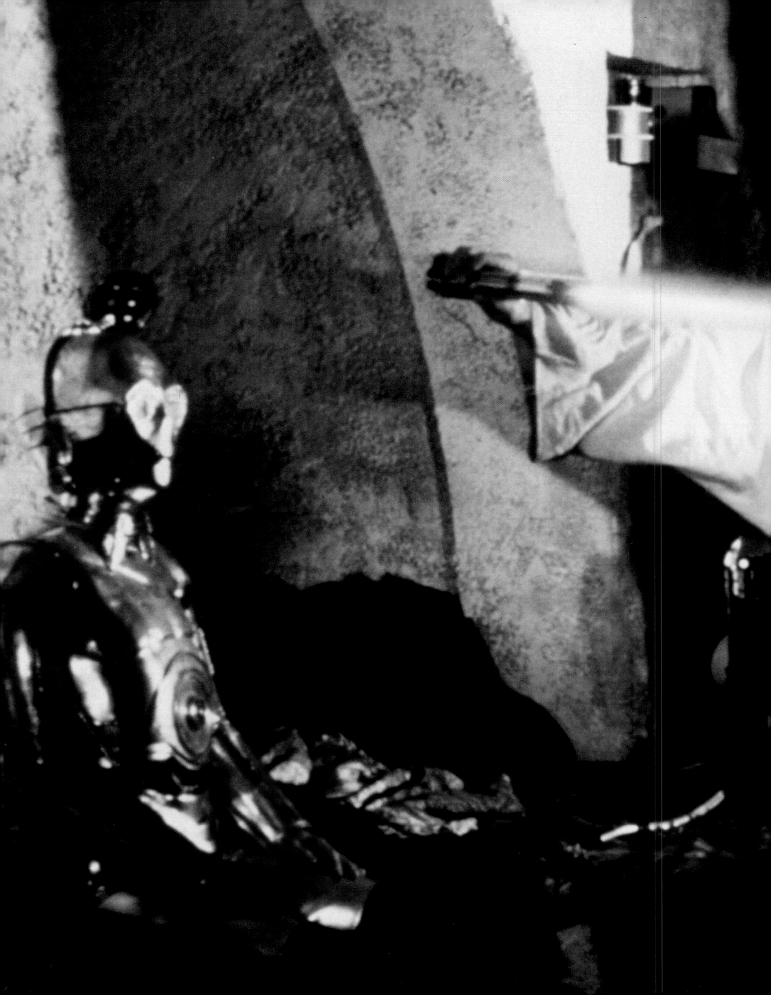

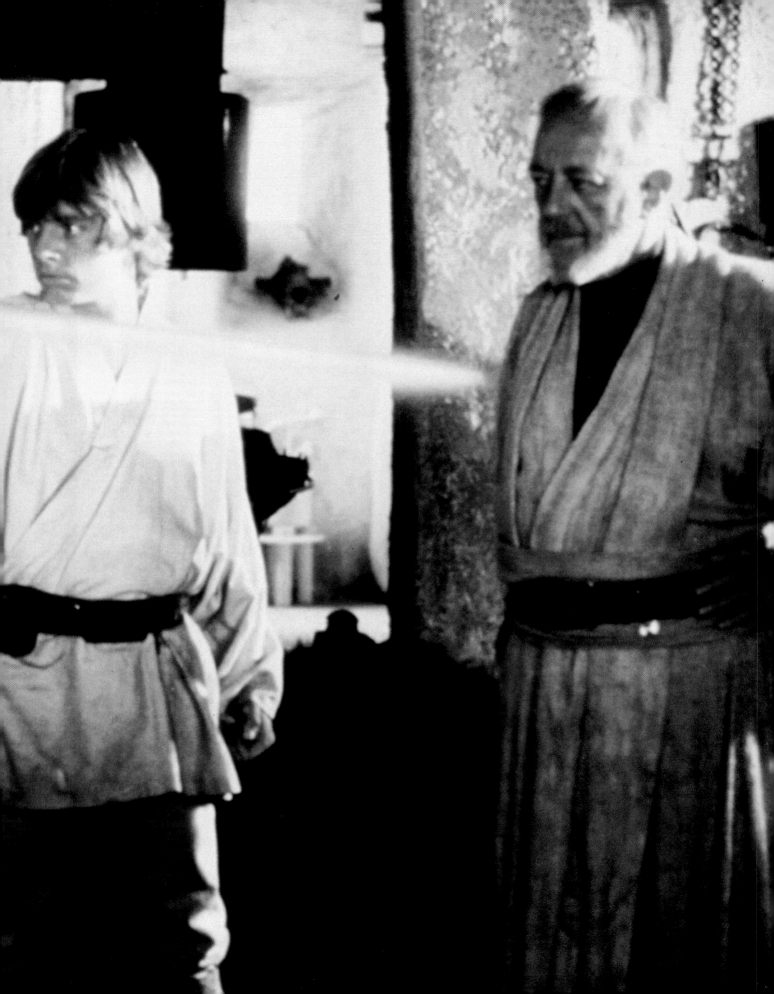

often a symbol of legitimacy, and the sword passed from father to son as a sign of inheritance and an especially potent weapon appears over and over. Siegfried, the hero of a medieval Germanic epic poem, reforges his father's broken sword and uses it to slay the dragon Fafner. This act connected him to his father's hero-heritage, and he goes on to accomplish many deeds of greatness.

The magic sword is a talisman laden with symbolism. An amulet can protect a hero from evil, but it doesn't require any action on the hero's part. The hero must actively wield a sword, which means that he must not only acquire skills but also make choices. If he fights for good, the sword stands for justice; if he fights for evil, then it represents destruction. The importance of the sword to the warrior is evident in the myths of all cultures where swords were used. Arthur depends for his kingship on Excalibur, for example, which—depending on the version of the story—is either the sword he pulls from the stone or the one he receives from the Lady of the Lake; this is a sword so sacred that it must be returned to her when he dies.

Offering Luke the lightsaber is, of course, just one of Ben's tasks as guide. He must also introduce Luke to the spiritual power known as the Force and to its dark side— the potential to use the Force for evil. Now all the essential elements of the quest are in place, for the Force lies at the heart of the struggles Luke will face and the triumphs he will achieve. We know now, if we ever doubted it, that the road ahead will be full of peril, for the hero must be tested. The direction will often be inscrutable, for the hero must learn and have faith, even while the adventure seems irrational.

REFUSAL OF THE CALL

HEROES AND HEROINES ATTEMPT TO back out of a life-changing adventure so often that Joseph Campbell gave this phenomenon a name: the refusal of the call.[11] The Greek nymph Daphne was approached by the god Apollo, but she refused his love and fled from him. Because Daphne stood fast in her rejection of the adventure, her father, the river deity Peneus, changed her into a laurel tree: "Her feet, but now so swift, grew fast in sluggish roots, and her head was now but a tree's top. Her gleaming beauty alone remained."[12]

When Ben retrieves Leia's message from Artoo and finds that they must travel to Alderaan, Luke is no different from other heroes who hesitate on the brink; he offers a list of standard excuses: "I've got to go home. . . . I can't get involved! I've got work to do." But the hand of fate has once

FROM TOP: **Arthur Removes the Sword from the Stone,** Arthur Rackham, 1902.

King Arthur's sword is returned to the Lady of the Lake.

How Bedivere Cast the Sword Excalibur into the Water, Aubrey Beardsley, 1893-94.

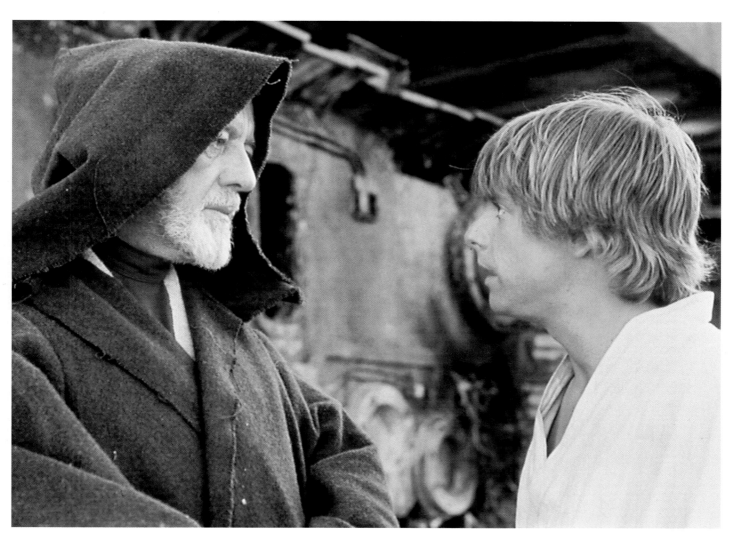

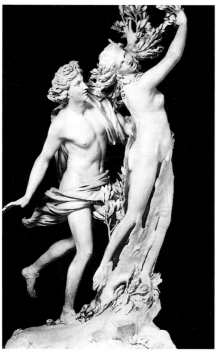

ABOVE: **Fearing for his family's safety, Luke initially refuses the call to adventure, but later decides to go after his family is destroyed.**

LEFT: **Daphne is turned into a tree when she refuses the call to adventure.**

Daphne and Apollo, Gian Lorenzo Bernini, 1622-23.

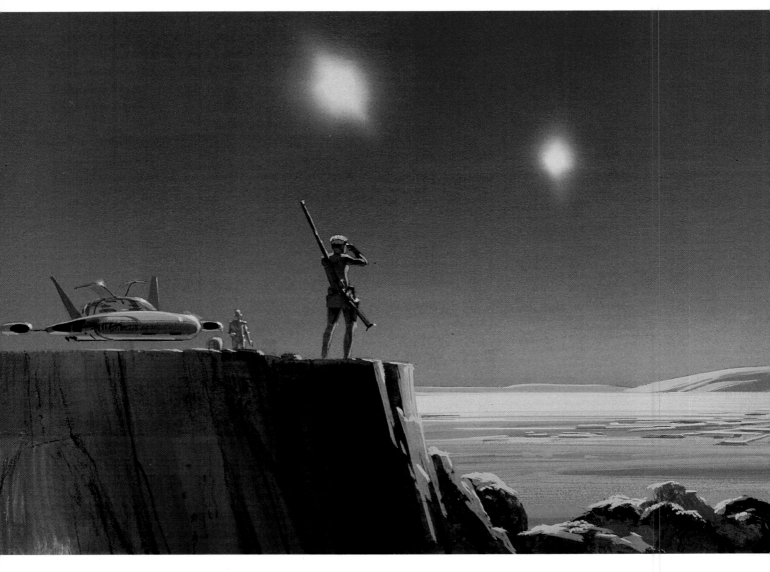

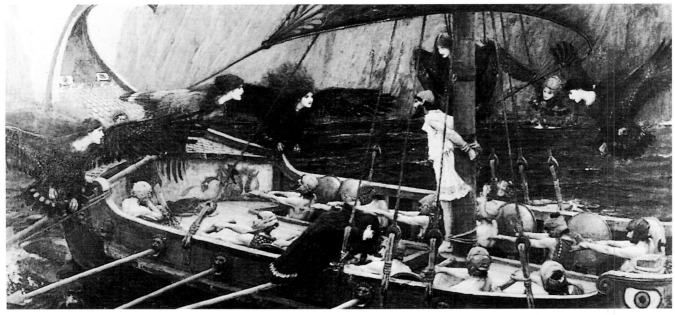

again done its work: when Luke rushes back to the Lars homestead, he discovers that Imperial troops have burned his home and killed his family.

This event sets Luke firmly on his path; now he has the motivation to join Ben and the droids in their attempt to rescue the Princess and save the Rebellion. He has literally been cut off from his old life; there is no way to go but forward. From a mythic point of view, this is the first real intimation that the hero's journey is not just a rollicking adventure—it also involves shattering pain, loss, and despair.

PASSING THE FIRST THRESHOLD

THE FINAL ACT OF SEPARATION FOR Luke is to leave not only his home behind but even his planet. Luke departs from Tatooine thinking he will travel to Alderaan; instead he will wander for a number of years before completing his adventure. This seemingly aimless roaming is a typical element of the mythic hero's journey. In much the same way, the Greek hero Odysseus leaves Troy at the close of the Trojan War, thinking he is on his way home to Ithaca; it will take him ten years to get there. As for all mythic heroes, the journey will involve trials and obstacles, victories and setbacks. Eventually the hero loses his traveling companions and must go alone to meet his destiny.

And like Odysseus, Luke needs a ship and shipmates in order to set out. The Mos Eisley spaceport represents another threshold that Luke must cross in order to begin this journey. Here he finds danger as well as opportunity in an unlikely pair of hero partners who provide the vehicle that will carry them on their journey.

HERO PARTNERS

THE HERO PARTNER IS AS OLD AS THE first written hero tale, the epic of Gilgamesh (668–626 B.C.). The gods send Gilgamesh a rival, Enkidu, but when neither can best the other, they become friends. In classical mythology, the most famous hero partners may be the Argonauts, a group of Greece's noblest heroes recruited by Jason to serve as the crew for the *Argo* and to assist in his quest for the Golden Fleece.

To find their hero partners, Ben and Luke must descend from the streets of Mos Eisley into the dark, mysterious world of the cantina, a gathering place for spaceborne pirates and adventurers. The descent into the underworld is an archetypal passage on the hero's journey, and this visit to

ABOVE: **Mos Eisley.**
Production painting by Ralph McQuarrie.

LEFT: **Odysseus (Ulysses) facing one of many obstacles on his journey.**
Ulysses and the Sirens, J. W. Waterhouse, 1891.
Courtesy of the National Gallery of Victoria, Melbourne, Australia.

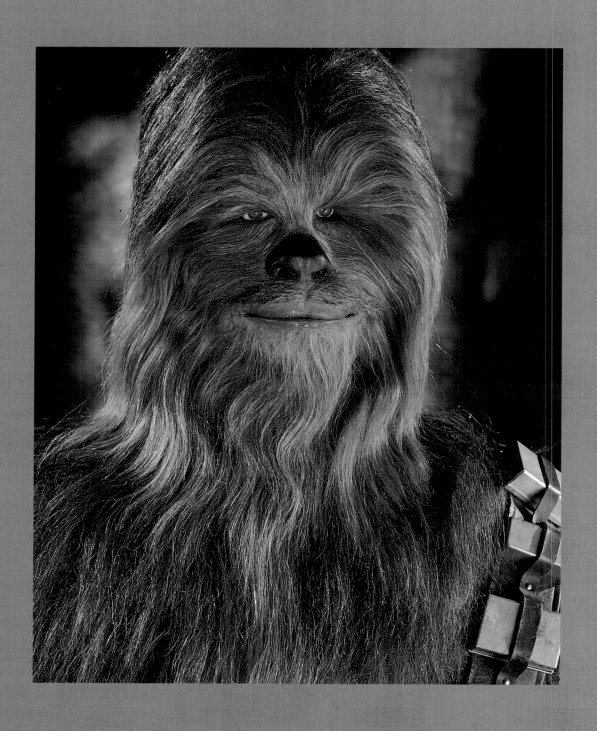

the cantina is just the first of several such descents found throughout the *Star Wars* trilogy. In a psychological sense, Ben and Luke are leaving behind everyday consciousness and descending into the lower regions of the unconscious, where strange, wonderful, and perilous forces reign. The cantina is a "murky, moldy den" housing "a startling array of weird and exotic alien creatures and monsters."[13] It's a bit like examining a drop of pond water under a microscope: we find a world full of horrific-looking life forms that are fascinating all the same. Inside the bar, an incredible variety of species, yeasty and contentious, exists side by side in a fragile and temporary state of truce.

But not all of the creatures found in the underworld represent negative forces. Sometimes, if they can be conquered or if one knows just the right magic words, they may be helpful to the wayfarer. Ben evokes just such a character. He talks to "an eight-foot-tall savage-looking creature resembling a huge grey bushbaby monkey with fierce baboon-like fangs"—a two-hundred-year-old Wookiee, to be exact.[14] This fearsome animal is Chewbacca, first mate on the *Millennium Falcon*.

Chewie leads Ben and Luke to Han Solo, a pirate, smuggler, and captain of the *Falcon*. Through the course of

OPPOSITE: **Chewbacca.**

THIS PAGE: **Hero Partners in Myth and Story**

FROM TOP: **The Argonauts with Athene.**

Concept drawings for Han Solo and Chewbacca
by Ralph McQuarrie.

Illustration for Westward Ho!,
John Oxenham, N. C. Wyeth, 1920.

CALS (FARMERS)

⑥ 2 × FARMERS.

⑦ 3 × CORELLIAN PIRATES

⑧ 3 × STARPILOTS

6' foot Fenny Leg Stilts.

FREDWOOD, ROY STAITE, ANTHONY LANG
ROBERT DAVIES, SALO GARDNER
JEFF MOON.

BARRY COPPING SKETCH

DIANA
SADLEY WAY
3 × Mar

Brown Shirt.

Khaki

Stone

martian head

3 × radion man

SKET

col

BRIDGET
DENHAM

SATION

STURGEON

⑭ 4 × LOCAL UGLY MEN

ERICA SIMMONS
ANNETTE JONES

SKETCH.

⑮ 1 × GRASSHOPPER

TOMMY ILSLEY
JOE KAYE.

⑯ 3 × PLUTONIAN martian

BARRY GNOME

NOTE.

㉔ ORCHESTRA: This consists of
1 × No 3.; 1 × No 7.; + 2

㉕ JAWAS Not Shown

㉖ Stormtroopers Not Show

3'6 midget

FLASH GORDON MIDGET
Macon Pouch

the trilogy, Han will also become a hero, and the arrival of Luke and Ben represents his own "call to adventure."

But the first step in Han's hero's journey is also hindered by the presence of a threshold guardian. Greedo, a bounty hunter, shows up with a message from Jabba the Hutt; Han must pay his debt or be killed. Unlike Luke, Han needs no supernatural aid to cross this threshold; in the best tradition of the old Westerns (which we'll explore in Chapter Two), he blasts Greedo and then heads for the ship.

MYSTICAL INSIGHT

"**W**HAT ALL THE MYTHS HAVE TO deal with is transformations of consciousness of one kind or another. You have been thinking one way, you now have to think a different way," Joseph Campbell told Bill Moyers.[15] To become a Jedi, Luke must know the Force. "The Force is what gives the Jedi his power. It's an energy field created by all living things. It surrounds us and penetrates us. It binds the galaxy together," Ben tells him. As the heroes travel to Alderaan, Ben begins to train Luke in the ways of the Force. Han, meanwhile, pokes fun at "hokey religions and ancient weapons," for his hero path will follow that of the warrior and lover. The spiritual way falls to Luke; he has left behind his circumscribed physical world, and now he must leave behind his mental preconceptions as well. In order to use the magic talisman that Ben has given him—his father's lightsaber—Luke must find the quiet place within himself and learn to act out of it, without being distracted by desire or fear.

In many ways, the Force combines the basic principles of several different major religions yet it most embodies what all of them have in common: an unerring faith in a spiritual power. The French sociologist Emile Durkheim stated that religion provides an individual with inner strength, purpose, meaning, and a sense of belonging.[16] In the *Star Wars* saga, the Force provides all of these things to those who know how to tap into it.

As we will see later, the Jedi approach to the Force incorporates many concepts from Eastern philosophy, while remaining true to a classic Western value: the importance of the individual. Today spiritual seekers often focus on developing a sense of wholeness and well-being and on actualizing their self-identity; this is part of a belief that the world can only be transformed for the better through change in individuals, rather than through widespread change in organizations and governments.[17] Although the *Star Wars* heroes will certainly learn about self-sacrifice and teamwork, they also

PREVIOUS PAGE:
Creatures from the cantina.
Costume designs by John Mollo.

TOP TO BOTTOM:
Luke and Ben barter with Han Solo.

Han's threshold guardian, Greedo.

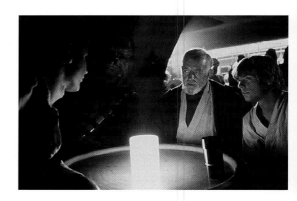

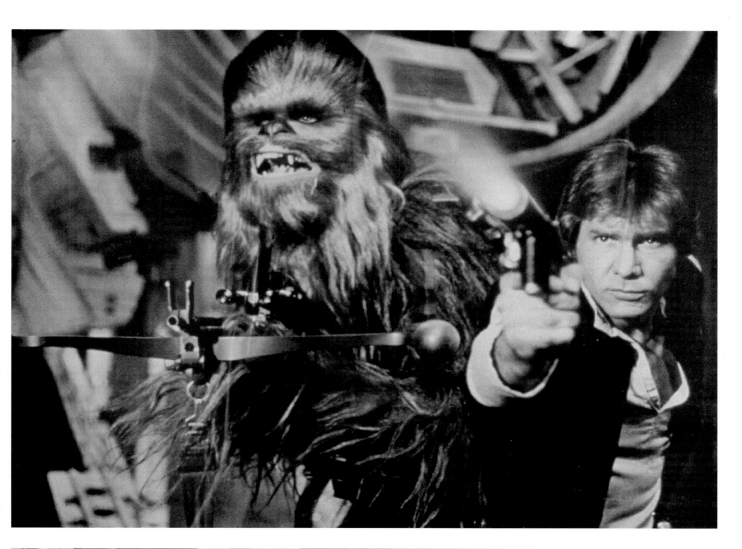

ABOVE:
Chewie and Han.

LEFT: **The cantina.**
Production painting by
Ralph McQuarrie.

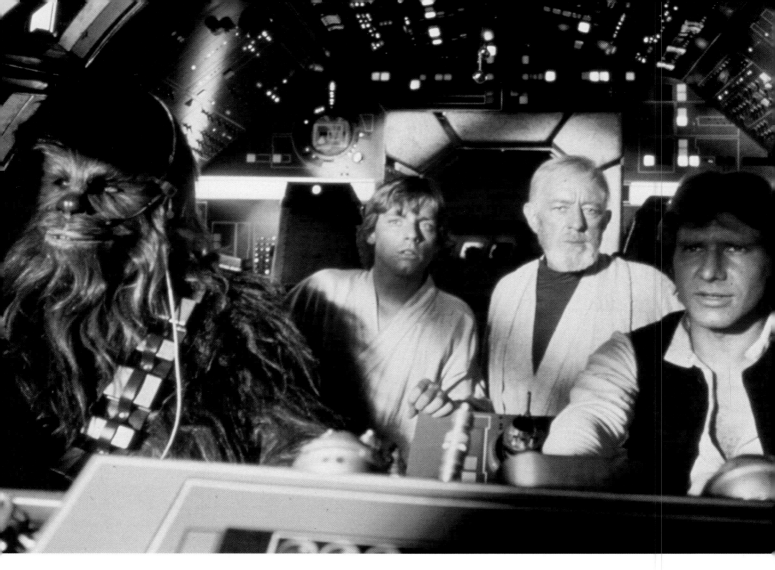

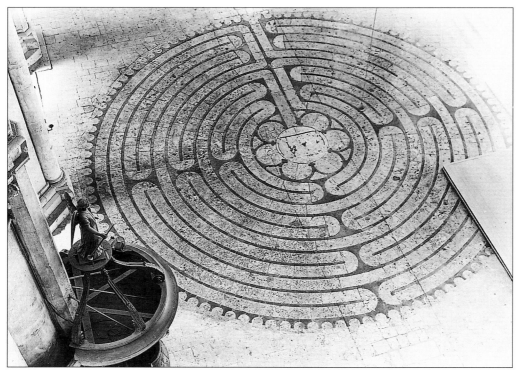

ABOVE: **Chewie, Luke, Ben, and Han aboard the Millennium Falcon.**

LEFT: **The labyrinth from the floor of Chartres Cathedral.**

demonstrate the power of the individual even in the face of a massive machine like the Empire.

THE LABYRINTH AND
THE RESCUE OF THE PRINCESS

WHEN THE HEROES COME OUT of hyperspace to approach Alderaan, they discover that the planet has been destroyed by the giant Imperial space station, the Death Star. Once the Death Star has pulled the *Millennium Falcon* into its innards, the heroes find themselves in a labyrinth, a maze of passages and rooms, dead ends and bottomless trenches. Each has a different goal. For Obi-Wan it is to free the ship. For Han and Luke, it is to rescue the princess and then make their escape.

In classical mythology, the labyrinth has always represented a difficult journey into the unknown. It is really a metaphor for our experience of life, which often seems, while we are in the midst of it, to be a twisting, winding road with no sense to its digressions; only at the end, if we're lucky, does a pattern appear that seems to have been in place all along. It is interesting to note that George Lucas created a mazelike environment in *THX 1138* as well; in fact, when he first conceived of that film as a student production, the first part of its title was *The Labyrinth*. In *Star Wars*, the Death Star's labyrinth forces the heroes to split up in order to accomplish their goal.

The traditional triangle in ancient hero stories consists of "hero-monster-woman," in which the hero must overcome a monster in order to rescue a maiden.[18] Leia, taken captive by the dark knight Darth Vader, is now guarded by the "dragon" of the Death Star. As is suitable for a twentieth-century story, the dragon is a high-tech monster, but it can still breathe fire and destroy everything in its path. Like medieval knights, the heroes will don armor, stealing it from stormtroopers they overcome along the way, then make their way through mazelike passageways, and finally be trapped in the belly of the beast before their job is done.

As they set out, however, Han does not act much like a chivalrous knight; Luke is only able to persuade him to help rescue the princess by offering a large reward. *Star Wars*, after all, was created in an age when irony ruled and sentimentality was definitely outmoded. In fact, Luke's first meeting with Leia is something of a satire on the classic story of "Sleeping Beauty." It's true that Leia is asleep, that she has been entrapped by an evil power in the midst of a well-defended fortress, and that her knight has fought his way to her side to

TOP TO BOTTOM:
Luke persuades Han to help rescue Princess Leia.

The Prince Awakens Sleeping Beauty,
Donn P. Crane, 1936.

NEXT PAGE: **Imperial stormtrooper.**

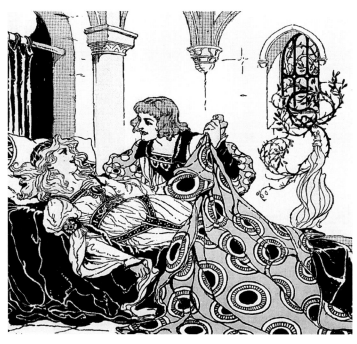

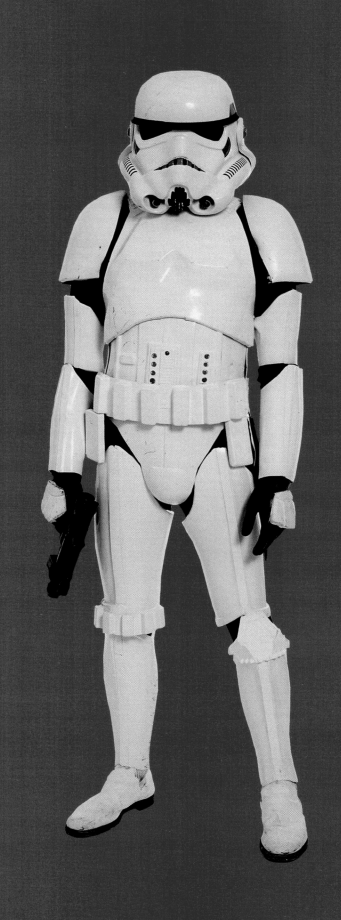

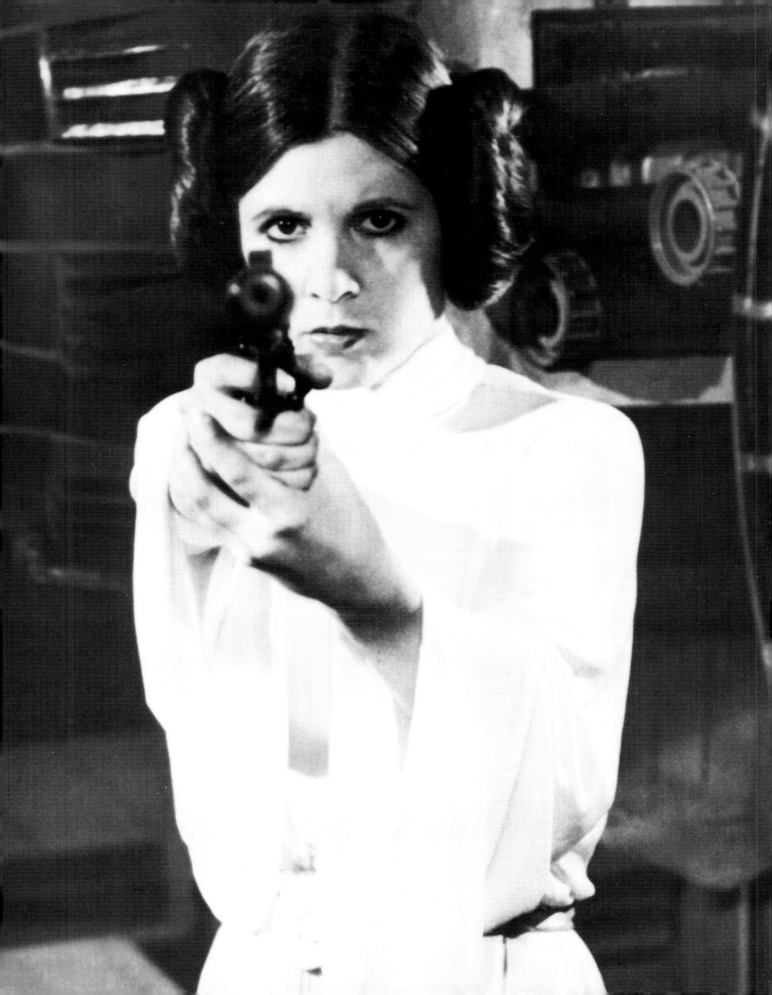

rescue her. But there will be no magic kiss for this duo. Instead, Leia wakes to the sound of Luke opening her cell door and immediately asks, "Aren't you a little short for a stormtrooper?" Leia may be in trouble, but she is certainly not a helpless victim. Lucas was clear on this: "I wanted a princess . . . but I didn't want her to be a passive damsel in distress."[19]

Indeed, Leia is a career woman with her own hero powers. She has refused to betray the Rebellion, even under torture, and now she does not scream, faint, plead, or cry. Rather, she introduces herself to Han with the comment, "Looks like you managed to cut off our only escape route," to which he responds, "Maybe you'd like it better back in your cell, Your Highness." Such is the stuff of modern-day courtly love. The princess and the pirate will eventually make a match, but it is the fashion these days for the protagonists in the affair to begin their relationship with antagonism.

We can also look at Leia in terms of Jungian archetypes. Vader is a perfect shadow figure; he is powerful and ruthless, representing the forces of evil in his all-black mask, battle

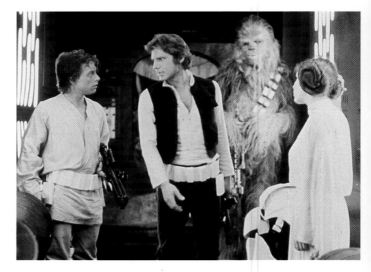

PREVIOUS PAGE: **Princess Leia is no "passive damsel in distress."**

THIS PAGE:
The Rescue of the Princess

CLOCKWISE FROM TOP:
Princess Leia takes an ironic tone with her rescuers.

Dante and Beatrice,
Donn P. Crane, 1936.

Itha Rode Away with Her Lord,
Thomas Heath Robinson, 1898.

OPPOSITE:
The Horseman of Night,
Ivan I. Bilibin, 1976.

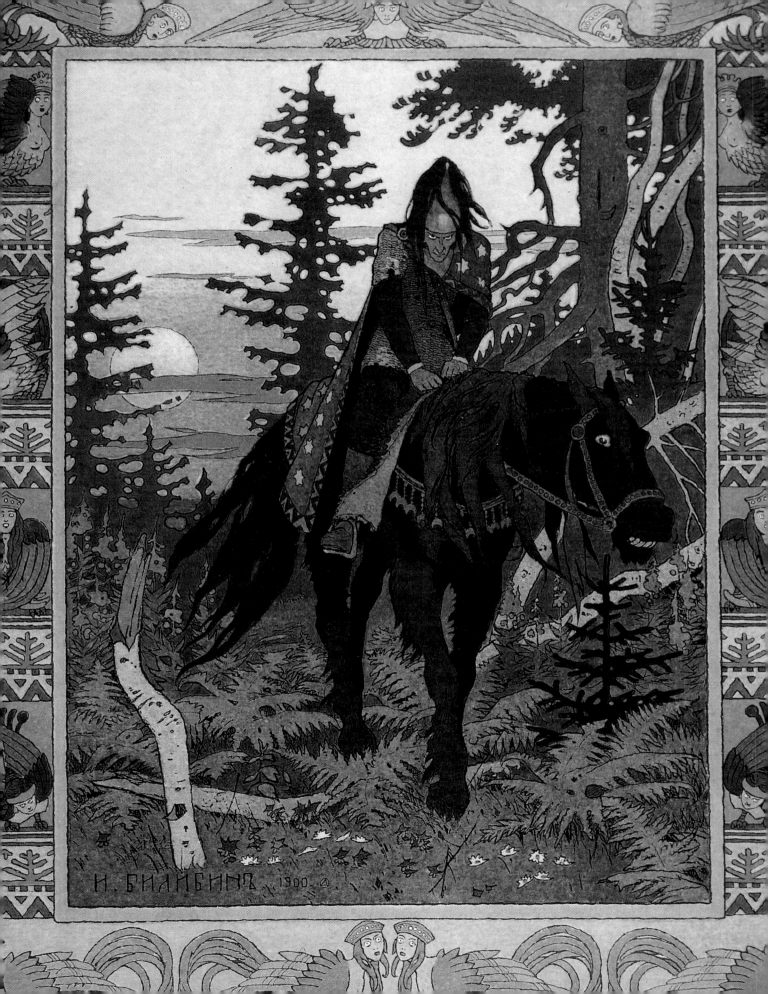

И. БИЛИБИНЪ 1900

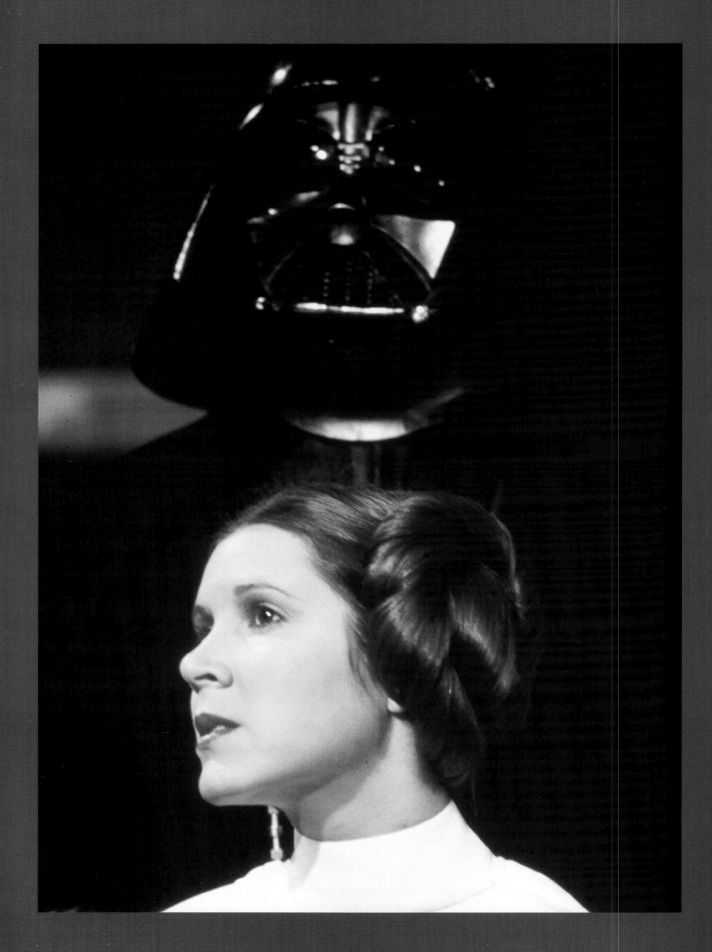

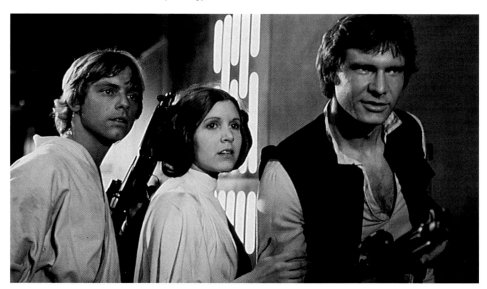

FROM TOP:
Leia with Luke and Han.

Joan of Arc at Orléans,
Martin, 1936.

OPPOSITE: **Light and shadow: Leia and Darth Vader.**

armor, and robes. Brought to him at his first appearance is a woman in white, his angelic opposite in every respect; small and feminine, she wears a simple white robe and embodies the forces of good. Leia Organa is a leader of the living, organic Rebellion against a mechanistic, sterile system.

Jung calls such a figure the anima; it personifies the feminine aspects of the masculine psyche, and it often shows up just behind the shadow. The anima can take on a number of shapes or forms, as does Leia on her journey through the trilogy.

But Leia, of course, is not just a symbol. She has her own capacity for action and is on her own hero quest. She is a military leader, a sort of Joan of Arc to the Rebellion, and is a seeker in her own right. She is Luke's inspiration, and by the end of *The Empire Strikes Back,* she will be Luke's rescuer, playing Beatrice to his Dante. But for now, he is her stalwart knight, and she is his inspiration for heroic deeds.

There is one more mythic motif to examine before we follow the heroes out of the Death Star. Yoda later warns, "Beware the dark side: consume you it will"—and throughout the trilogy, the imagery of the heroes being consumed is repeated over and over.

Now, in the Death Star, the heroes have found a power too strong for their current abilities and skills to overcome, so they have been literally swallowed up into its very bowels. The Death Star has sucked them in and gulped them down, and as the walls of the garbage masher begin to contract, they must either be masticated and digested, fight their way out, or use sorcery to escape, just like the classic hero who encounters the dragon.

By entering into the maze of "caves" in the Death Star, the heroes have traveled down into its body and are in its very belly, surrounded by water; we can even think of this as a

return to the womb. And we can take the analogy even further: the walls of the room begin to close in on its occupants just before their final release through a small door—rather like the contractions that push a baby out into the world. So on the one hand, the experience is that of being consumed by the Death Star; on the other, this is an ordeal of initiation and rebirth. It may even be both; in Egyptian mythology, these consumption and birth motifs are combined. Nut, goddess of the heavens, swallows the sun every night; it travels through her body and is reborn each morning. The *Star Wars* heroes, too, will survive this ordeal and will emerge transformed.

Much the same symbolism is at work as the heroes fight their way out of the maze. The labyrinth as a symbol was invested with mythic power before recorded history, when humans still sought shelter in the mouths of caves. With the discovery of fire, these caves could be explored, and it is clear from the images painted on rock walls more than thirty-five thousand years ago that the deeper recesses were often used for ritual purposes. If the earth was the great cosmic Mother, then to travel into the complex maze of deep caves was to be enveloped by her body, and to re-emerge was, in a sense, to be reborn.

Perhaps the most famous story about a labyrinth is the myth of Theseus and the Minotaur. Theseus is able to tread that maze safely because Princess Ariadne has given him a ball of twine; unwinding it as he travels toward the monster at the center of the labyrinth, Theseus ensures that he is not crossing or retracing his steps on the way in, and he can follow the twine on the way out. Luke has his equivalent of the thread, also given him (inadvertently) by a princess: the droids. Artoo and See-Threepio help lead Luke out of the Death Star maze through the magic charm of the comlink.

On the hero's journey, the trip through the maze represents a passage through the confusing and conflicting

TOP TO BOTTOM:
Garden Maze,
Hans Puec, 1592.

Theseus, Ariadne, and the Minotaur, 15th c.

OPPOSITE: **Luke and Han in the garbage masher—the belly of the beast.**

pathways of the mind in order to reach the center of one's being; there the seeker can discover some essential truth about his or her own nature. In this way, the journey through the maze of the Death Star acts as the first level of initiation for the *Star Wars* heroes, and the group emerges from the dirty ooze of the garbage masher as though reborn. They begin to behave differently and to come together as a hero team. The formerly self-serving Han risks his own life chasing stormtroopers down a hallway so that the others can get away, and faithful Chewie follows him. Luke, meanwhile, swings Leia across a precipice in the best action-adventure style; his magical transformation—from hapless adolescent to competent adult—is under way.

LOSING THE GUIDE

N MANY MYTHS AND FAIRY TALES, THE HERO slays a monster in the labyrinth; in this case the monster, Vader, slays one of the heroes, Ben. While the rest of the group is rescuing the princess, Ben has disengaged the tractor beam that holds the *Millennium Falcon* hostage, but on his way back to the hangar, he encounters Darth Vader. The challenge to single combat represented the height of medieval chivalry, especially when engaged in the aid of a princess. In the Arthurian cycle, Sir Gareth

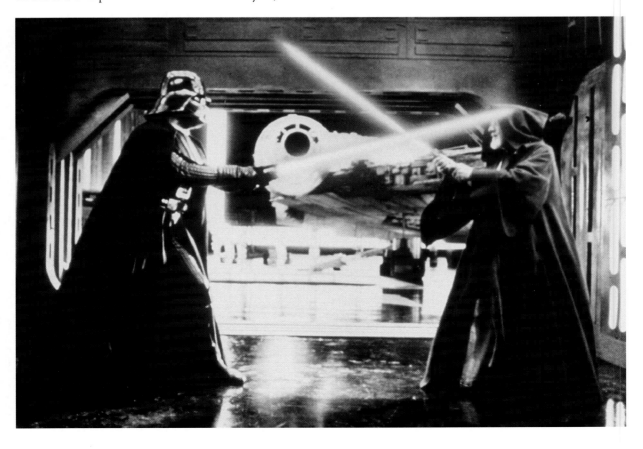

TOP: <u>**Sir Kay Overthroweth**</u>
<u>**His Enemies,**</u> Howard Pyle, 1903.

ABOVE: <u>**David and Goliath,**</u>
Gustave Doré, 1866.

OPPOSITE: <u>**Darth Vader and**</u>
<u>**Ben Kenobi in single combat.**</u>

fights the Red Knight to rescue the Lady of Lyonesse; now Ben fights the "black knight" for the safety of Princess Leia.

In the classic structure of the hero's journey, the guide can only bring the hero so far, and Ben has now fulfilled his functions: he has ferried Luke across the preliminary threshold, given him the magic talisman, introduced him to the ways of the Force, found him a pair of hero partners and protectors, brought him to the princess, and enabled his escape. Luke, as part of his growth, must let go of his mentor, just as Arthur has to become independent of Merlin once he grows to manhood. And so Ben gives Luke a smile and a salute before letting Vader cut him down. Yet Luke will soon find that this guide has been incorporated into his own psyche and will return to him in spirit form to help out when needed.

HERO DEEDS AND DRAGON SLAYERS

HAVING SUCCESSFULLY PASSED THIS first stage of their initiation, the heroes are ready for a more direct confrontation; it is time for them to prove themselves through daring deeds. At the Rebel base, they plan the attack on the Death Star, and Luke joins the fighter pilots of the Rebellion, setting aside his youthful identity and pledging his life to a higher cause. With the rest of the squadron, he flies off to slay the dragon.

In myths and fairy tales, dragons guard treasure or maidens, yet they can use neither. Symbolically, this means that they hold the riches and creativity of life in bondage, while wreaking senseless destruction. The hero's force is always equal to that of the dragon; otherwise he would not have the power to slay the beast. But his power is of a very different sort, and his use of this force "for right, not might," is what makes him a hero.

In *Star Wars*, the Death Star is the dragon, and Luke and Han have liberated the princess from its clutches; now they must liberate the galaxy from the menace that holds it hostage. In many ways, this combat between the Rebels and the Empire is reminiscent of the fight between David and Goliath. The Rebels have nothing to match the mighty firepower of the space station. Their only hope is to drop a proton torpedo into a small target, the thermal exhaust port, not unlike David launching a small stone at the mighty giant. But it is not the size of the missile that will determine the outcome; rather, it is the knowledge of exactly where to cast it that counts. Similarly, only the small X-wing fighters can penetrate the station's defenses, and success depends on the accuracy with which they can hit their tiny target.

In this trial, the climax of the first film, the heroes'

SHOT # **278**	BACKGROUND: LOW ALTITUDE DEATH STAR HORIZON STARS	P.P. #	PAGE # 45 **GOLD**
OPTICAL:		LAZER	FRAME COUNT: 52 / BOARD # 203

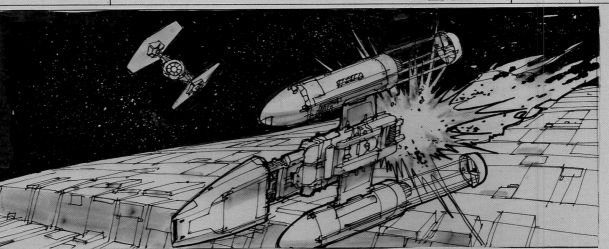

DESCRIPTION: ENGINE EXPLODES ON Y WING. SHIP DIVES OUT OF CONTROL TOWARD D.S. SURFACE.	ROTO: **LAZER**
DIALOGUE:	

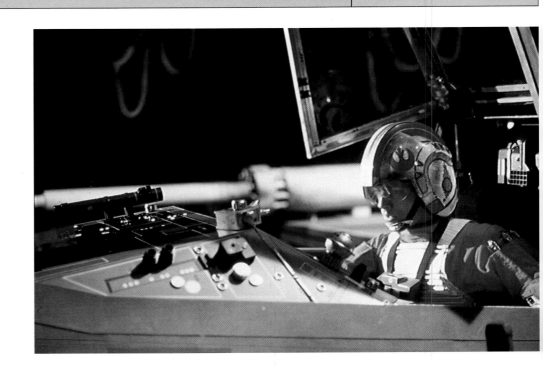

CLOCKWISE FROM OPPOSITE BELOW:
Luke sets off to slay the "dragon."

Storyboard for the battle over the Death Star
by Gary Myers, Paul Huston, Steven Gawley, Ronnie Shepard under the direction of Joe Johnston.

Test of skill: The X-wings must hit a tiny target.
Production painting by Ralph McQuarrie.

Leia rewards Luke and Han for their heroic deeds.

mettle will be tested. Have they learned what they needed to learn during the initiation through which they have just passed? Han at first appears unredeemed; he accepts the reward for the rescue of the princess and leaves before the battle begins, not willing to sacrifice himself for a cause he has not yet joined. But just as Vader is about to destroy Luke on his final attack run, Han returns to save his friend and partner. The first stage of Han's transformation is complete; he has transcended his selfishness and now acts as part of the team. As Joseph Campbell expressed it, "Solo was a very practical guy, at least as he thought of himself, a materialist. But he was a compassionate human being at the same time and didn't know it. The adventure evoked a quality of his character he hadn't known he possessed."[20]

As Luke charges down the trench of the Death Star, the disembodied voice of Ben advises him to "use the Force, Luke. . . . Let go." Ben, the master of secret ways and potent words, is part of Luke now. Luke's new powers triumph when he successfully completes his bombing run without the use of the targeting computer, and the Death Star explodes. Luke has become a dragon slayer.

When Siegfried slays the dragon Fafner, he gains its gold and, by drinking its blood, its wisdom. As *Star Wars* ends, Luke and Han are rewarded for their valiant deeds with respected positions in the Rebel Alliance, and they have each discovered a new part of themselves. The heroes will find, however, that victory comes with a price and they will eventually have to pay with their own blood. This ending, then, marks just the beginning of the next stage of initiation—and more adventures on the road of trials.

THE DARK ROAD OF TRIALS

WHEN *THE EMPIRE STRIKES BACK* opens, the hero's journey is only at the midpoint; this is the point at which begins, as the Italian poet Dante describes it, a journey through hell:

Midway in our life's journey, I went astray from the straight road and woke to find myself alone in a dark wood. How shall I say what wood that was! I never saw so drear, so rank, so arduous a wilderness! Its very memory gives a shape of fear. Death could scarce be more bitter than that place![21]

The heroes have not yet conquered the powers of darkness. The next stage represents a long and perilous set of tests and ordeals that will also bring important moments of illumination and understanding. Again and again, monsters must be slain and barriers must be passed. At this midpoint in the journey, the theme of the hero's quest darkens, and the pattern of capture, rescue, and escape becomes relentless and oppressive, until finally rescue and escape become impossible.

THE HUNT

THE MOTIF OF THE HUNT IS REPEATED IN different guises throughout this second film in the trilogy. Predators stalk, snare, and even consume their prey, while the victims manage to wiggle away, only to be captured again. Out of the dangerous, exhilarating exertion and peril of the hunt came the first hero stories, for this early means of providing human sustenance demanded that hunters draw on an awesome power from within themselves. In these prehistoric survival dramas, the contest exchanged a life for a life, and the feeding of predator on prey represented a sacred rite of transubstantiation. Hunter and victim were bound like kin, for they both mystically participated in the transmutability of the life force.[22]

This relationship changed when humans began to hunt each other. In the cantina at Mos Eisley toward the beginning of *Star Wars*, Greedo is the first bounty hunter encountered in the trilogy. In *The Empire Strikes Back*, bounty hunters play a prominent role, as Vader calls a group of them together to search for Luke's companions. They are perhaps the most fearsome predators that the heroes will face.

It has been three years since the destruction of the Death Star, and young Luke is now a commander of the Rebellion. In destroying the Death Star, Luke completed his

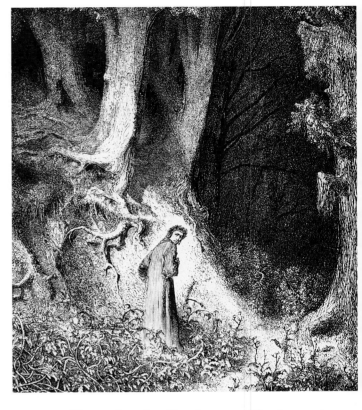

ABOVE: "I woke to find myself alone in a dark forest...," Dante

The Forest, Gustave Doré.

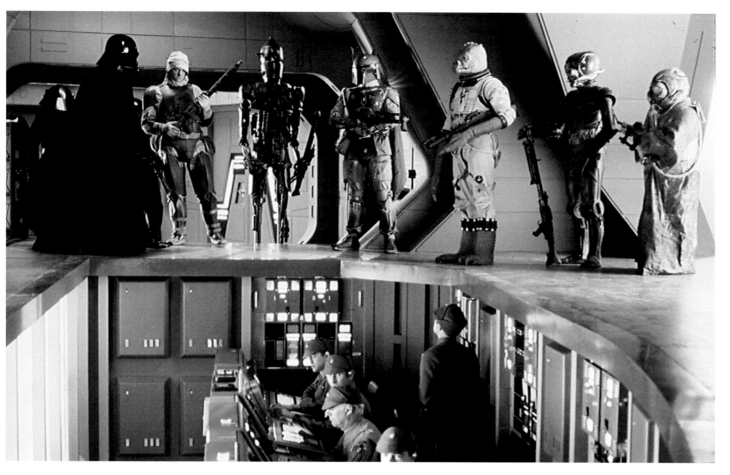

ABOVE: **Vader assembles the bounty hunters.**

BELOW RIGHT: **The ice-bound planet of Hoth.**

Matte painting by Michael Pangrazio.

first hero task—an act of physical courage and faith. Now he must accomplish a moral victory. The setting of the action on the ice-bound planet of Hoth symbolizes his state of being. Luke has made a firm place for himself in the Rebellion, but he has also become "frozen" there. For further growth to occur, events must work him loose again, and he must move on alone to the deeper realms of his vision quest.

Shamans, the priests and visionaries of earlier cultures dating back to the Paleolithic period, were apparently closely linked to the animal world and the hunt. In order to enter the visionary realms, the shaman himself must become a victim,

TOP RIGHT: Luke hangs upside down in the wampa's ice cave.

TOP LEFT: A wounded Luke escapes from the cave.

ABOVE: Storyboards for the wampa scene in the <u>Special Edition</u> by George Hull.

LEFT: Han rescues Luke, marking another stage in Han's development as a hero.

OPPOSITE: The wampa, Luke's first test on this stage of the journey.

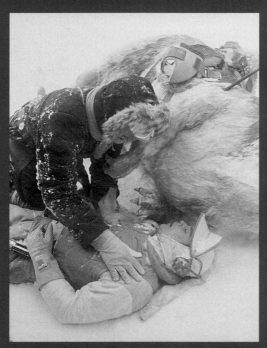

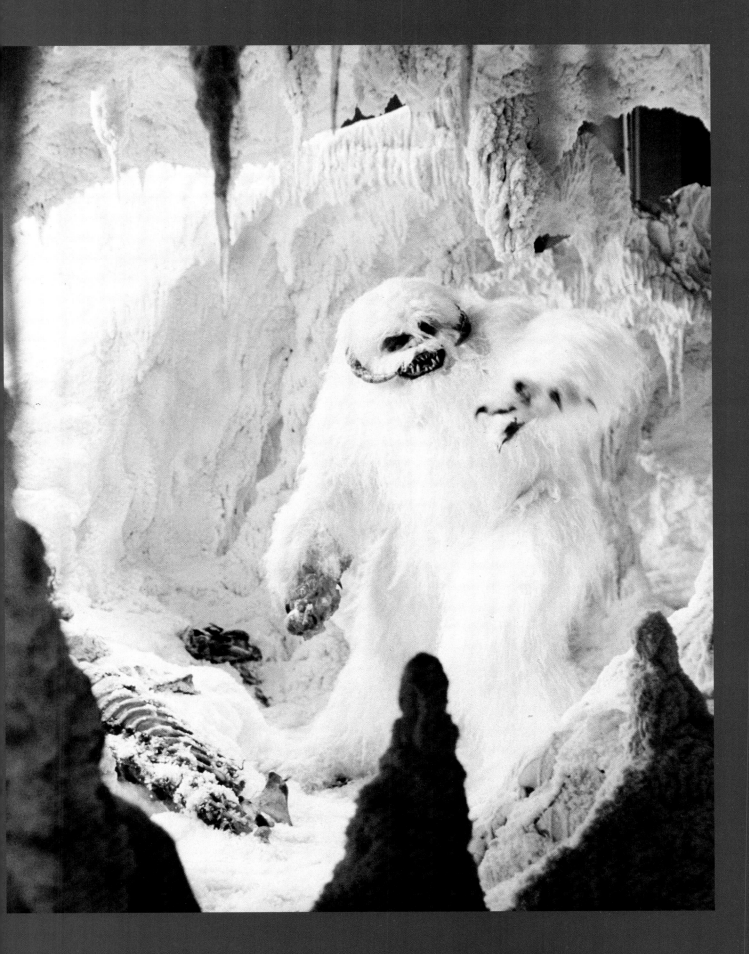

often experiencing an illness or wounding. This is the imagery of the first few minutes of the film: as Luke is scouting the wastelands around the Rebel base, he is attacked by a wampa, a huge ice creature, and dragged unconscious to its lair. When Luke comes to, he is able to access the Force to pull his lightsaber into his hand and kill the beast. But night is falling, and he cannot survive it unprotected. As he struggles and then collapses in the snow, Luke sees a vision of Ben, who tells him, "You will go to the Dagobah system. . . . There you will learn from Yoda, the Jedi Master who instructed me."

This vision of the "wise and helpful guide" fades when Han arrives on his tauntaun; for the moment, Han has replaced Ben in the real world as Luke's protector. Since the time when Han had to be bribed into helping save Leia, he has become an adept rescuer, with the warrior hero's extraordinary capacity for action.

The hero group is reunited at the Rebel base, only to be sent in different directions during an Imperial attack. Now the hero's journey branches out onto several different paths: Han and Leia will go one way, for they have their own quest to achieve, while Luke pursues his destiny in a distant system. This is the beginning of Luke's spiritual quest, which will lead him to another archetypal event in the hero's journey: the atonement with the father. Han, meanwhile, will find his "hero heart" and the realm of the "sacred marriage." Once again, the heroes stand on the threshold of a new journey. Leaving Hoth, they once more separate themselves from the status quo and answer the call to adventure.

INTO THE BELLY OF THE BEAST

THE PASSAGE OF THE THRESHOLD TO spiritual and emotional transformation often requires a form of self-annihilation; in this transition, the physical body of the hero may be slain or even dismembered. In the first film the heroes were dragon slayers; now they will become the slain, and each will undergo a symbolic death—for, in psychological terms, the hard shell of the hero's ego must be shattered in order to gain access to the spirit and the heart.

As Joseph Campbell made clear, the hero's journey requires a separation from the world in order to penetrate some source of power, and this will eventually lead to a life-enhancing return.[23] When Han and Leia leave Hoth, they are chased by Imperial Star Destroyers. Han escapes by piloting the *Falcon* into an asteroid field and then into a cave on one of these giant rocks. Unknowingly, he has set the ship down in the stomach of a giant space slug. Once again, Lucas has

BELOW: Space slug.
Production painting by Ralph McQuarrie.

FAR BELOW: Jonah emerging from the belly of the whale.
Courtesy of Culver Pictures, Inc., New York.

OPPOSITE: Leia and Han in the belly of the space slug.

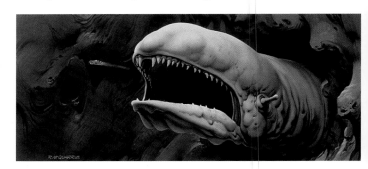

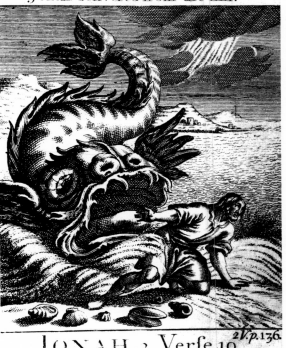

JONAH CHAP. II.
Jonah delivered from the fish.

33

JONAH 2. Verſe 10.

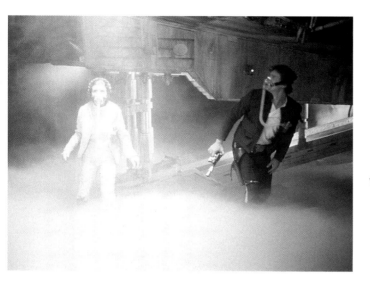

woven into the story the imagery of consumption and of the journey into the belly of the beast. With its great-toothed jaw, this particular beast is the cousin of the dragon. Han, Leia, Chewie, and See-Threepio have been swallowed whole, just as Jonah was swallowed by the whale. Like the heroes' earlier transit through the Death Star, this experience will lead to a rebirth. This time, however, Han is able to cross the threshold unaided. To be able to pass in and out of the dragon shows that Han's metamorphosis is nearly complete. He found the compassionate side of his cynical nature at the end of *Star Wars;* now he will find love.

THE MYSTICAL MARRIAGE

WITH THIS REBIRTH AND THE opening of their hearts to love, the real romance between Leia and Han is only just beginning, but this is a good time to look at the place that love holds in the hero's journey. After the obstacles have been surmounted and the monsters slain, the hero's and heroine's ultimate adventure is the mystical marriage.

Twelfth-century troubadours, telling stories of the likes of Tristan and Iseult, transformed the Western concept of romantic love, exalting the love between two people to the level of a sacrament. In myths and fairy tales dating from the medieval period and before, the life-enhancing treasure and vital forces held hostage by the dragon are symbolized by Woman, the complement to the male hero. Mystically she represents the sum total of all that can be known, and since this is a journey of discovery, it is thus the hero's job to come to know her. Joseph Campbell puts it this way:

> As [the hero] progresses in the slow initiation which is life, the form of the goddess undergoes for him a series of transfigurations: she can never be greater than himself, though she can always promise more than he is yet capable of comprehending. She lures, she guides, she bids him burst his fetters. And if he can match her import, the two, the knower and the known, will be released from every limitation. Woman is the sublime acme of sensuous adventure.[24]

According to the rules of courtly love, however, the hero must earn the maiden; in the course of the *Star Wars* story, Han has already performed three typical tasks for his princess: fighting his way to her side, rescuing her, and working in the service of her surrogate father, the Rebellion. Now Han shows Leia his "gentle heart," and their true love begins to bloom.

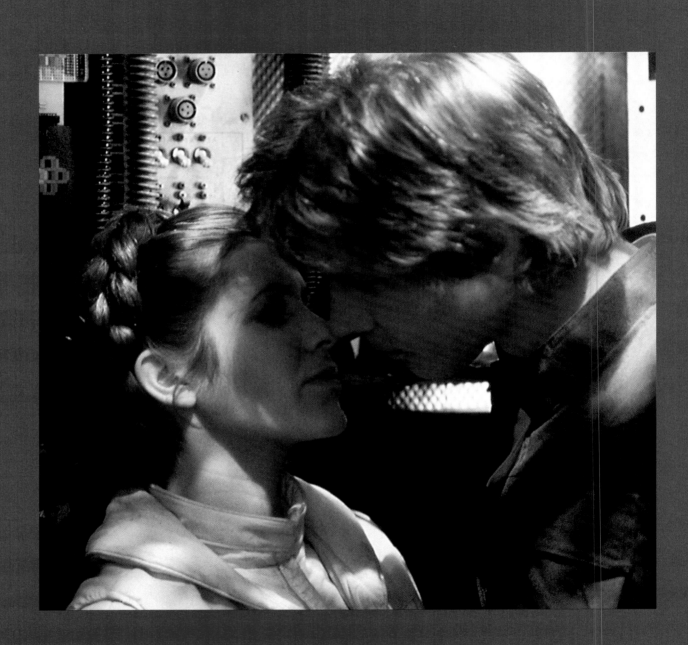

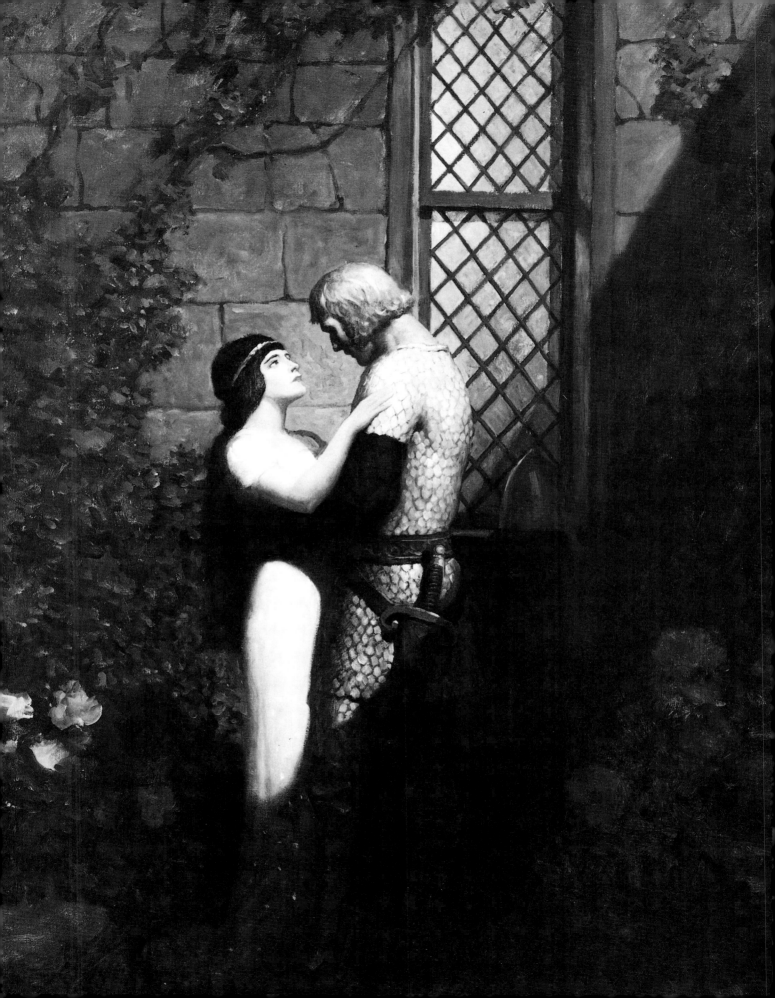

THE SACRED GROVE

MEANWHILE, WHEN LUKE LEAVES Hoth, he follows Ben's instructions and travels to the swamp planet of Dagobah. There, he too enters an enclosure where he will be transformed. In his case, the enclosure is formed by the large, oddly shaped trees that characterize the landscape of Dagobah. This is the sacred grove. Many ancient cultures held the tree to be sacred, infused with creative energy. Certain trees were not to be cut or injured, while special groves surrounded open-air altars or temples. The Druids, for example, worshiped the Celtic gods beneath such holy trees. These places were usually dominated by oaks, sheltered by sacred stones, and regarded with such terror that even the Druids who presided over them feared to enter after sunset.[25]

Similarly, in many myths and fairy tales, forests have symbolized mastery and transformation; in them dwell sorcerers and enchanters. They are home to a very early "pre-hero" archetype, the ancestor of the shaman and the yogi; this figure is hunter, warrior, and ascetic all in one. He is master both of the powers of nature and of those found deep within himself, although this mastery is often hidden behind a simple, naive facade; he shares a mystic solidarity with wild creatures. Just such a figure is the Jedi Master Yoda, who will instruct Luke in the ways of the Force.

Forests also represent the unconscious mind, where secrets or dark memories and emotions lie waiting to be discovered. This is the realm Luke enters on Dagobah. He has left his friends and the familiar world behind in order to follow his vision quest.

As Yoda expresses it, the Force is to be used only for "knowledge and defense," rather than aggression. It provides the ability to foresee certain events and to move external objects with the power of the mind alone. Thus, Yoda urges Luke to "concentrate," teaching him to find the still center within from which he can act with clarity and balance.

Some elements of the Force are reminiscent of Zen Buddhism, with its emphasis on enlightenment by means of direct, intuitive insights. In Japan, the study of Zen gave the samurai warrior an awareness of the transitory nature of all things, particularly human life. Thus, every action was to be performed as if it were the last. Warriors did not live in the future or the past but in the present. Yoda echoes this concept when he complains to Ben about Luke, "All his life has he looked away . . . to the future, to the horizon. Never his mind on where he was, what he was doing. Adventure!

PREVIOUS PAGES: Images of courtly love: Leia and Han... Iseult (Isolde) and Tristan

"Oh, Gentle Knight," Said la Belle Isolde, N. C. Wyeth, 1917. Collection of the Brandywine River Museum, gift of Mrs. Gertrude Mellon.

ABOVE:
Luke and Artoo on Dagobah.

RIGHT: **Luke's X-wing sinking in the swamp on Dagobah.**
Production painting by Ralph McQuarrie.

OPPOSITE: **Grove of the Druids,**
from The Story of the Greatest Nations, 1901.

FOLLOWING PAGE: **The sacred grove where Luke begins his Jedi training.**
Production painting by Ralph McQuarrie.

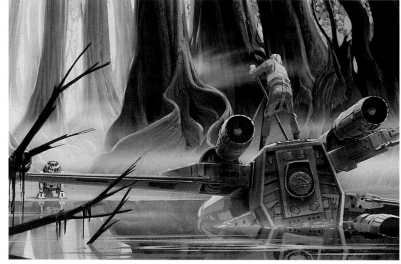

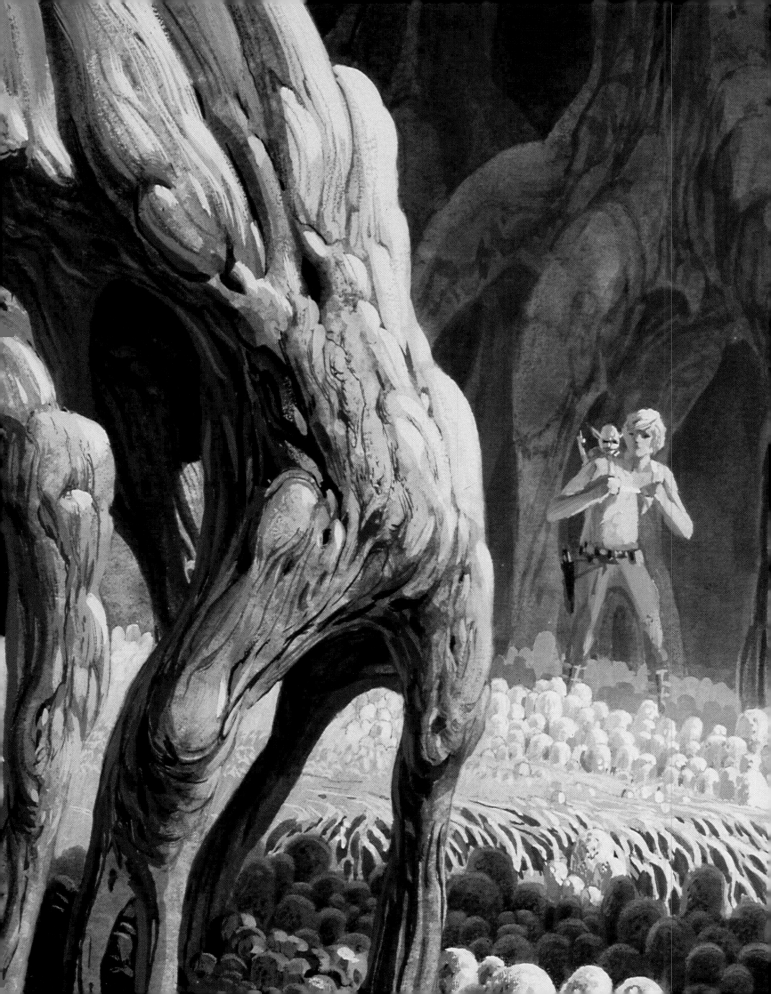

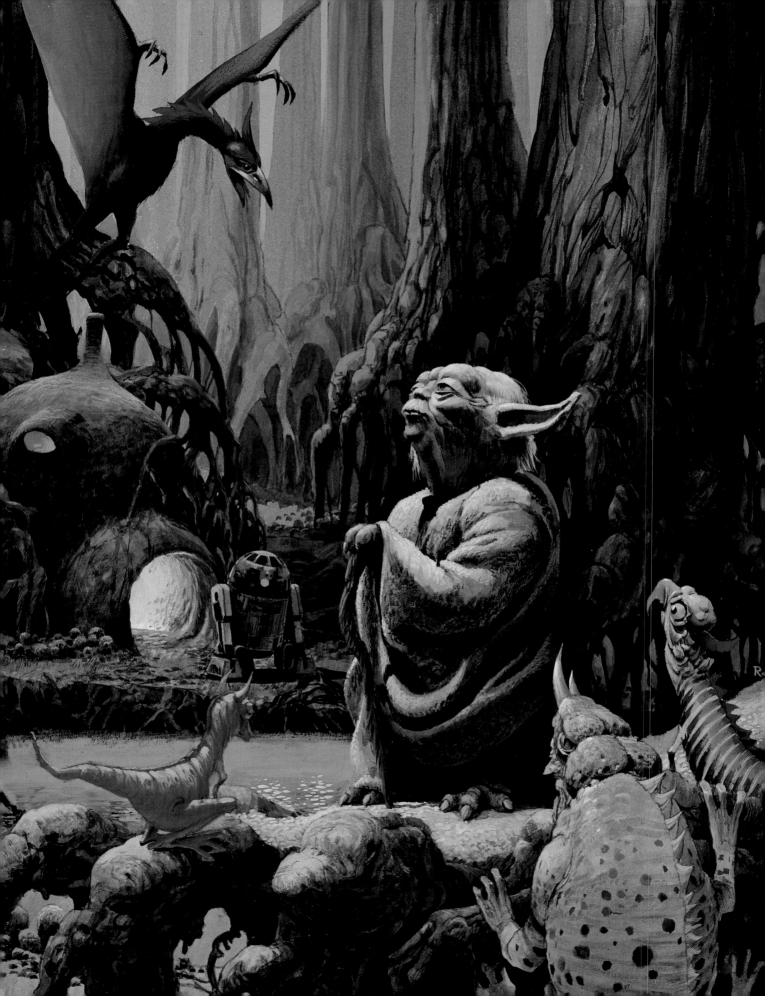

OPPOSITE: Yoda shares a mystic solidarity with wild creatures.
Painting by Ralph McQuarrie.

ABOVE: Yoda meets Artoo and Luke at their encampment.

RIGHT: Gama Sennin, a Taoist Sage, Soga Shohaku, 18th c.

Excitement! A Jedi craves not these things." And then he chastises Luke: "You are reckless!"

To begin to conquer these aspects of himself, Luke must enter the tree cave "strong with the dark side of the Force." When Luke asks what is in the cave, Yoda tells him, "Only what you take with you," but Luke girds on his weapons anyway. They symbolize his impatience and lack of faith, his indoctrination into the ways of violence and hostility in the outside world. But this is truly a descent into another spiritual labyrinth, for in the depths of the tree lies the revelation that Darth Vader is not some external evil presence but the shadow side of Luke himself. The dark side of the Force lies within as well as without—but this is a message that Luke is not yet ready to understand or accept.

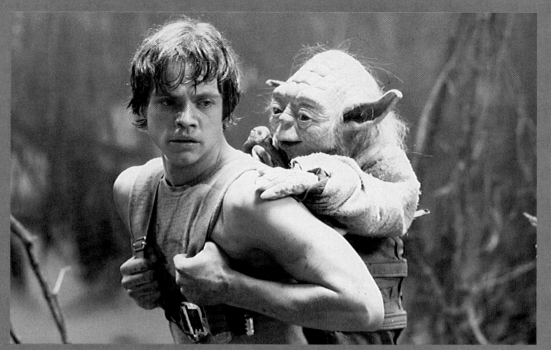

THIS PAGE:
**Yoda Instructs
Luke in the Ways
of the Force and
Sends Him into
the Tree Cave,
Where Luke Must
Confront His Own
Shadow Side**

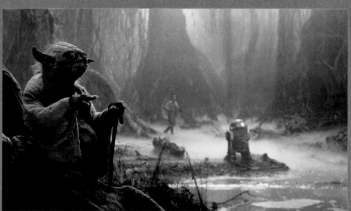

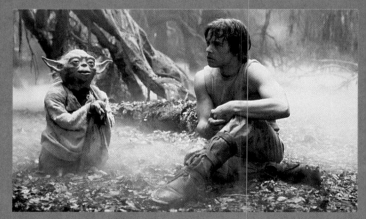

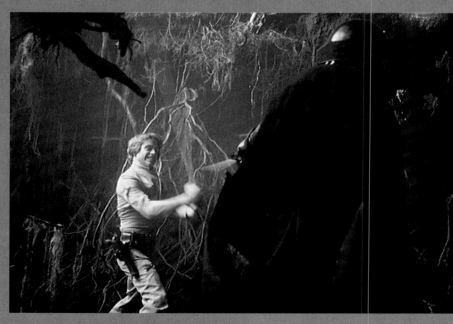

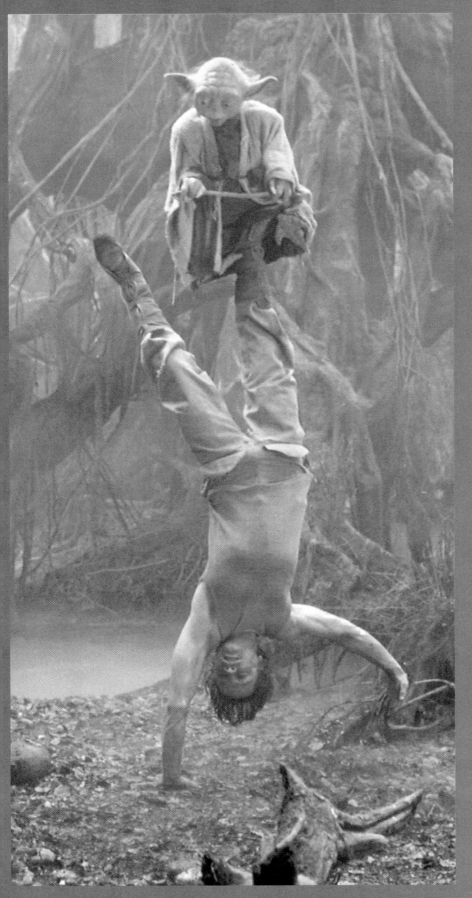

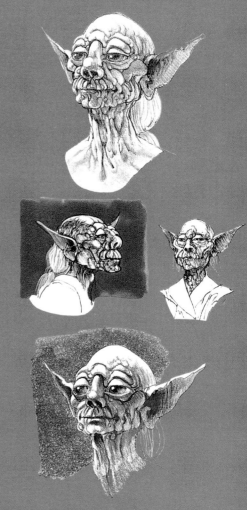

LEFT: **Yoda urges Luke to "concentrate!"**

ABOVE: **Concept drawings for Yoda**
by Ralph McQuarrie.

SACRIFICE AND BETRAYAL

A
S LUKE BEGINS TO ACCESS THE FORCE, he gets a vision of the future; this glimpse of Han and Leia in pain causes him to leave impetuously for Cloud City before his training is complete. Cloud City symbolizes the dangers of illusion: at first it appears transcendent as it rises above the planet Bespin, yet in reality it has a dark underside that will prove a crucible of sacrifice and betrayal for the heroes. The opening of the mind and heart to spiritual knowledge requires a sacrifice—and this sacrifice is all too often accompanied by betrayal. In Norse myth, the god Loki

THIS PAGE, CLOCKWISE FROM BELOW: **Lando greets Han on the Cloud City landing platform.**

Lando welcomes Leia to Cloud City.

Chewie shows Leia and Han the dismembered See-Threepio. Concept drawing by Ralph McQuarrie.

Threatened by Chewie and Leia, Lando has a plan to save Han.

OPPOSITE: **Lando's betrayal of Han sets Lando on his own hero's journey.**

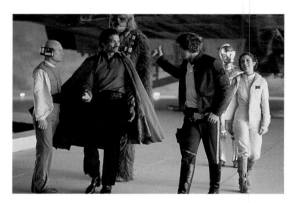

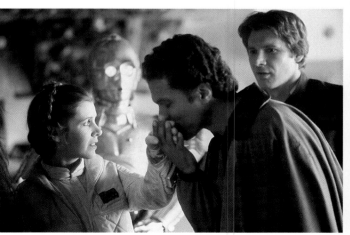

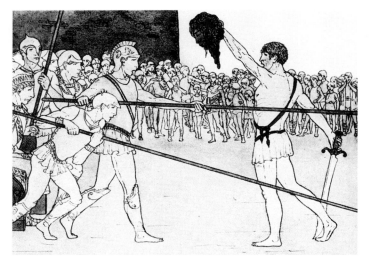

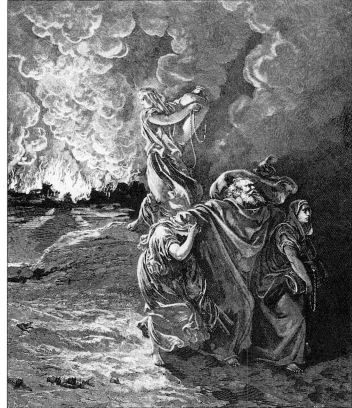

arranges for the death of the beloved Balder; in Christianity's central story, Judas Iscariot sells Jesus for thirty pieces of silver.

In the *Star Wars* trilogy the betrayer is the smooth, charming Lando Calrissian, a one-time comrade who embraces Han and then delivers him to Vader. (This crisis will set Lando on his own hero's journey and lead to his transformation in *Return of the Jedi*.) Vader decrees that Han will be frozen alive in a tomb of carbonite. This carbon-freezing chamber is yet another symbol for hell, with its sulfurous fumes and red-yellow glow. It is as if the city were a glamorous veil laid over this treacherous foundation—a magical illusion hiding the hellhole below, where Han will be turned to stone.

The act of turning a person to stone is found in many mythic stories. For example, as Lot and his family flee the biblical Sodom and Gomorrah to escape God's wrath, Lot's wife looks back and is turned to a pillar of salt. Perseus uses the Gorgon's head to turn his enemies to stone. Han is turned to stone as he is encased in carbonite, and his rescuers will have to descend once again into the underworld of Jabba's lair to reclaim him. Orpheus travels to the kingdom of the dead to search for his wife Eurydice, but it will be Leia who rescues Han.

And in fact, Han's last words before entering the carbon-freezing chamber are an acknowledgment of Leia's love; his heroic acts have been dedicated to her. In the Middle Ages, when the heroic path became the way of the heart and the hero only attained the highest expression of his masculine power when he was able to surrender it, the woman's role was also transformed. She was no longer just a helpless victim to be rescued from the dragon; instead, she herself became deliverance, the hero's "Domina," lord and superior, determining the purity of his motives and the value of his actions.[26]

ABOVE LEFT: Perseus holding up the head of the Gorgon, Mary Hamilton Frye, 1905.

ABOVE: Lot's wife looking back on Sodom and Gomorrah, The Flight of Lot, Gustave Doré, 1866.

OPPOSITE:
Han "on the rack."

Leia and Han bid farewell.

Han is lowered into the chamber.

Vader, Lando, and bounty hunter Boba Fett.

FOLLOWING PAGE:
Cloud City carbon-freezing chamber.

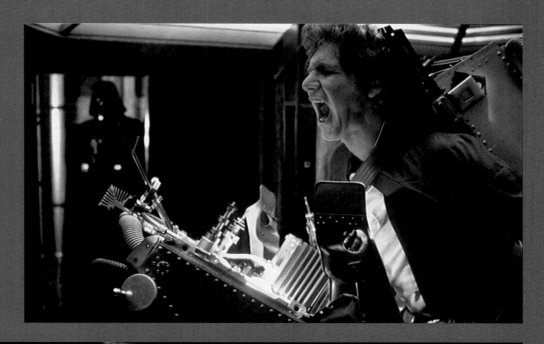

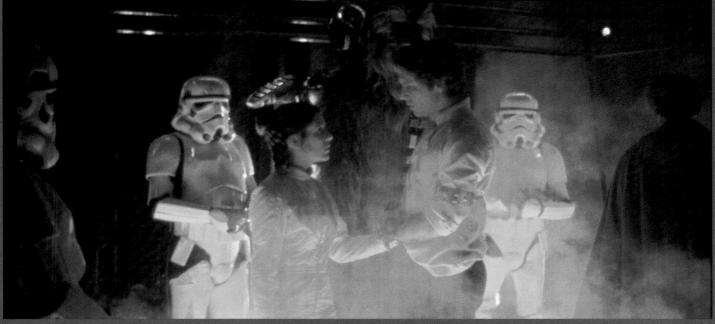

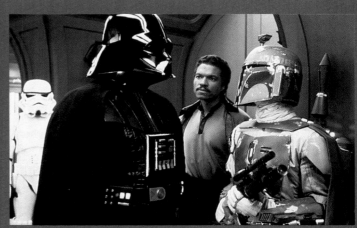

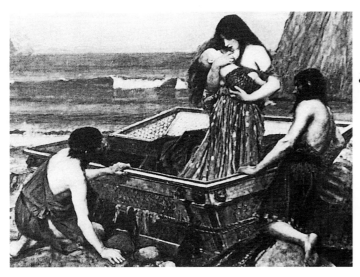

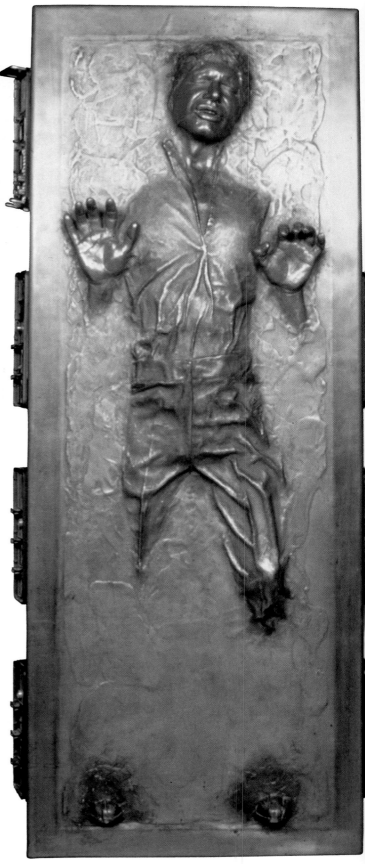

Han's going into "perfect hibernation" has other mythical overtones, as well. Often the mythical hero is depicted as "sleeping" until the hour destined for his awakening. The carbonite slab is indeed a tomb, but in mythological terms, death is not an end to existence; it is instead a doorway to a new form of life. For now, Han's frozen body departs with the bounty hunter Boba Fett to travel through the dark ocean of space. This "night-sea journey," with the hero enclosed in a box or in the belly of a sea creature, is a vital part of his adventure.[27] Sometimes it occurs when the hero is a child: Moses is a baby when he floats into the bulrushes in a cradle of reeds and pitch, and Perseus is still an infant when he and his mother Danaë are cast into the sea in an ark. But whenever the hero travels this way, his release will be the equivalent of another rebirth.

Cloud City marks the turning point in the trilogy; all the forces of destiny seem to meet here. Luke once again finds himself in a mazelike enclosure, but this time he is going toward Vader, not away from him. And he too descends into the underworld—the dark underside of the city, full of fumes and pits, tunnels and bottomless voids. Here he will have a revelation that will shake the foundations of his spirit. The monster at the heart of this maze is no stranger but a part of himself. Names often hold symbolic power in the *Star Wars* tales, as in many myths, so now we find that Vader is really Anakin, Luke's father "and akin" to him. As Joseph Campbell states:

> *The hero ... discovers and assimilates his opposite (his own unsuspected self) One by one the resistances are broken. He must put aside his pride, his virtue, beauty, and life, and bow or submit to the absolutely intolerable. Then he finds that he and his opposite are not of differing species, but one flesh.[28]*

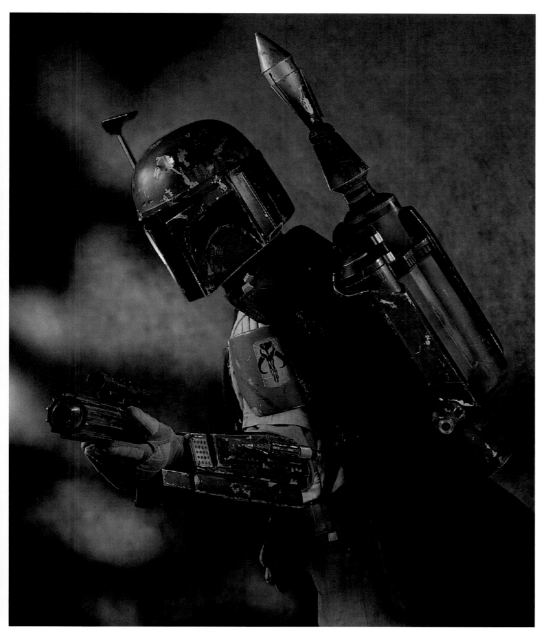

OPPOSITE: **Heroes making the "night-sea journey": Han frozen in carbonite, and the infant Perseus with his mother Danaë.**
Danaë, J. W. Waterhouse, 1892.

LEFT: **Boba Fett.**

BELOW: **Luke confronts Vader in the Cloud City core.**

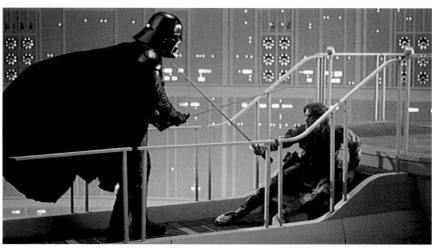

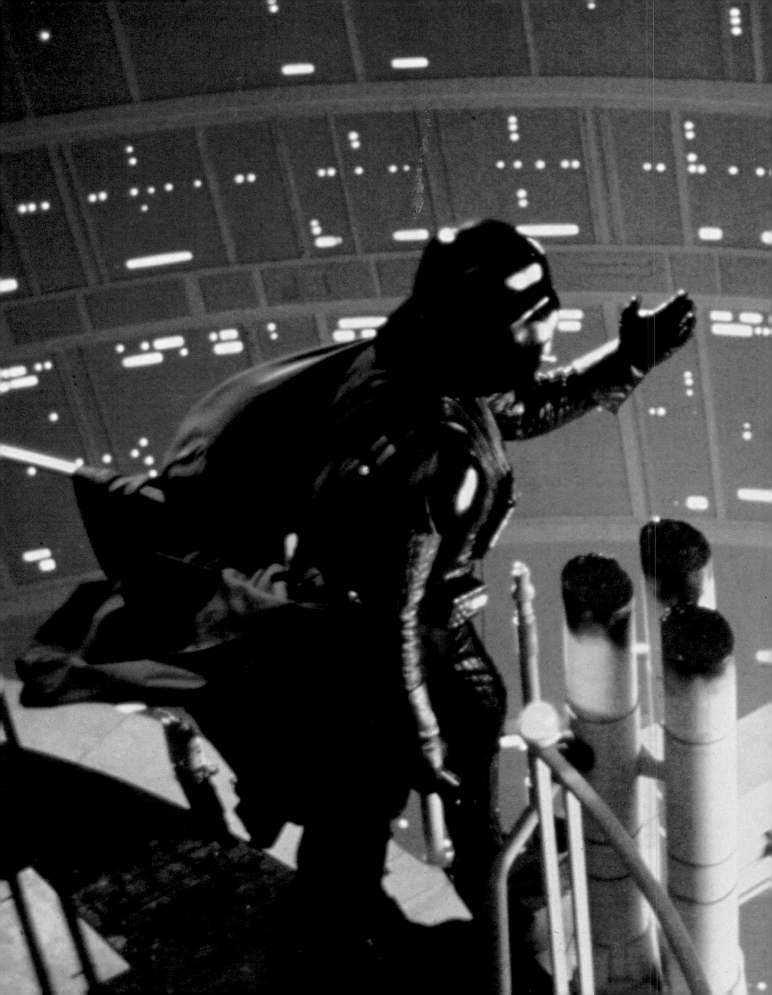

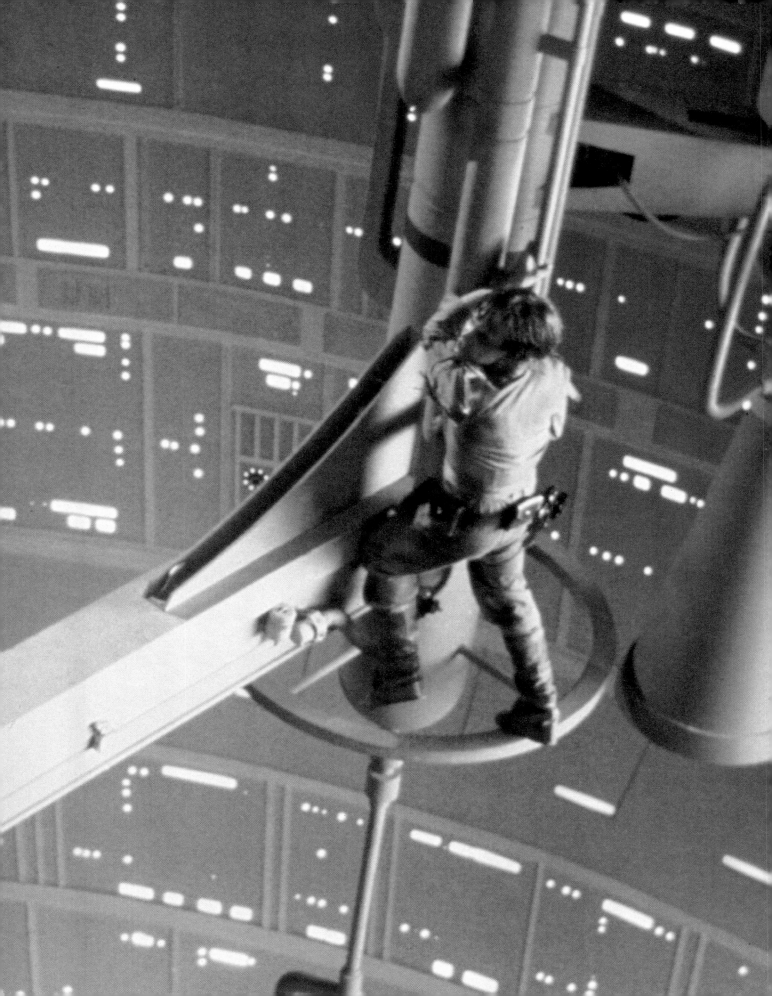

PREVIOUS PAGE: "Join me!"
Vader urges Luke to join
forces with him.

PANEL, RIGHT: Storyboards for Luke's
confrontation with Vader

by Ivor Beddoes.

BELOW: Luke's dismemberment:
Vader cuts off his hand.

OPPOSITE, BELOW LEFT:
The Death card from the Tarot.

OPPOSITE, BELOW RIGHT:
Saturn Devouring His Children,

Francisco de Goya y Lucientes, 1819–23.

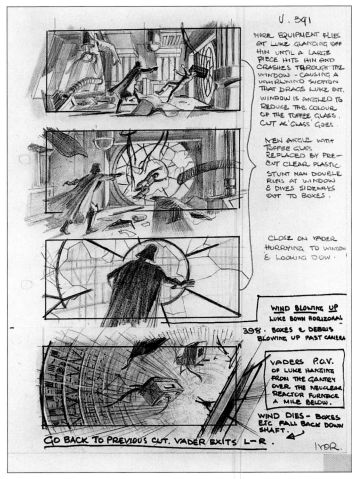

U. 391

MORE EQUIPMENT FLIES
AT LUKE GLANCING OFF
HIM UNTIL A LARGE
PIECE HITS HIM AND
CRASHES THROUGH THE
WINDOW — CAUSING A
WHIRLWIND SUCTION
THAT DRAGS LUKE ONT.
WINDOW IS ANGLED TO
REDUCE THE COLOUR
OF THE TOFFEE GLASS.
CUT AS 'GLASS' GOES.

NEW ANGLE WITH
TOFFEE GLASS
REPLACED BY PRE-
CUT CLEAR PLASTIC.
STUNT MAN DOUBLE
RUNS AT WINDOW
& DIVES SIDEWAYS
OUT TO BOXES.

CLOSE ON VADER
HURRYING TO WINDOW
& LOOKING DOWN.

WIND BLOWING UP
LUKE DOWN HORIZONAL
398. BOXES & DEBRIS
BLOWING UP PAST CAMERA

VADERS P.O.V.
OF LUKE HANGING
FROM THE GANTRY
OVER THE NUCLEAR
REACTOR FURNACE
A MILE BELOW.

WIND DIES — BOXES
ETC FALL BACK DOWN
SHAFT.

GO BACK TO PREVIOUS CUT. VADER EXITS L-R.

IVOR.

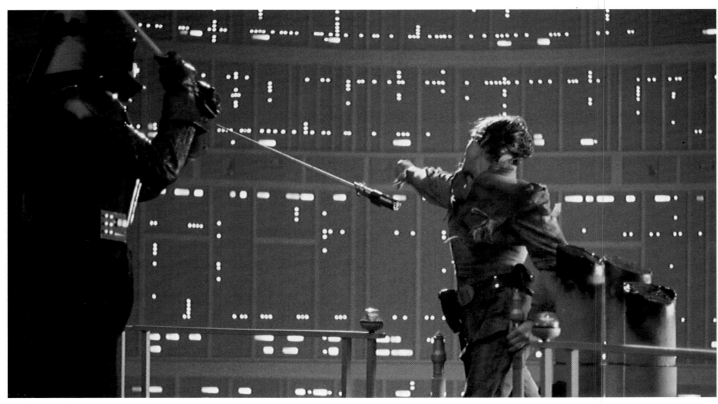

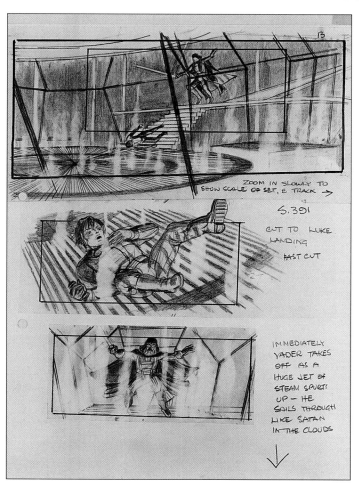

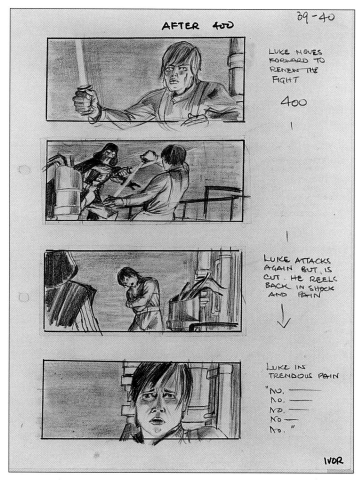

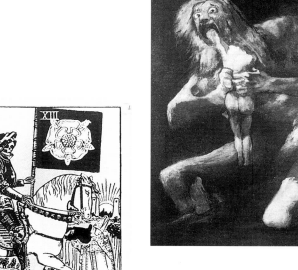

In the battle that ensues between Luke and Vader, father is pitted against son for mastery of the world. In Greek mythology, Cronus (Saturn) learns that one of his sons will succeed him as leader of the gods. To prevent the prophecy from occurring, Cronus devours his own children—except that his wife Gaia manages to hide her last child, giving Cronus a rock to swallow instead. This child, Zeus, will grow up to slay his father, free his siblings, and marry his sister.

In the contest depicted in the *Star Wars* trilogy, Vader too would devour his own children to ensure the Empire's mastery. At this stage, Luke cannot win through sheer physical power or skills. One of the tragic flaws that may put the hero in harm's way is the trait of hubris, an arrogant pride that blinds the hero to his true capabilities. Luke has rushed to meet Vader prematurely, and the cost is great: Vader slashes away Luke's hand, and Luke's own flesh is now part of his sacrifice.

The dismemberment of the hero or god is another archetypal occurrence in ancient myths. In early Egyptian mythology, for example, Osiris, king of the gods, is murdered by his brother Set, who dismembers him and scatters the parts of his body along the Nile. Isis, the sister and wife of

Osiris, retrieves these parts, and Osiris lives on in spirit form, becoming the just judge of the underworld and weighing the worth of the human heart. Luke's path, as we will see, will be similar.

But for the moment, Vader and Luke are still locked in combat. Vader has not been able to dominate Luke, so he now tries to seduce him. The temptations of the hero are legion: to refuse the call, to stray from the path leading to pain and suffering, to give up the difficult quest. Vader first appeals to Luke's self-preservation instinct: "Don't make me destroy you." Then he attempts to lure Luke with the black magic of flattery and egoism: "You do not yet realize your importance. You have only begun to discover your power. Join me and I will complete your training." But neither of these can bring Luke to his side. Next Vader throws out a hook aimed at Luke's very hero values: "With our combined strength, we can end this destructive conflict and bring order to the galaxy." Many a hero has given in to the desire to use his powers to make things right in the world—and has ended up a tyrant. But Luke is still not swayed, and Vader must play his final and most wicked card: family. "You can destroy the Emperor. . . . Join me, and together we can rule the galaxy as father and son. Come with me." Now Luke teeters, both

BELOW: Chewie contemplates See-Threepio's severed head.

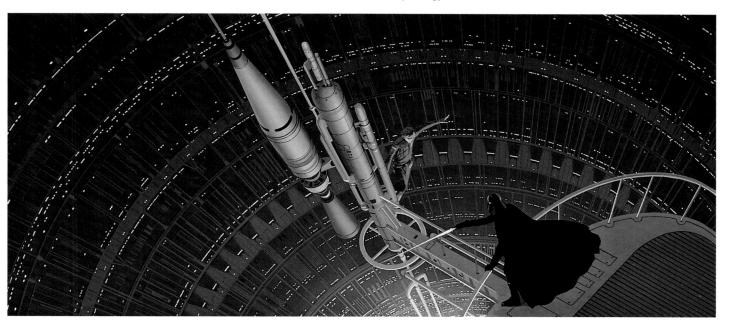

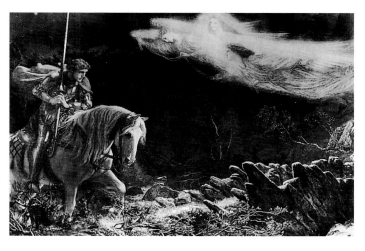

FROM TOP: **Rather than join the forces of darkness, Luke steps into the abyss.**
Production painting by Ralph McQuarrie.

Like Luke, Sir Galahad must fall from innocence,
Sir Galahad, Arthur Hughes, 1870.

literally and figuratively, at the edge of the void, and there is no way back to life except through Vader. Rather than surrender to the dark side, however, Luke chooses an almost certain death. As Vader croons, "Come with me, it is the only way," Luke steps off into the abyss. The act of giving one's life if necessary to preserve one's honor is the ultimate sacrifice required of heroes from those of the Homeric epics to the samurai of Japan.

Luke's leap also represents a final fall from his innocence. Up until this time, he has been like the "bright boy knight" who features so prominently in Alfred Lord Tennyson's 1842 retelling of the Sir Galahad story. Sir Galahad embodies the ideal young knight who is dedicated to honor, service, and purity. He is "an energetic youth dedicated to manly achievement but motivated by the pure and naive ideals of a boy's innocent exuberance."[29] His lifelong quest, which absorbs every aspect of his being, is for the Holy Grail. Interestingly, later in life Tennyson himself questioned the validity of his own creation. In 1869 he published "The Holy Grail," a follow-up to the Galahad story, in which he points out that by following his obsession, Galahad deprives his community of the services he can render. In the end, "gone is the boyhood exuberance and fantasy of invincible immortality. . . . This Galahad crosses the threshold from boyhood to manhood and comprehends the profound meaning of his passage."[30] As Luke leaps into the abyss, he relinquishes the last of his childhood innocence and ensures that if he survives, he will return with the "ultimate boon" to save his community.

And indeed, the hand of fate reaches out to make certain that he will fulfill his destiny, for Luke is sucked

through an exhaust pipe in the shaft down which he is tumbling, and he falls out through the bottom of the city. Now he hangs suspended on a slender beam between the clouds of heaven and the sulfurous fumes of hell, the gaseous planet below. For his rescue, Luke instinctively turns to Leia, the female force in his life. She hears him call and turns the *Falcon* back to save him. Leia, too, has grown through the trials of this stage of the journey; we see here how her love for Luke and Han has linked her to the Force—even before we know that she, like Luke, is heir to her father's gifts.

As the *Falcon* speeds Luke away from this harrowing initiation, Vader calls to him telepathically, and Luke responds with a single word: "Father." This acknowledgment of the dark side of himself concludes *The Empire Strikes Back* but marks the beginning of the final stage of the journey, for it opens the path toward Vader's own transformation and a reconciliation between father and son.

TOP AND ABOVE LEFT:
Luke hangs suspended between "heaven" and "hell."
Production painting by Ralph McQuarrie.

ABOVE RIGHT: Leia tends Luke's wound.

THE HERO'S RETURN

N THE BEGINNING OF THE TRILOGY, THE object of the quest was clear: the heroes set out to rescue the princess and slay the dragon. At midpoint, the quest turned inward to explore and develop the heart and spirit of each hero. Now, the focus turns outward again in order to bring the themes and motifs introduced in the first film to a final, unambivalent conclusion.

As *Return of the Jedi* begins, Luke has achieved a traditional fairy-tale triumph—that of the ordinary child who has grown into the mastery of extraordinary powers. He has tapped into the powers of the Force, given up the illusions of his youth, and attained a higher level of maturity and understanding. He is now ready for the hero's return, in which he will translate his newfound knowledge and skills into action.

But this will not be an easy transition for Luke. Credibility is always the most difficult part of the hero's return, and Luke's abilities will be doubted by friend and foe alike. When Luke left Tatooine, he was a "simple but lovable lad with a prize-winning smile."[31] Now he will have to work hard to change his image and translate his insights into a form that can be understood by those who have not shared his experiences. And because his training is incomplete, Luke will suffer at times from both disregard and misunderstanding. His first test comes at the palace of Jabba the Hutt.

TOP: **The hero's return: Joseph Makes Himself Known to His Brethren,** Gustave Doré, 1866.

BOTTOM: **Banthas on the walkway to Jabba's palace.** Painting by Ralph McQuarrie.

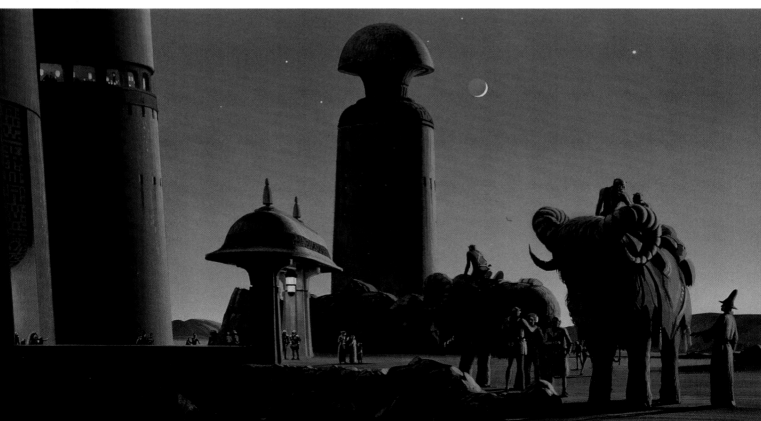

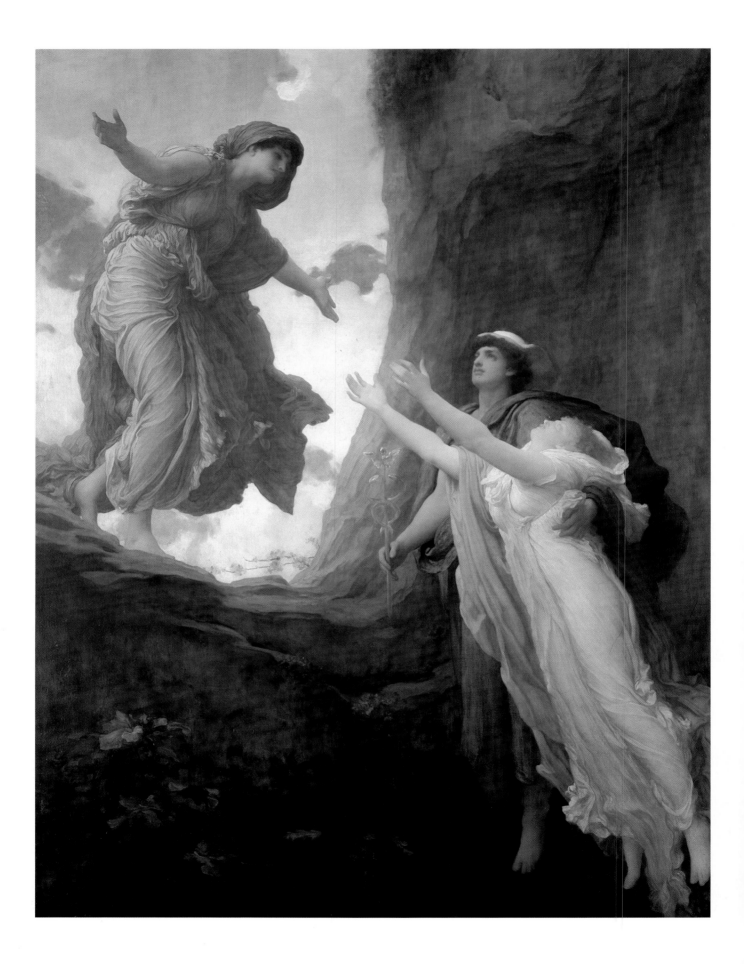

RESURRECTION

Persephone rises from the land of the dead,
The Return of Persephone, Frederic, Lord Leighton, 1891.

BELOW, CLOCKWISE FROM LOWER RIGHT:

Jabba and Bib Fortuna.

Leia resurrects Han from his carbonite "death."

Leia's costume as the bounty hunter Boushh.

Boushh offers Chewie to Jabba.

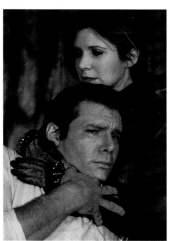

N THIS THIRD FILM OF THE TRILOGY, EACH OF the heroes faces enormous tasks and discovers new inner resources that allow him or her to triumph. Leia, in particular, is full of surprises. As the movie begins, she disguises herself as the bounty hunter Boushh and forces her way into Jabba's court in order to rescue Han. Jabba, a monstrously fat and maliciously destructive creature, has kept Han encased in his carbonite tomb for the sheer pleasure of seeing the pirate's innate vitality imprisoned. In the middle of the night, Leia sidesteps the guards and melts Han's carbonite shell, allowing him to rise miraculously from the dead.

This part of the story has its own mythic overtones. In Greek mythology, Persephone, daughter of the goddess Demeter, is abducted by Hades, god of the underworld, and taken to the land of the dead where she is imprisoned. After a long search, Demeter obtains her daughter's release— a resurrection and reunion that symbolize the return of spring each year.

But for Leia and Han, the joy of the reunion does not last long. Jabba has them surrounded and consigns Han to the palace prison, where he is reunited with Chewie, while Leia becomes Jabba's slave, chained to him like a pet on a leash. It remains for Luke to stage a rescue, but although the Force has grown strong in him, he too is captured and dropped into the dungeon where the hungry rancor waits.

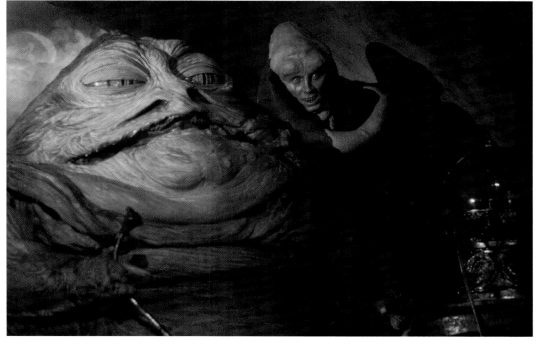

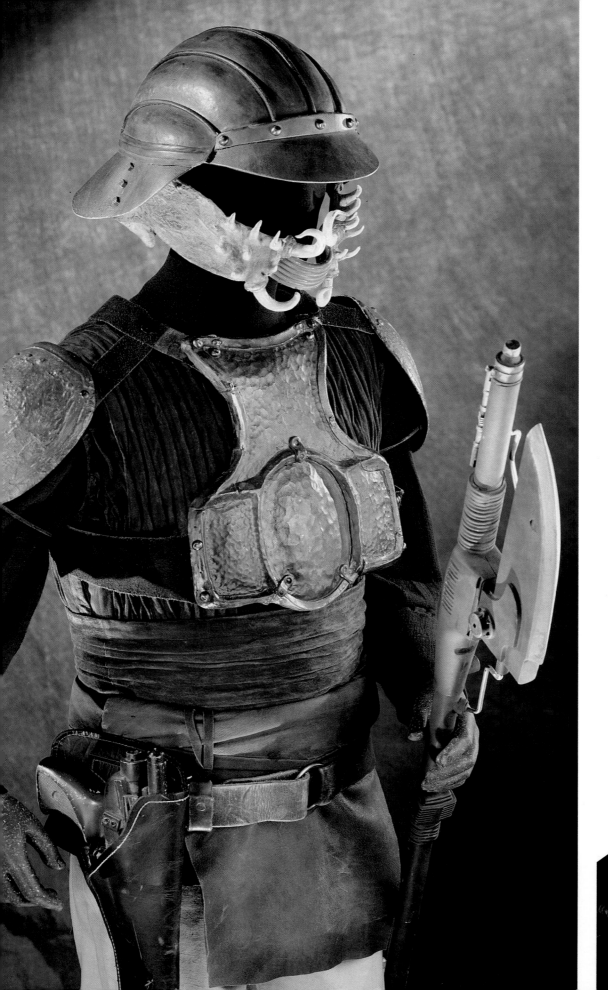

OPPOSITE: **Lando's costume as Jabba's palace guard.**

RIGHT: **Leia's costume as Jabba's slave.**

BELOW: **Sy Snootles and Salacious Crumb in Jabba's court.**

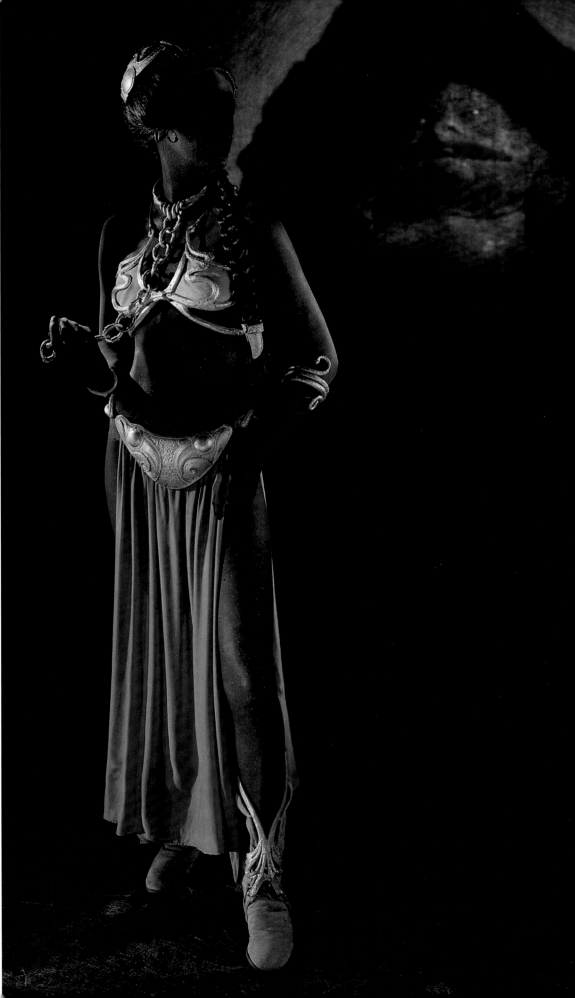

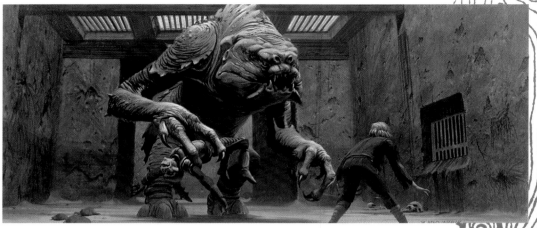

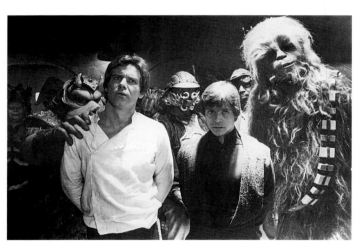

FROM TOP, THIS PAGE:
**Luke fights
the rancor.**
Production painting by
Ralph McQuarrie.

**Han, Luke, and
Chewie are
sentenced to
walk the plank.**

**The road
creature, like
Jabba, is a
symbol of
consumption.**

MONSTER COMBAT

N MYTH, ONE OF THE WAYS IN WHICH THE
hero proves himself is through hand-to-hand combat.
The hero of the Anglo-Saxon poem *Beowulf,* for
example, kills the man-eating monster Grendel in a
wrestling match. In the best heroic style, Luke is able
to vanquish the horrific rancor without his lightsaber. But
this sense of triumph is also short-lived, as Jabba decides that
Luke, Han, and Chewie will walk the plank, pirate-style.

The consumption motif reappears, for the heroes are
to be swallowed up by the Sarlacc, the Dune Sea's equivalent
of a huge and ravenous shark. This whole section is rife
with images of consumption, as we watch Jabba gobble down
a squirming animal and see the road creature outside the
palace gates snap up some helpless morsel. But the heroes
now have the strength to withstand the powers that would
devour them. And although Luke is forced to the very edge
of the plank, much as Vader pushed him to the end of the
gantry platform in Cloud City, Luke is indeed a new person
now. When a guard moves to shove him, Luke jumps off by
himself, flips back into the floating skiff, and catches his
lightsaber, thrown by Artoo. This striking style of action

LEFT: **Beowulf Fights
Grendel,** Donn P. Crane, 1936.

BELOW: **The rancor is the
monster Luke vanquishes.**

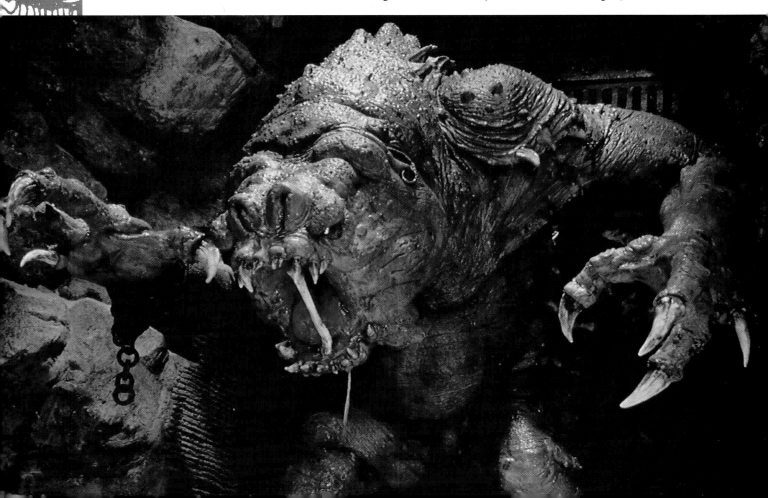

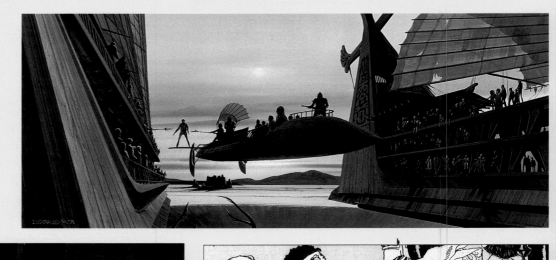
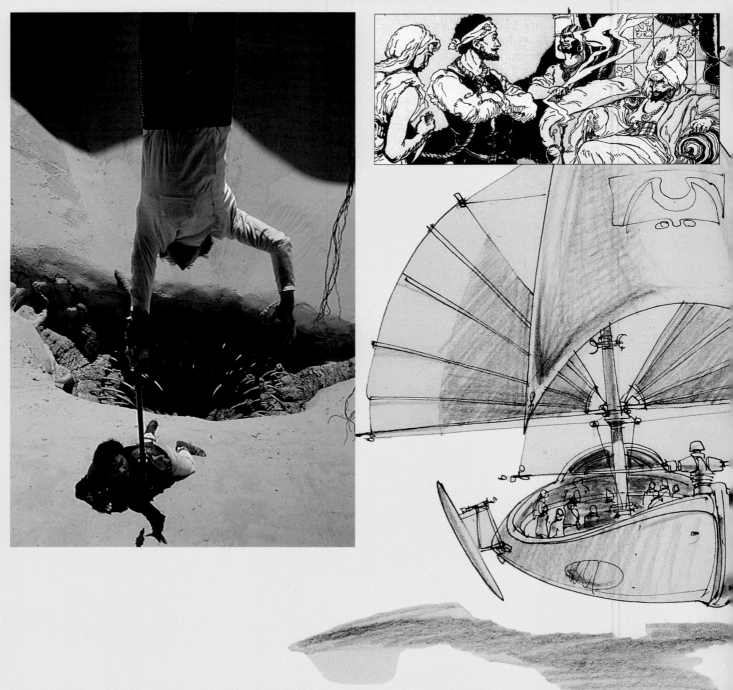

OPPOSITE, CLOCKWISE FROM TOP:
Luke walks the plank.
Production painting by Ralph McQuarrie.

Cervantes Brought Before the Pasha,
Donn P. Crane, 1936.

Concept drawing for skiff
by Joe Johnston.

Han rescues Lando from the Sarlacc.

ABOVE: Walking the Plank,
Howard Pyle, 1921.

RIGHT: Luke and Leia prepare to escape from the sail barge.

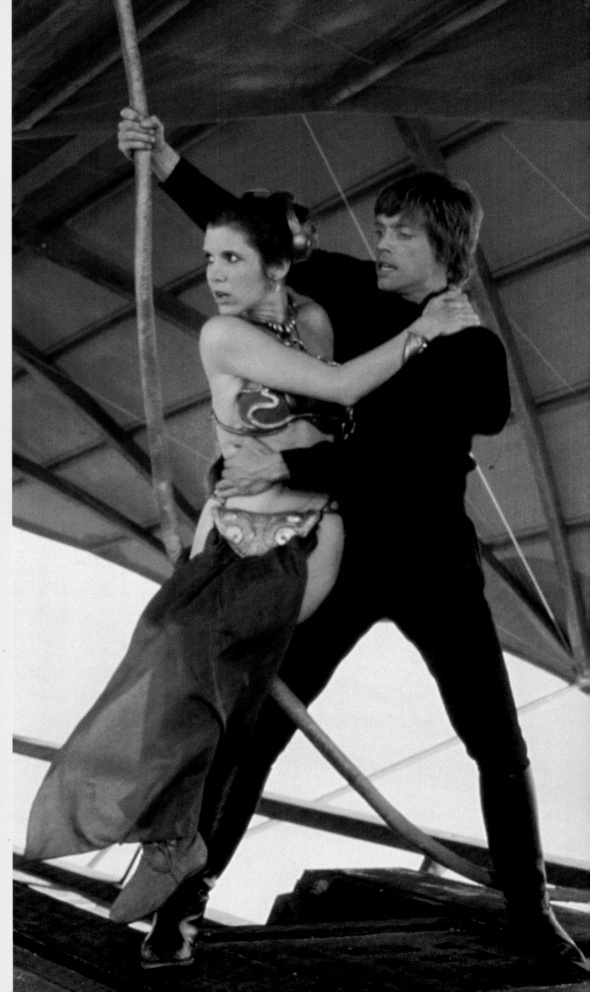

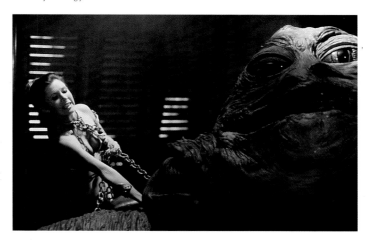

marks Luke as having achieved another characteristic of the classical Greek hero: *arete*—excellence.

While this group of heroes fights its way free, Leia takes matters in her own hands, strangling Jabba herself. The heroes have now triumphed over the "dark road of trials," and they are ready, physically and spiritually, for the final showdown.

THE RESURGENCE OF EVIL

R EGENERATION IS NOT JUST THE province of the good, however. Evil too has a tendency to rise again. In Greek mythology, this resurgence is symbolized by the monster Hydra, with its doglike body and many snaky heads. Whenever one of these heads is cut off, two new ones spring up in its place. The hero Hercules finally vanquishes the monster with the help of his nephew Iolaus; as Hercules cuts off each of Hydra's heads, Iolaus applies a blazing branch to the stumps, preventing more heads from growing.

In the *Star Wars* mythology, the resurgence of evil takes the form of a new Death Star, under construction by the Empire even while the Rebel Alliance has continued to struggle against its tyranny.

Now, while Luke returns to Dagobah to complete his training, the Emperor arrives at the new Death Star. The Emperor represents the essence of the monster that is the Galactic Empire. He is all ego with no spirit, locked within a fortress of hate and aggression. Looking much like the Grim Reaper, the very embodiment of death, he transforms the world around him into a wasteland that is in danger of becoming one giant machine. The only person who can penetrate the dark castle with the spark of divine fire is the hero whose heart and spirit have become whole and integrated.

Ben appears to tell Luke that Leia is his twin sister. Divine twins are found throughout mythology, from the

OPPOSITE: **The essence of evil: the Emperor.**

COUNTERCLOCKWISE FROM ABOVE RIGHT: **Leia slays her own monster.**

Hydra—classic symbol of the resurgence of evil, 17th c.

The Rebels gather on the Headquarters Frigate.

Romans' Romulus and Remus, to the Greeks' Apollo and
Artemis and the Norse Freyr and Freyja. Leia in many ways
represents Luke's anima—the feminine side of his own nature.
With this knowledge, Luke's integration of the opposites
within him—light and dark, masculine and feminine—is
almost complete.

THE ENCHANTED FOREST AND
HELPFUL ANIMALS

LANDO CALRISSIAN HAS REDEEMED
himself by helping Han and the other heroes
escape from Jabba. Now, while Lando leads a
squadron of X-wing pilots toward the new
Death Star, the rest of the heroes travel to the
moon of Endor to destroy the shield generator that protects
this weapon. Coincidentally, Endor is the name of an ancient
town that appears in the Old Testament—the abode of a witch
or medium whom Saul consults on the eve of the battle of
Bilboa.[32] This Endor, too, contains a certain sorcery, for once
again the path has led the heroes into the magical forest.
There they are confronted by the small furry Ewoks, who like
all elves, fairies, and other inhabitants of fairy-tale forests,
may be either dangerous or helpful. The Ewoks' lush green
environment and harmony with nature make a warm contrast

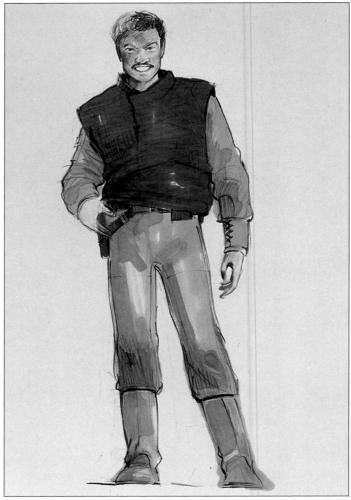

CLOCKWISE FROM ABOVE LEFT:
Luke tells Leia that they are twins.

Nien Nunb and Lando aboard
the Falcon.

Lando as Rebel general.
Costume design by Nilo Rodis-Jamero.

Rebels plan the attack on the new
Death Star.
Production painting by Ralph McQuarrie.

RIGHT: **The Ewoks at first appear dangerous to the heroes.**

BELOW: **Baby Ewok.**

ABOVE: **Leia in the Ewok village.**

LEFT: **Artoo and the Ewoks.**

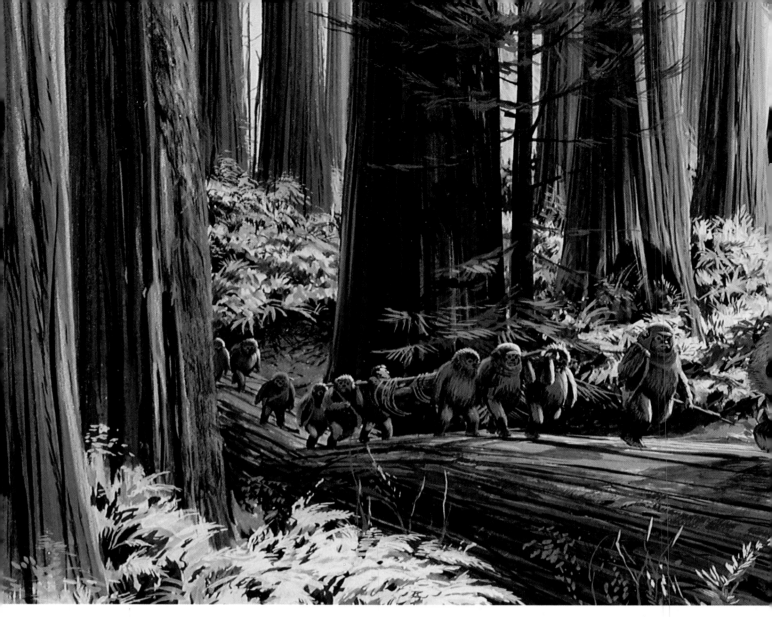

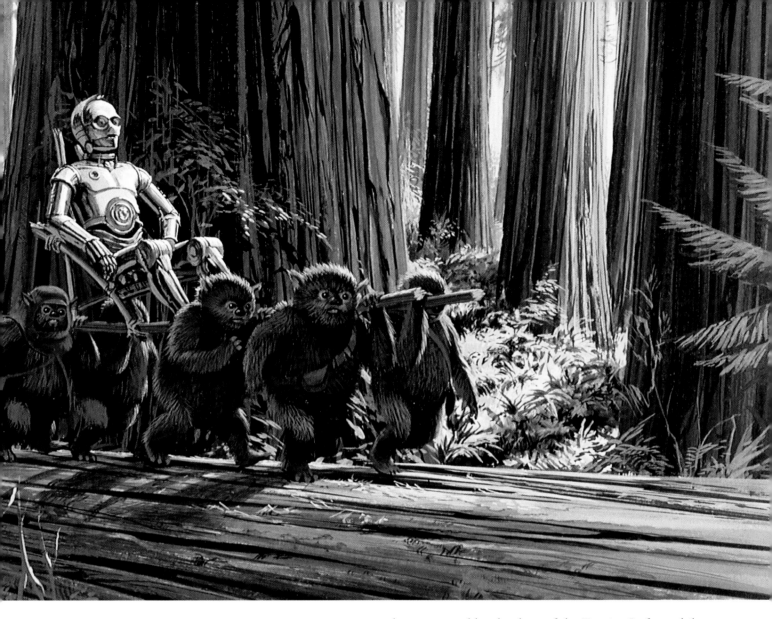

ABOVE: **The Ewoks give See-Threepio a royal procession.**
Production painting by Ralph McQuarrie.

FAR LEFT: **An Ewok warrior.**

LEFT: **Ewok concept drawing**
by Joe Johnston.

to the austere, cold technology of the Empire. In fact, while in the Ewok village, Leia wears a soft animal-skin dress and lets down her magnificent hair, perhaps reflecting the subtle magic of the Ewoks' connection to the natural world; their creative powers are shown by the fact that they are the only creatures in the trilogy shown with children.

The Ewoks take See-Threepio for some kind of deity. Throughout the trilogy, See-Threepio's voyage has mirrored the hero's journey—but in an ironic way. He has been caught up in the quest, dismembered and reborn, and he now receives the adulation of a hero's apotheosis. Yet he has remained his own limited self, and he is now quite helpless to prevent the Ewoks from preparing a ritual feast whose main course will be the heroes themselves. Luke, however, uses his Jedi powers to impress them; now he is the one with the magic to evoke the help needed. See-Threepio finally achieves his transformation later that evening as he captivates the audience gathered round the fire with the story of the heroes'

adventures—a story that will no doubt become myth for the Ewoks.

Inspired by See-Threepio's story, the Ewoks join forces with the Rebel band, battling the high technology of the Empire with logs, stones, and vines. Chewie captures a walker and Han uses it to trick the Imperials into opening the door to the shield-generator bunker. At last the Rebels succeed in blowing up the generator and demolishing the protective shield, clearing the way for Lando's strike on the Death Star's reactive core. Throughout this final phase of the trilogy, new heroes are made as the crisis demands it; Luke, Han, and Leia have become mature leaders who inspire others. Thus, it is Chewie who saves the day at the shield bunker, Lando and Wedge who will blow up the Death Star, and ultimately, Vader himself who will destroy the Emperor.

DESCENT INTO THE UNDERWORLD

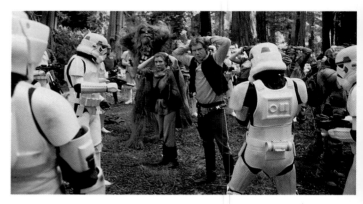

O NCE AGAIN, LUKE REALIZES THAT HE must set out on a different path from his friends to attempt to reach that part of Vader that is still Anakin Skywalker and turn him back from the dark side. Luke's trip into this second Death Star is another descent into the underworld, a classic theme in Greek and Roman mythology. Hercules brings his friend Theseus back from Hades; Aeneas journeys there to converse with his father Anchises. Now Luke will confront his own father and discover whether atonement is possible.

In the final stage of the hero quest, the physical conflict raging on Endor and around the Death Star mirrors Luke's spiritual conflict as he engages in a battle of wills with the Emperor. Luke has been separated from the common people, his Rebel friends, and with the Emperor and Lord Vader, he must watch the conflict from a distance. As though looking down from Mount Olympus, these three are above the battle, directing the affairs of others.

The Emperor is now the monster at the heart of the Death Star's labyrinth. In the Greek story of Theseus and the Minotaur, the maze is guarded by a creature who is half man and half animal. Here the guardian is Vader, who is half man and half machine. The Emperor has been given great power but has refused to use it for his people; he has subverted his leadership role to serve his own ego. This has stifled the flow of the life force of the galaxy, and the hero must unlock and release this energy so that it may flow once again. For Luke, this means reasserting the most vital human values in the face of the Empire's encroaching technological sterility.

FROM TOP: **Stormtroopers capture Chewie, Leia, and Han on Endor.**

An AT-ST from Return of the Jedi.

Orpheus pursues his true love Eurydice into the underworld.

In this final encounter, the Emperor alternately offers Luke a position alongside his father and the opportunity to replace him. Yoda has warned Luke that feelings of anger, fear, and aggression open the spirit to the dark side of the Force. The Emperor plays on this now, taunting Luke and offering to return his lightsaber. "The hate is swelling within you now," the Emperor says. "Take your Jedi weapon. Use it. I am unarmed. . . . Give in to your anger." The battle within Luke grows fierce as he struggles to contain his fear and rage. Forced to stand by while his friends are in mortal danger, assured by the Emperor that they cannot succeed, Luke faces the ultimate crisis—and turns finally to face his father and the darkness of his own soul.

ATONEMENT WITH THE FATHER

LUKE ATTACKS VADER IN A FRENZY OF hate, and this time it is he who beats Vader down and severs his father's sword hand, which turns out to be a mechanical appendage. As the Emperor urges Luke to finish his father, Luke looks at his own mechanical hand and realizes that he is on his way to becoming the next Vader. And so Luke casts aside his lightsaber, mastering his worst instincts and refusing to obey the Emperor's command.

Enraged, the Emperor uses his own dark powers to zap Luke. As Luke pleads with his father for help, the crucial moment has arrived. Will Darth Vader be able to redeem himself? Will Luke achieve the atonement with his father that marks the final passage on his journey?

This process of becoming at one with the father is one of the great archetypal themes found in myths from many cultures. The Twin Warriors of the Navaho, for example, go in search of their father the Sun. He puts them through terrible trials and tests, throwing them at sharp spikes, boiling them in an overheated sweat lodge, and poisoning them with a smoking pipe. When at last he is satisfied with their courage and skills, he admits them as his sons.[33] Vader acknowledged that Luke is his son at the end of *The Empire Strikes Back;* now he must act on that knowledge for atonement to occur.

Vader's true nature has been imprisoned by the system, but within him still reside all the "life-potentialities" (to use Joseph Campbell's term) that once belonged to Anakin Skywalker. Now he has the chance to fulfill one of those potentialities: that of hero and savior.

Luke too must find a new life-potentiality within himself—that of the child who cannot perform the task on his own. He renews his own life and makes renewal possible for his civilization by rediscovering the child within. In his

THIS PAGE, TOP TO BOTTOM:
Luke, in surrendering his lightsaber to Vader, invites the final confrontation.

Luke and Vader arrive in the Emperor's chambers.

NEXT PAGE: **Like gods, Vader, the Emperor, and Luke look down on the conflict.**

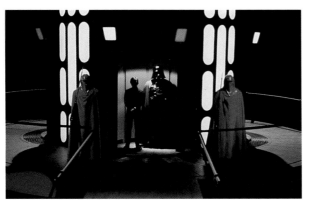

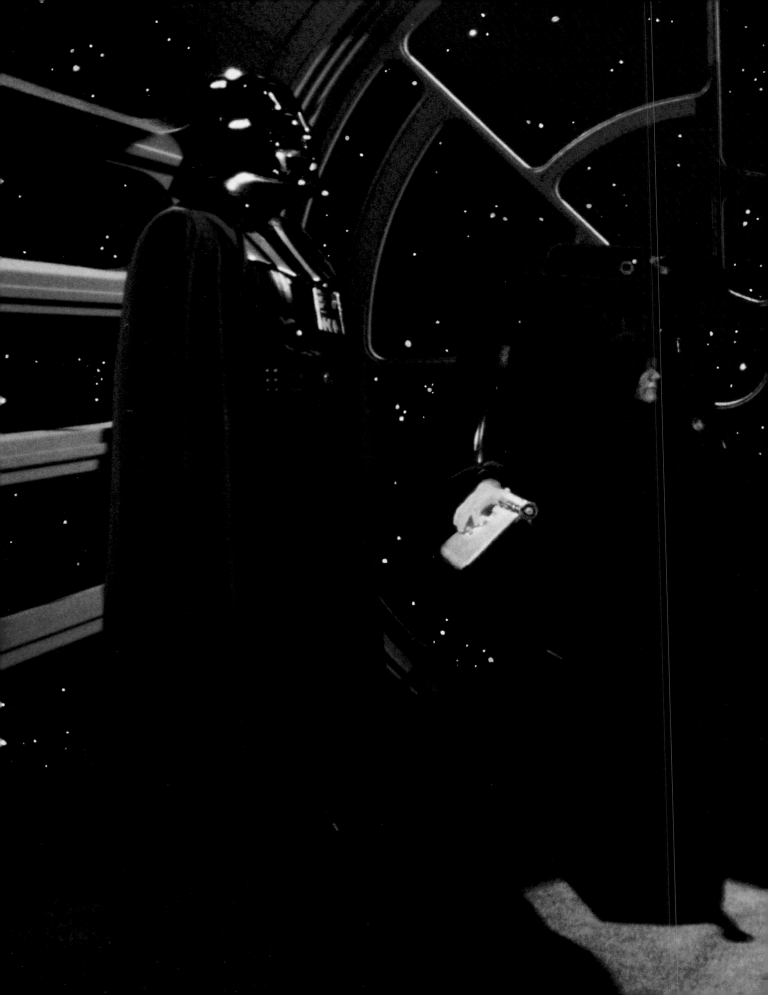

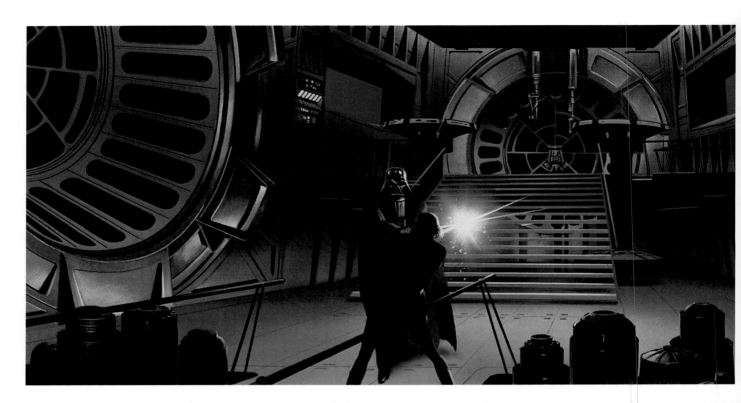

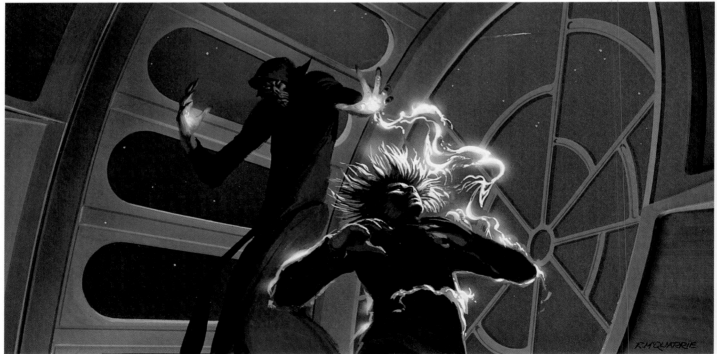

FROM TOP: **Luke and Vader duel in
the Emperor's throne room.**
Production painting by Ralph McQuarrie.

The Emperor zaps Luke.
Production painting by Ralph McQuarrie.

confrontation with Vader and the Emperor, Luke does not use his warrior skills but rather an appeal to the heart: "Father, please. Help me," he cries as the Emperor is about to destroy him. And at last Vader seizes his master in order to save his son. As the Emperor's lethal electric charges rain back on Vader, he throws his former master into the shaft at the core of the Death Star. Regeneration has occurred within the very walls of the tyrant's kingdom. Vader has detached himself from his evil master and has been transformed through his son. Vader has become a tragic persona, and his own suffering is now the supreme monstrosity with which he must contend. Vader's hero quest has been only hinted at because, like many hero's journeys, the heroic feats and monster tests he must overcome take place within. Vader is, in a sense, a fallen angel who reveals his true essence at last.

UNMASKING

ONE OF THE OVERARCHING THEMES of *Return of the Jedi* is the stripping away of disguises to reveal the true being within. Leia, for example, first appears in this film in a tough disguise and hard mask; we might see this as symbolic of her original persona. When this is stripped away, she reveals herself to be a sensual and loving woman as well.

In cultures where myths are acted out as part of a ritual, masks serve several purposes. In Africa, masks have been used to ward off enemies, to summon ancestors, and to celebrate alliances among tribes. The mask can also invoke a

ABOVE: **Twin warriors of the Navaho and "father atonement,"** sand painting, c. 1950.

BELOW: **The Falcon and an X-wing shoot out the Death Star's main reactor.** Production painting by Ralph McQuarrie.

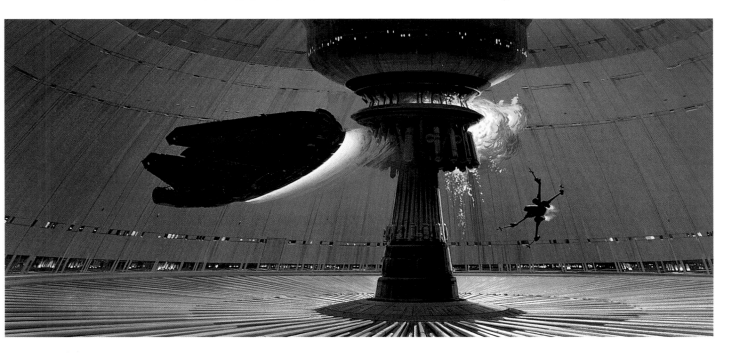

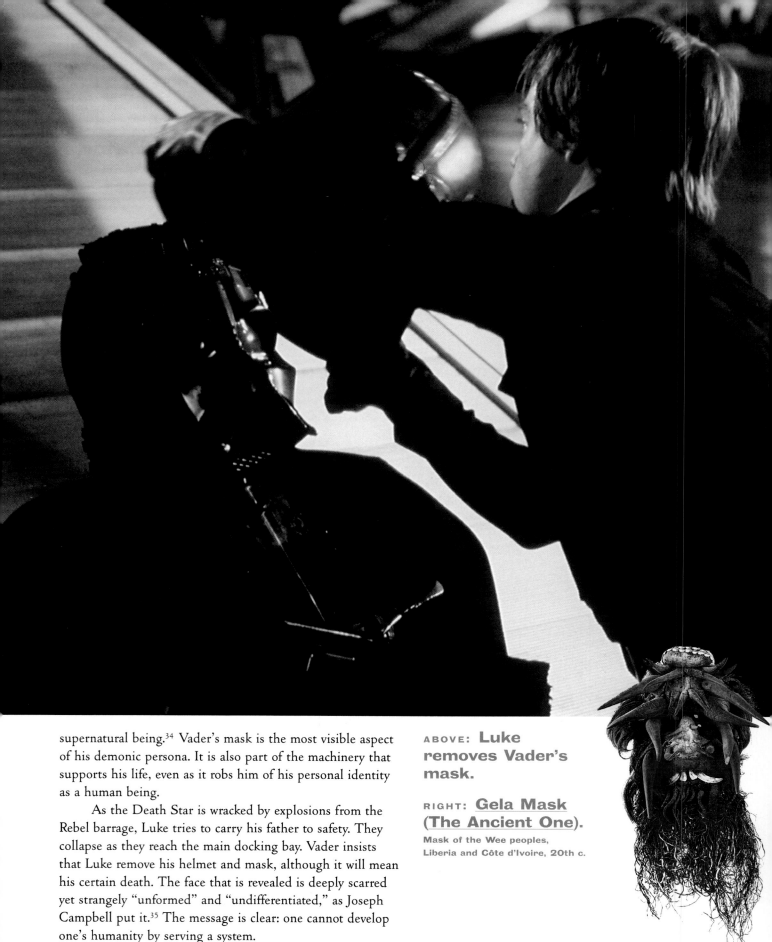

supernatural being.[34] Vader's mask is the most visible aspect of his demonic persona. It is also part of the machinery that supports his life, even as it robs him of his personal identity as a human being.

As the Death Star is wracked by explosions from the Rebel barrage, Luke tries to carry his father to safety. They collapse as they reach the main docking bay. Vader insists that Luke remove his helmet and mask, although it will mean his certain death. The face that is revealed is deeply scarred yet strangely "unformed" and "undifferentiated," as Joseph Campbell put it.[35] The message is clear: one cannot develop one's humanity by serving a system.

ABOVE: **Luke removes Vader's mask.**

RIGHT: **Gela Mask (The Ancient One).**
Mask of the Wee peoples, Liberia and Côte d'Ivoire, 20th c.

FINAL VICTORY

AS THE REBELS CELEBRATE THE RELEASE of the galaxy from bondage to the Emperor, Luke gives his father a hero's send-off by placing his armor on a funeral pyre. In myth and ritual, fire is associated with purification, and the hero's spirit is thought to rise on the smoke to the heavens. The Greek hero Hercules was carried up to Olympus from his funeral pyre and made one with the gods. Anakin, having attained grace through his love for his son, undergoes a similar apotheosis: as Luke rejoins his friends, he looks back to see that his father has been reunited with Ben and Yoda to form a triad of Jedi Knights. The wisdom and compassion of the sage, the saint, and the warrior-hero now live on in Luke; the atonement is complete. Joseph Campbell sums up this transcendent moment in this way:

> *The hero ... for a moment rises to a glimpse of the source. He beholds the face of the father, understands—and the two are atoned. ... For the son who has grown really to know the father, the agonies of the ordeal are readily borne; the world is no longer a vale of tears but a bliss-yielding, perpetual manifestation of the Presence.*[36]

By the end of the trilogy, Luke, who first appeared in *Star Wars* as an untested youth, has completed the final task of the mythic hero's journey: he has brought back from his adventures the boon that will allow his society to live and to grow.

TOP TO BOTTOM:
Heracles Rises to Olympus,
Ingri and Edgar Parin D'Aulaire, 1962.

The Jedi triad reunited: Anakin Skywalker, Yoda, and Obi-Wan Kenobi.

The Conflict of Good Versus Evil

On its most basic level, the *Star Wars* saga represents a conflict of the Light versus the Dark, an ancient precept of Indo-European myths that spread to many other mythologies. The conflict in *Star Wars*, and in many myths, branches off from this central opposition. Walter Burkert could have been describing Luke and Vader when he wrote about narrative structure in Western mythology:

> *The prospective victor and the antagonist are made opposites in every respect: the victor will be bright, handsome, nice, young, perhaps slim and small, but tough and virtuous, while the adversary will be dark, ugly, repulsive, old, big and powerful. . . . The contrast between light and darkness obtrudes itself.* [37]

THIS PAGE AND OPPOSITE:
The Light versus the Dark: Luke and Darth Vader.

In *Star Wars*, Luke and Vader represent good and evil on a cosmic scale. Luke is golden-haired and fair-skinned; his home is a twin-sunned planet so bright that it appears to be a sun itself:

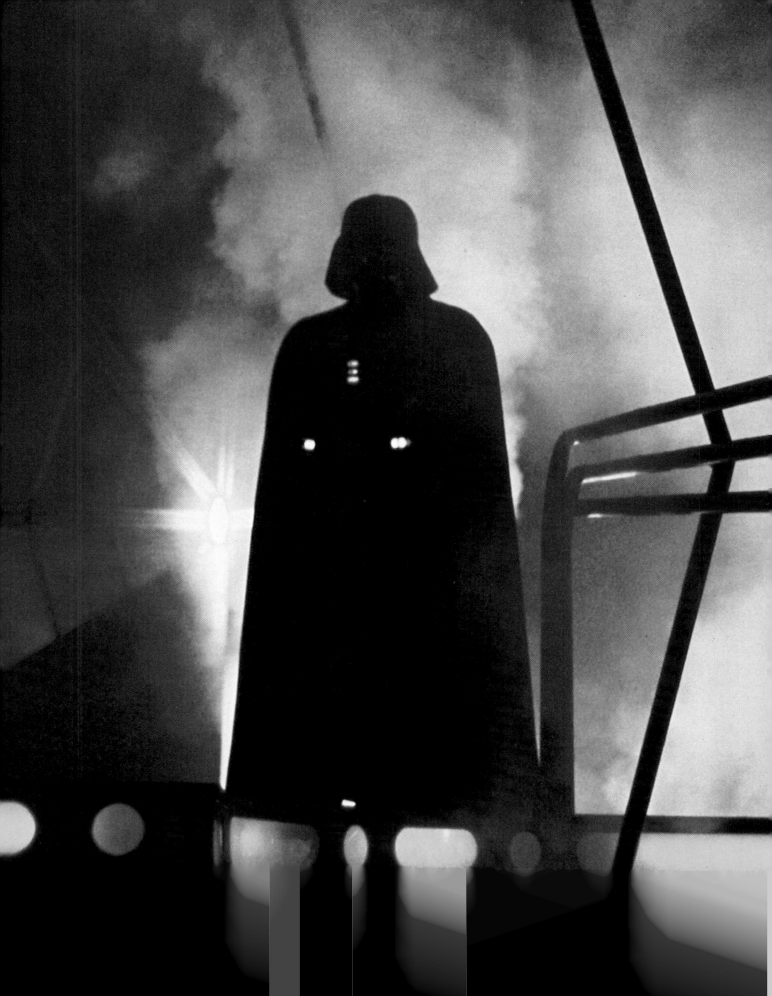

It was a vast, shining globe and it cast a light of lambent topaz into space—but it was not a sun. Thus, the planet had fooled men for a long time. Not until entering close orbit around it did its discoverers realize that this was a world in a binary system and not a third sun itself.[38]

Luke is thus a solar hero, the bringer of light, symbolizing goodness and truth. Leia too is a figure of light who remains feminine and mysterious. In Western mythologies, the Sun is often male while the Moon is female. Since Luke and Leia are Vader's children, one metaphorical interpretation might see Vader as the all-encompassing darkness out of which Luke shines as the sun and Leia as the moon.

From the beginning, *Star Wars* reveals that good and evil are at war. This first film divides good and evil clearly: the dark side uses the power of the Force for aggression, and the light side for defense. The heroes make the right power choices: they seek independence rather than dominance, and they fight because they must, not because they are consumed by bloodlust. The hero, as we saw in the section on the hero's journey, is an ordinary character who is put into an extraordinary situation and rises to the occasion.

This clear distinction between good and evil has its roots in Zoroastrian belief. Zoroaster (also known as Zarathustra) dates from about the sixth or seventh century B.C. and was the great prophet of Persia. He gave ancient mythology an abstract interpretation, teaching that the world is the creation of good and that God is not in any way associated with evil. Good and evil, like light and darkness, are contrary realities. In other words, Zoroastrianism holds that the two are fundamentally opposing forces at work in the universe. Evil is not simply the absence of good; it is a real substance and force in its own right. Good and evil cannot coexist; they are mutually destructive and ultimately derive from the two "first causes," which are themselves mutually antagonistic and irreconcilable. One source is Ahura Mazda, the wise lord, mother and father of creation; all of his works, including humans, are good. The other "first cause" is Angra Mainyu, the evil spirit, who limits the omnipotence of Ahura Mazda and dwells in an abyss of endless darkness. He is ignorance, harmfulness, and disorder, and his aim is always to destroy or spoil the creation of Ahura Mazda. All human evil is due to Angra Mainyu, as he resides like a parasite in the bodies of men and animals.[39] The evil one pollutes Ahura Mazda's pure creation, but the energy of life and growth continues to war with death and decay, and Mainyu will eventually be overcome.

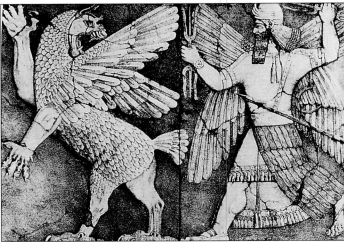

THIS PAGE: Evil and Good Face Off

Luke confronts the Emperor.

Chaos Monster and Sun God,
A.H. Layard, engraving from
Assyrian wall panel, 885-860 B.C.

Zoroaster held that the cosmic battle was fought in this world. The evil Empire, then, is the work of Mainyu. There is no crossover between the two forces; when the Death Star is destroyed along with everyone on it, it is a clear-cut victory of good over irredeemable evil. There is no point in attempting to "save" any of the Imperial troops. In the Zoroastrian universe, saviors are not mythical beings but rather those who through justice and truth overcome passion; just so are the heroes of *Star Wars*.

The Empire Strikes Back presents a rather different picture of the conflict between good and evil, culminating in the revelation that Darth Vader is Luke's father. Now the conflict descends to the level of the human spirit. Vader is the shadow of Luke's bright side. Luke's experience in the mystic tree cave reveals that he carries something of the dark side within himself, while Vader's continued refusal to kill Luke

BELOW: Vader represents Luke's shadow side.

NEXT PAGE: Luke severs his father's sword hand.

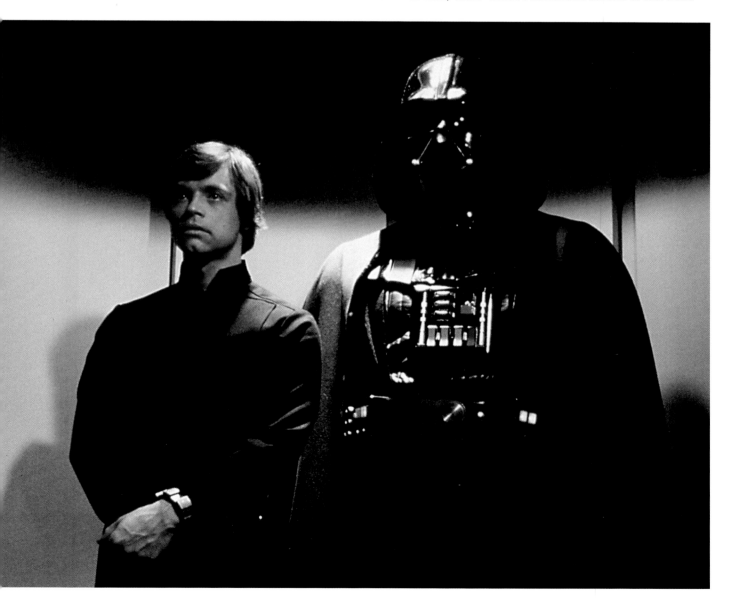

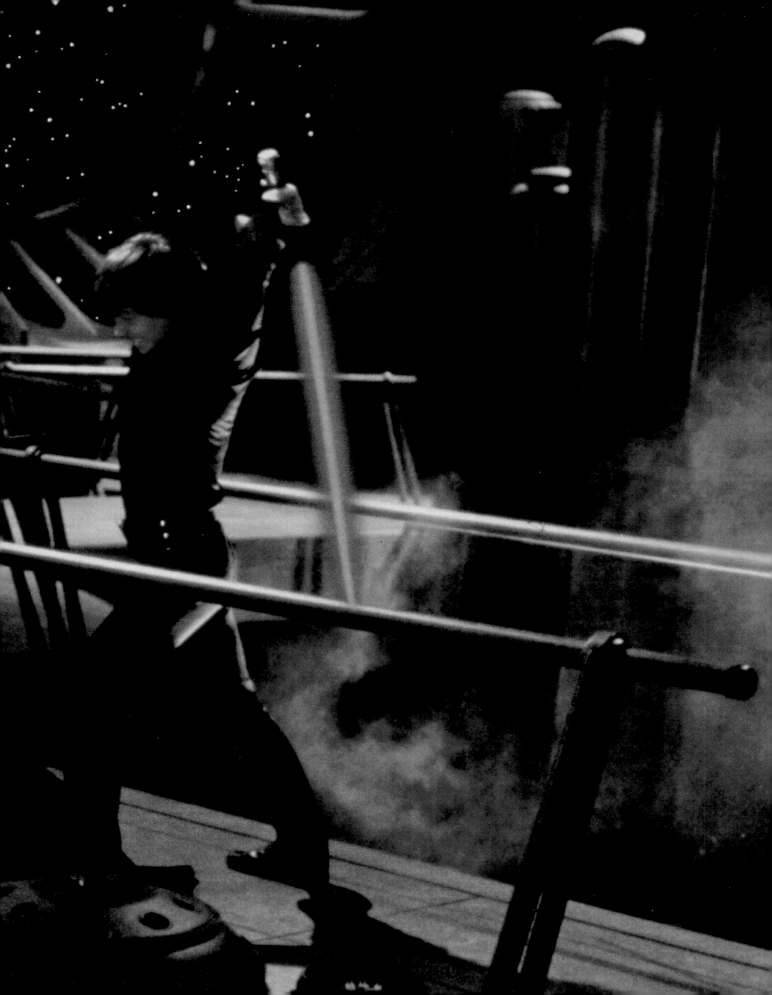

shows that some vestige of the forces of good are still at work in him. From ancient Egypt comes the "Secret of the Two Partners." Horus, god of good, and his uncle Set, god of evil, appear to be implacable enemies, yet behind the scenes they are of one mind, two halves of the same entity, in a sense. Joseph Campbell put it this way: "Mythologically representing the inevitable dialectic of temporality, where all things appear in pairs, Horus and Set are forever in conflict; whereas in the sphere of eternity, beyond the veil of time and space, where there is no duality, they are at one; death and life are at one; all is peace."[40] The pairs of opposites may act out their drama in the field of the universe, but beyond time and space is the mystery of the One.

Vader and Luke, as father and son, embody this "secret." One personifies evil but carries within him the potential for redemption, while the other personifies good but carries within the potential for evil. Beyond the struggle between them lies the hope of their reconciliation through atonement. Like the Chinese yin and yang, each contains a drop of the other.

Return of the Jedi shifts the perspective on good and evil once again. Luke's redemption of his father is reminiscent of Christian belief. In this tradition, evil is the result of a fall from grace; Satan and his followers are rebels against the covenant of Yahweh. According to Saint Augustine, Adam and Eve are created of the goodness of God, but when they are successfully tempted by Satan to eat of the tree of good and evil, they are born again in the devil. "Therefore there are two births, that of Adam and that of Christ, the one casting us down to death, the other raising us up to life; the one bearing with it sin, the other freeing us from sin."[41] In one sense, Vader, who as Anakin Skywalker belonged to a powerful spiritual elite and then rebelled against it, has fallen from grace. However, since the fallen angels of Christianity are apparently not redeemable, Vader is perhaps closer to Adam, who is human and has made a sinful choice. Adam, along with humanity, is redeemed by Christ, the son of God, who could be considered Adam's son as well because he took human form.

By weaving in these shifting approaches to the classic conflict of good versus evil, Lucas created a complex texture that deepens our experience of the story. "*Star Wars* is not a simple morality play," Joseph Campbell explained to Bill Moyers, "it has to do with the powers of life as they are either fulfilled or broken and suppressed through the action of men."[42] But this complexity comes not just from the inclusion of so many classic mythological elements; the contemporary themes that form the backdrop of the *Star Wars* story provide another layer of mythic images.

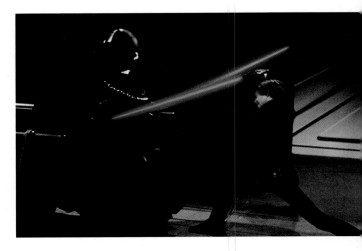

ABOVE: **Vader and Luke engaged in the ultimate battle.**

OPPOSITE: **In the tree cave on Dagobah, Luke discovers that the darkness lies within himself.**

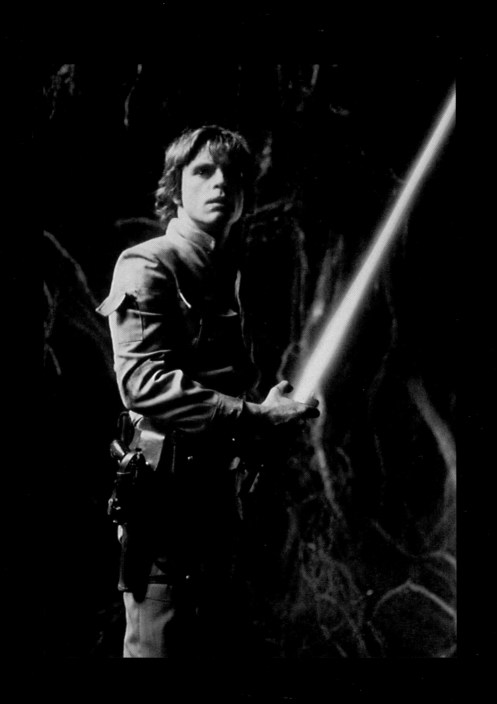

Chapter Two

THE MAKINGS OF MODERN MYTH:
Cultural and Historical Influences

"I had wandered into the little public library of the town

where I grew up and, casually exploring the stacks,

pulled down a book that opened wonders to me:

Prometheus, stealing fire from the gods for the sake of the human race;

Jason, braving the dragon to seize the Golden Fleece;

the Knights of the Round Table, pursuing the Holy Grail.

But not until I met Joseph Campbell did I understand

the Westerns I saw at the Saturday matinees had borrowed freely

from those ancient tales. And that the stories

we learned in Sunday school corresponded with those of other cultures

that recognized the soul's high adventure, the quest of mortals

to grasp the reality of God. He helped me

to see the connections, to understand how the pieces fit."

BILL MOYERS, *The Power of Myth*

Myths are made

not just of classic recurring themes but of the specific context out of which they spring. The STAR WARS saga tells a time-less story of a hero's journey to fulfill his destiny and conquer the forces of darkness. It is distinctly a myth of the late-twentieth century. And so we need to look at the other stories that were being told and at the stories that history was in the process of writing when STAR WARS came into being. Some of these elements may have had a conscious influence on George Lucas as he created the STAR WARS scripts; others are simply part of the general context in which the story appeared, having an impact on viewers instead.

The Western

Lucas had been impressed by many different mythic stories discovered in his days as an anthropology student and later at film school. He saw the Western, which had its golden age in the years following World War II, as a modern mythology that had drifted out of fashion by 1970, and he wanted to recapture some of its glory.

After I finished American Graffiti, *I came to realize that since the demise of the Western, there hasn't been much in the mythological fantasy genre available to the film audience. . . . I'm trying to reconstruct a genre that's been lost and bring to it a new dimension so that the elements of space, fantasy, adventure, suspense and fun all work and feed off each other.*[1]

The notion of the frontier and, as time went on, tales of the Old West are perhaps the most important defining elements of the American psyche. At first this ethos explained and justified the establishment of the American colonies; as the colonies expanded, it helped drive the development of the nation.

When Lucas was growing up in the late forties and the fifties, the Western story was undergoing a renaissance. John Ford's cavalry trilogy of *Fort Apache* (1948), *She Wore a Yellow Ribbon* (1949), and *Rio Grande* (1950) prompted a wave of such stories in the film industry, while the Western era also dominated the new medium of television, from children's shows like the *Lone Ranger* and *Hopalong Cassidy* to adult Westerns such as *Gunsmoke* and *Wagon Train*.

PREVIOUS PAGE: **A scene from Fritz Lang's Metropolis,** 1926.

ABOVE RIGHT: **Sitting Up Cross-Legged with Each Hand Holding a Gun...,** N. C. Wyeth, 1906.

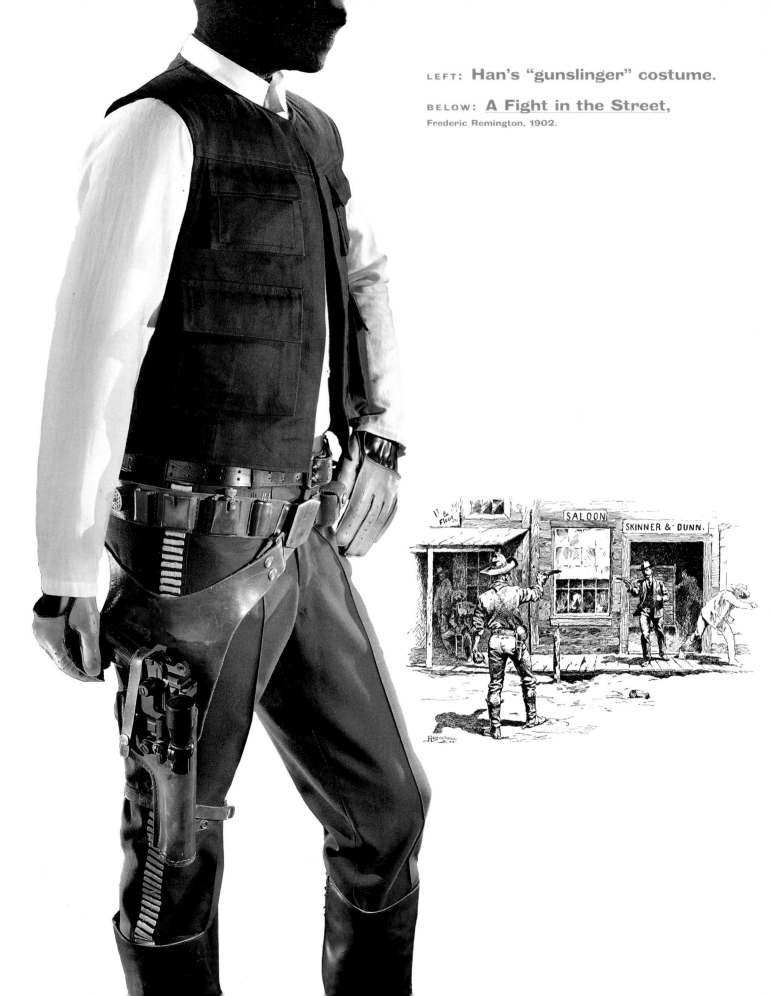

LEFT: **Han's "gunslinger" costume.**

BELOW: **A Fight in the Street,**
Frederic Remington, 1902.

OPPOSITE:
The Pay Stage, N.C. Wyeth, 1910

BELOW:
Han's costume design.
Sketch by John Mollo.

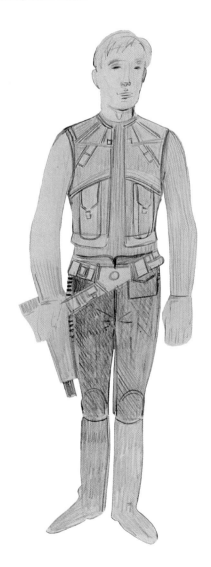

Perhaps this trend was set in motion by the end of World War II, which sparked both internal and external problems for the United States. America needed to adapt to new social and political expectations and concerns. The rich symbolism of the Western provided an imaginative field in which to enact "subjects like race relations, sexuality, psychoanalysis, and Cold War politics."[2] Yet it located these problems safely in a fantasy world; set in the past and affirming American success against all odds, the boundaries of this world seemed very secure.

For his *Star Wars* fantasy, Lucas used a mix of themes from the Westerns of his youth. The first major Western motif we recognize is life on the frontier. Luke, Uncle Owen, and Aunt Beru are "farmers" living at the edge of civilization. The Western's cabin on the plains is replaced with a cave in the dunes, the plow mule with droids, the buckboard with a landspeeder, the waves of grain with ranks of moisture vaporators. Owen and Beru live on the brink of wilderness; the Sand People take the place of the uncivilized "other," the Western's predators. Although this exchange between Luke and his friend Biggs was cut from the edited version of the film, it illustrates the kinds of analogies that give *Star Wars* its Western feel:

> LUKE: *There has been a lot of unrest among the Sand People since you left. . . . They've even raided the outskirts of Anchorhead.*
> BIGGS: *Your uncle could hold off a whole colony of Sand People with one blaster.*

Living on the frontier was dangerous, and in many Western films, the destruction of the wagon train, the burning of the homestead, or the slaying of the kinfolk provided the motivation for the hero's journey of revenge. Just so, Luke is pushed on his journey by the destruction of the Jawa caravan, his own home, and the deaths of Uncle Owen and Aunt Beru.

The Western's gunfighter persona became, in *Star Wars,* the rough-riding, quick-on-the-draw Han Solo. Mos Eisley's cantina is the frontier-town saloon, and Greedo is indeed the bounty hunter. Han's quick dispatch of his adversary proves that Luke and Ben have hired themselves a proficient gunslinger.

The climax of *Star Wars: A New Hope* is a classic Western shoot-out, with the Death Star standing in for the OK Corral. Like the good guys and the bad guys of the Westerns, the combatants demonstrate that their aim is excellent, even on the fly.

Western themes reappear in *Return of the Jedi.* As in the

ABOVE: **The duel between Luke and Vader.**
Production painting by Ralph McQuarrie.

The Samurai Represent the "Cowboys" of the Far East

THIS PAGE, CLOCKWISE FROM LEFT:
The Thirty-six Master Poets, Sakai Hoitsu, Edo period.

Imperial snowtroopers concept drawing by Joe Johnston.

Boba Fett concept drawing by Ralph McQuarrie.

The Kusazur-biki Scene..., Torii school, Edo period.

OPPOSITE ABOVE:
Portrait of Actor Nakamura Nakazo... fan print, Katsukawa Shunsho, 1726–92.

OPPOSITE BELOW:
Samurai, from Secrets of the Samurai: A Survey of the Martial Arts of Feudal Japan, 1973.

Westerns in which the hero returns to tame the town overrun by villains, Luke returns to his hometown—in this case, his home planet—where a powerful criminal and his gang have imposed a reign of terror. Luke not only has a personal score to settle; he also represents the fight for right against might in true "town tamer" fashion. The Western itself borrowed themes from other stories in America's contemporary cultural mythology. For instance, the gangster films of the 1930s influenced the "town tamer" motif; such Western classics as *Dodge City* (1939) and *My Darling Clementine* (1946) used these gangster elements in much the same way that *Return of the Jedi* does.

Influences on the Western genre were not all drawn from within Hollywood itself or from the historical context of the Old West. In a fascinating turn of events, the Western was also influenced by a wholly different cultural mythology—that of the Far East. John Sturges' *The Magnificent Seven* (1960) and Sam Peckinpah's *The Wild Bunch* (1969), for example, were inspired by a Japanese film, the *Seven Samurai* (1954) by Akira Kurosawa. Born in 1910, Kurosawa is considered to be one of the most influential film directors and his classic *Seven Samurai* one of the best films of all time. Hollywood film-makers were impressed by Kurosawa's innovative techniques and the indomitability of his "cowboys" from feudal Japan; Japanese moviegoers, on the other hand, could not seem to get enough of Hollywood's cattle-punching "samurai."

Lucas recalls his discovery of Kurosawa when he was in film school:

> *I was very intrigued by a lot of his movies because they were samurai movies, feudal Japan. The look of them was very exotic . . . and I found it very interesting that nothing was explained. You are thrown into this world, and obviously if you know about feudal Japan then it makes sense to you; but if you don't, it's like you're watching this very exotic, strange thing with strange customs and a strange look. And I think that influenced me a great deal in working in science fiction because I was able to get around the idea that you have to explain everything or understand what everything is. . . . You just put yourself into this environment. It's like the world of an anthropologist. You walk into this strange society; you sit there and observe it.*[3]

Lucas particularly admired the look of "immaculate reality" that infused Kurosawa's films. They were meticulously crafted so that nothing looked like a set, nothing looked designed; the environment seemed completely real, and the films began in the midst of the action, putting the viewer in the position of an observer just arrived on the scene who needs to catch up with what is going on.

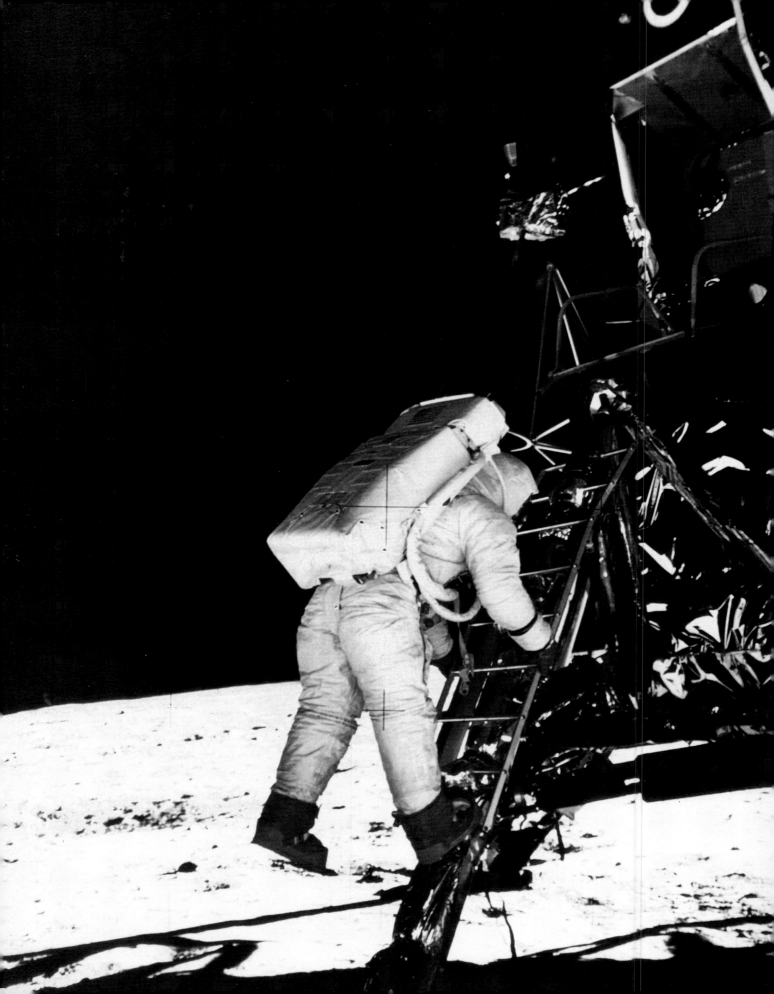

The Space Age and Science Fiction

At the time that Lucas was creating his *Star Wars* saga, the Old West was not the only mythic American frontier; the new frontier of space beckoned seductively. On October 4, 1957, the Soviet Union launched *Sputnik I*, the first human-made satellite. The United States launched the *Explorer* the following year, and the space race was on. By 1961 a Soviet cosmonaut, Yuri Gagarin, followed by a U.S. astronaut, Alan Shepard, became the first human space travelers. That year, President Kennedy committed the United States to landing men on the moon before the end of the decade.

OPPOSITE: **Astronaut "Buzz" Aldrin begins his walk on the moon.**

RIGHT: **U.S. and U.S.S.R. astronauts meet in space during Apollo-Soyuz Test Project.**

Generations earlier, America had fulfilled its desire to conquer new frontiers by expanding the nation from the Atlantic to the Pacific Ocean; now the country focused on a different kind of frontier. On July 20, 1969, while Michael Collins orbited above, Neil Armstrong and Buzz Aldrin landed on

the moon. This event was a triumph of the spirit and will, as well as a major technological feat. For a few moments, the whole world forgot its differences and united to celebrate the spacefarers' achievement.

For Lucas, the advent of the Space Age opened new cinematic prospects.

I became very fascinated with how we could replace this mythology that drifted out of fashion—the Western. One of the prime issues of mythology was that it was always on the frontier, over the hill. It was always in this mysterious place where any-thing could happen, so you could deal with metaphor and that sort of thing. And I said, well, the only place we've got left is space—that's the frontier. I'd always been very fascinated with Buck Rogers *and* Flash Gordon *as a child, and I'd seen a lot of serials and they were all very exciting. We were just beginning the Space Age, and it was all very alluring to say, gee, we could build a modern mythology out of this mysterious land that we're about to explore.[4]*

And so Lucas stirred his cowboys into a science fiction fantasy, combining and blending the imagery until the whole became so much more than the sum of its parts. For among the classic themes of science fiction are the development of supernormal powers and their effects on humans, encounters with alien worlds and life forms, travel through time or to "alternate universes," and space travel. In the *Star Wars* films, supernormal powers are used and abused, the drama is played out on alien worlds with an interesting variety of life forms, and the whole story is set in an alternate universe where space travel is commonplace: that galaxy "far, far away."

Lucas had long been a fan of science fiction pulp adventures, as well as movie serials and comic book fantasy. To him, the words *Flash Gordon* summed up the action, wonder, and romance of those images and stories. *Flash Gordon* began as a popular comic strip in 1934, intended to rival the first science fiction comic strip, *Buck Rogers*. Appearing in 1929, *Buck Rogers* introduced a generation to such classic science fiction

Just a Few of Star Wars' "Alien Life Forms"

ABOVE LEFT: Concept painting for Dagobah's tree creatures by Ralph McQuarrie.

ABOVE RIGHT: Weequay and Wooof.

OPPOSITE: Gamorrean guard.

FOLLOWING PAGE: Rancor.

Science Fiction
on Screen and
in the Comics

LEFT:
Flash Gordon
by Alex Raymond, 1935.

AS THEY PREPARE TO ENTER THE SOMBER STRUCTURE, THEY ARE STARTLED BY A MUFFLED ROAR-----

ABOVE: **Flash Gordon**
by Alex Raymond, 1935.

ABOVE RIGHT: **Buck Rogers memorabilia**
photo by Ross Chapple.

BELOW RIGHT: **A classic "lost world" image: the Ewok village.**

elements as interplanetary travel, villains who attempted to conquer the universe, and gizmos and gadgets that reflected the accelerating pace of technological development. *Flash Gordon* incorporated these elements into a period-costume fantasy with an emphasis on romance, which followed the basic pulp adventure formula of capture, rescue, and escape.

Science fiction author Brian Aldiss defined heroic space fantasy, or "space opera" as it is often called, in 1974:

> *Ideally, the Earth must be in peril, there must be a quest and a man to meet the mighty hour. That man must confront aliens and exotic creatures. Space must flow past the ports like wine from a pitcher. Blood must run down the palace steps, and ships launch out into the louring dark. There must be a woman fairer than the skies and a villain darker than the Black Hole. And all must come right in the end.[5]*

Except for the blood, the *Star Wars* saga fits this mold perfectly. And it is not the earth but the galaxy that is in peril from the evil Empire. Evil empires are the stock in trade of many science fiction narratives. They actually have their roots in the "lost world" fantasies of the nineteenth century, which in turn followed the long-standing tradition of the "traveler's tale"—a story of journeys to strange or imaginary places. In the lost world fantasies, a hidden civilization

flourishes undisturbed on an undiscovered island, in a valley deep in the interior of Africa or South America, or under the sea or underground. Among the first such tales was Jules Verne's *Journey to the Center of the Earth* (1864). H. Rider Haggard's *King Solomon's Mines* (1885), Sir Arthur Conan Doyle's *The Lost World* (1912), and Edgar Rice Burroughs' *The Land That Time Forgot* (1924) became icons of the tradition. Some portrayed a paradise on earth, but more often these worlds were ruled by men or women who maintained a mesmeric control over their domains, who sometimes had special powers or advanced scientific knowledge, and who occasionally contemplated emerging from their hidden fortress and conquering the rest of the earth.[6] And as exploration left little undiscovered on this planet, the potential invaders began to set their sights on other planets.

The first works of fiction about space travel were written in the second century A.D. by Lucian of Samosata. He imagined alien races and an interstellar battle between the empire of the Moon and that of the Sun. With the development of the telescope in the early seventeenth century, the idea that there might be a plurality of worlds began to be taken seriously. The moon, planets, and stars became possible destinations for the imagination, and fantasies about space travel appeared more frequently in literature. By the end of the nineteenth century, Jules Verne and H. G. Wells had made interplanetary voyages enormously popular.

About the same time that the inhabitants of lost worlds began to look to other planets as possible conquests, alien invasions of the earth also became a popular science fiction theme. The nature of these evil invaders usually reflected the concerns of the time in which they were imagined. For example, in an era when more and more bacteria were being discovered under the microscope, the aliens in Wells' *War of the Worlds* looked much like one of those "wiggly bugs" blown up to the size of repulsive monsters; ironically, they are destroyed by the very bacteria that they so much resemble. In the original cartoon of *Buck Rogers in the Twenty-fifth Century*, the invaders destroying America are "'half-breed' Mongols"— a reflection of the anti-Asian racism rampant in the United States in the 1930s. In the fifties, nuclear weaponry, the Cold War, and the rise of communism all contributed to feelings of anxiety and paranoia, which were expressed in a variety of science fiction films. Out of the fear of nuclear radiation came such monster mutations as giant killer ants (*Them!* 1954), while the evil aliens inspired by a fear of communism were likely to use mind control, exploiting humans for their schemes in such films as *Invaders from Mars* (1953), *Invasion of the Body Snatchers* (1956), and *I Married a Monster from Outer Space* (1958).

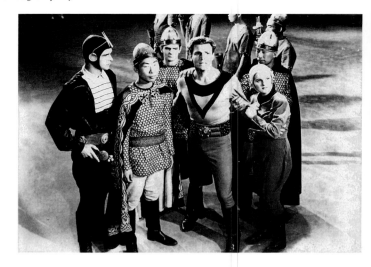

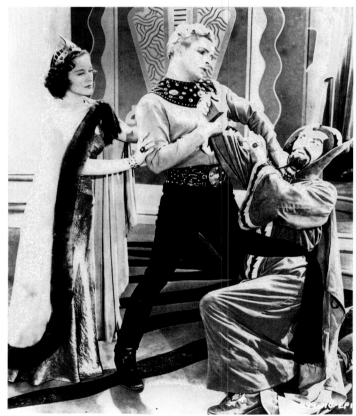

FROM TOP: **Scene from Buck Rogers in the 25th Century.**

Scene from Flash Gordon's Trip to Mars.

OPPOSITE: **Queen Fria and Flash Gordon** by Alex Raymond, 1935.

World War II

The trilogy's Galactic Empire was also influenced by real-life cultural concerns, capturing a cross section of images and attitudes from the history surrounding its creation. Lucas was born at the end of World War II and grew up in its aftermath. The Nazi concentration camps revealed all too clearly that humans could inflict the worst possible horror upon other humans, and the use of the atom bomb demonstrated that we could wipe ourselves out without any help from space invaders.

In *Star Wars*, the Death Star can be viewed as the ultimate nuclear weapon, and the look of the Imperial Army is clearly influenced by the Nazis.

ABOVE RIGHT: **Hitler and storm troops honor Nazi dead.**

OPPOSITE, FROM TOP: **The massed Imperial forces recall Hitler's SS troops.**

There are other references to Germany and World War II in *Star Wars* that go beyond the costuming. Lucas called one group of Imperial soldiers the "stormtroopers"—this was also the name given Adolf Hitler's personal bodyguards. Out of this group, Hitler created the elite black-coated Schutzstaffel (protection squad), or SS. The SS became "a state within a state," taking over the police function and military and civilian intelligence and forming such feared groups as the Gestapo—the "Death's Head Battalion" in charge of the concentration camps—as well as a number of military divisions. They were all loyal to Hitler himself rather than to the party or government, and they struck terror throughout occupied Europe.

There is something of the SS in Vader, with his all-black robes and helmet and his obsessive obedience to the Emperor. As for the Emperor himself, the prologue to the novelization of the first film, *Star Wars: From the Adventures of Luke Skywalker,* tells us that Senator Palpatine was elected president of the Republic and then declared himself emperor, exterminating his opponents. This brief summary matches Hitler's story; from the leadership of the fledgling Nazi party, he got himself appointed chancellor of Germany, then vaulted into the presidency, which he turned into a dictatorship, declaring himself the "Führer," or supreme leader. Hitler then shut himself away from any real contact with the people; he was surrounded instead by his personal bodyguards, who were pledged to defend him to the death. The Emperor, too, has isolated himself, giving audience only to a few of the select, always protected by his Red Guards.

Hitler officially ended the German Republic by passing an act that gave him absolute rule. Early on in *Star Wars,* Grand Moff Tarkin informs the other officers that the Emperor has permanently dissolved the Imperial Senate and that the last remnants of the Old Republic have been swept away.

History repeats itself, according to the old adage, and these images conjure other more distant historical eras. The combination of an old republic, a senate, and an emperor mirrors ancient Rome, to cite just one example. In 48 B.C., within a traditionally republican government, Julius Caesar became temporary dictator of the Roman Empire, recognizing no other power but his own and establishing a tradition of emperors. He did not dissolve the senate, but he weakened its power considerably, and the Republic eventually faded away years later.

Even more important than the political structure, however, is the atmosphere of rigid control and dehumanization that characterizes *Star Wars'* Empire. This ambiance seems chillingly reminiscent of the fascism of Hitler's Nazi Germany.

TOP: **Imperial Royal Guards serve as the Emperor's personal bodyguards.**

BOTTOM, LEFT TO RIGHT: **Star Wars' Emperor and Germany's Hitler.**

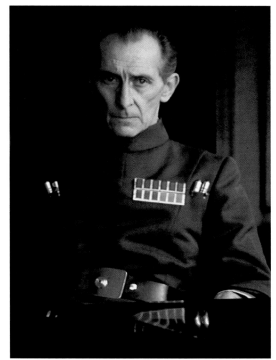

CLOCKWISE FROM ABOVE LEFT:
Rigid control characterized
Hitler's Germany,
just as it does the Empire.

Grand Moff Tarkin.

Imperial officer's uniform.

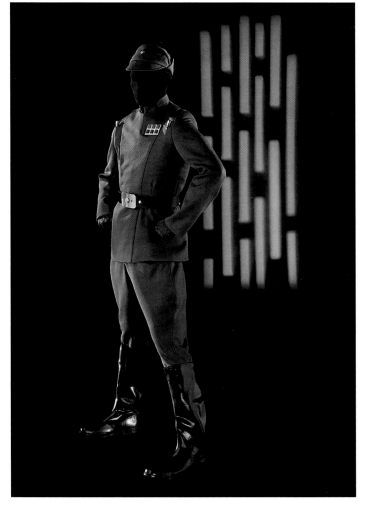

The Crises
of the Seventies

More recent historical events formed the immediate background for the *Star Wars* trilogy and contributed their own cultural flavor. The 1970s were certainly a time of crisis for the United States. The Watergate scandal and President Richard Nixon's subsequent resignation under the threat of impeachment seriously damaged Americans' faith in their government and in politicians in general. The Yom Kippur War of 1973, involving America's closest ally in the Middle East, Israel, and the Soviet-equipped armies of Egypt and Syria, suddenly exploded into a new stand-off between the superpowers.

**BELOW RIGHT:
The atom bomb
was the Cold
War's "ultimate
weapon."**

As a diplomatic strategy, National Security Adviser Henry Kissinger ordered the first nuclear alert since the Cuban missile crisis. A substantial rise in the price of OPEC oil helped send the American economy into a steep decline. In 1975, U.S. troops withdrew from South Vietnam and the Communists took over, while by 1977, the brief Cold War détente seemed increasingly fragile as the Soviets deployed their SS-20 missiles and supported Communist incursions into Angola, Mozambique, and Ethiopia.[7] For some viewers, the trilogy, with its democratic allies fighting a totalitarian power, seemed reminiscent not just of World War II but of the ongoing Cold War.

The ultimate weapon of the Empire was also similar to that which played such a prominent role in the Cold War. In

ABOVE: **Soviet missiles on parade in Moscow.**

real life this was the atom bomb, and in *Star Wars* it was the Death Star. The goals of these weapons were identical: to render the enemy incapable of making war. The threat of nuclear destruction is one of the great fears of the twentieth century; the Death Star simply follows through on that threat when it destroys the planet of Alderaan along with everything and everyone on it. Command of this weaponry can lead to domination of the galaxy. However, unlike developments in the Cold War, the Rebel Alliance does not rush out to build its own Death Star; rather, they focus on destroying the Empire's weapon.

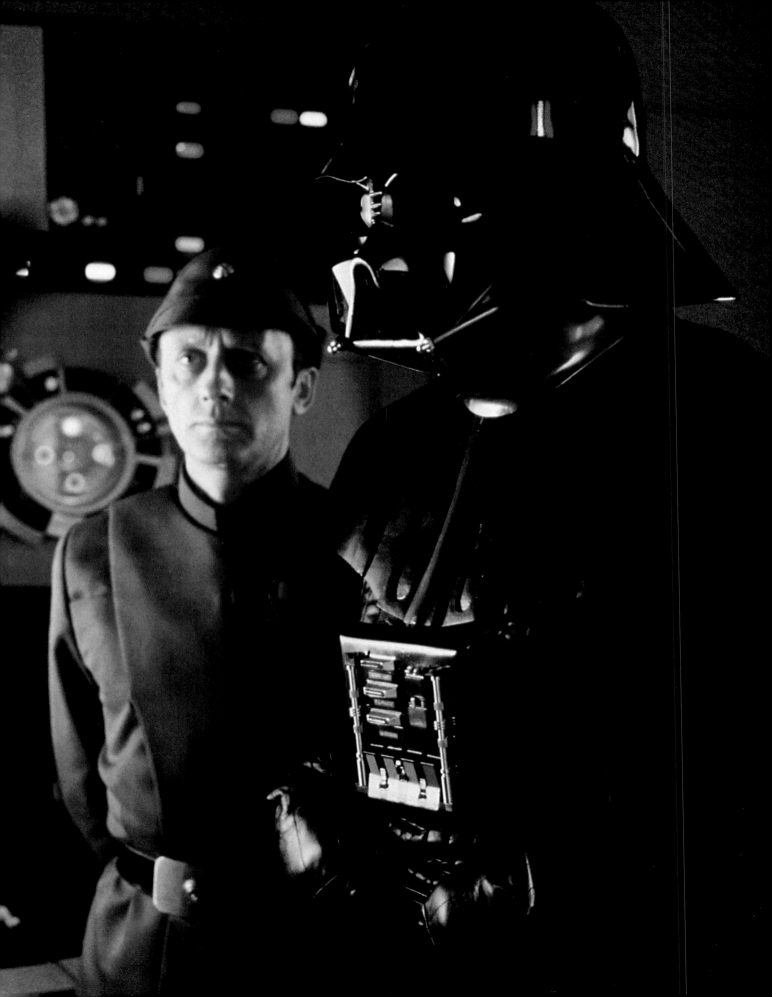

Humanity Versus the Machine

In the nineteenth century, the industrial revolution set in motion one of the great mythic conflicts of the modern era: that of "man versus the machine." Technology has alternately been idealized and demonized throughout the twentieth century. This conflict had grown particularly fierce by the 1970s and had its own impact on the nature of the evil Empire and the story of *Star Wars*.

In the 1960s, many people still believed that any problem could be solved with technology. But in 1969, as Lucas was gathering his ideas for the films, the conjunction of two events presaged the coming decade's ambivalent relationship with machines and the technocracy that controlled them. In a triumph of science and technology, humans set foot on the moon. At the same time, the Vietnam War continued to rage and President Nixon had just announced a plan to withdraw U.S. troops. In this grueling guerrilla war, high technology and advanced weaponry had not proved the victors.

In 1970, Charles Reich's *The Greening of America* expressed a growing wave of concern and dissent. "Uncontrolled technology and the destruction of [the] environment" were among the seven issues to be addressed by the "coming American revolution," according to Reich, along with "disorder, corruption, hypocrisy, war," and the "decline

OPPOSITE:
Darth Vader expects machinelike precision from Captain Piett.

of democracy and liberty."[8] In the mid-seventies, Robert Pirsig's *Zen and the Art of Motorcycle Maintenance* focused on the dilemma of how humans were to maintain their humanity in relationship to technology. Pirsig's approach to this conflict is somewhat like that of *Star Wars*, as this analysis of the book, taken from a study of the spiritualization of technology shows:

> The "reign of quantity" . . . results when technology is allowed to create not only its own rightful place but our relation to it as well. . . . Only when [the hero] reinstates the supremacy of quality over quantity, and thereby humanizes himself and technology . . . is there a path to integration and reunion. Man has regained his power of dealing with technology, and technology becomes a means of spiritual growth. Technology switches from a cruel God of fragmentation to a vehicle . . . of spiritualization.[9]

Lucas had intended, on graduation from film school, to create "isn't-it-terrible-what's-happening-to-mankind" movies.[10] And the elaborate imaginary worlds he created capture these concerns. In the technology-controlled world of *THX 1138*, for example, humans live belowground in a soulless society; each individual is just a cog in a vast machine. The lead character, THX 1138, is released from his state-required stupor of drugs and liberated through love, finally finding his way out of the maze. In many ways this world is reflected in the totalitarian Empire of the *Star Wars* films: a spirit-numbing, mechanistic social order with a subjugated citizenry whose individuals are ciphers while the machine is master. The android police of *THX 1138* anticipate the droids and stormtroopers of *Star Wars*. But *Star Wars* takes this mechanized civilization one step further, giving it a military objective.

In a dystopia, the Western belief in progress through technological development has gone terribly wrong. An overly rationalistic ordering of society has developed alongside technological progress, creating an evil empire where the expression of humanity is repressed. The dystopia is a uniquely twentieth-century construct, but it has its roots in the ancient concept of a utopia: an ideal commonwealth whose inhabitants exist under perfect conditions and which is held up as a model for civilization to follow even if the idealized state may actually be unobtainable. If a utopia is an imaginary dream world, then a dystopia is its nightmare.

By the middle of the nineteenth century, developments in science and technology were rapidly changing the world. Technology was developing so quickly that its influence on the human condition could be perceived in a single generation, and fiction often looked forward to what was to come.

ABOVE: **A devastated rain forest, symbol of technology gone wrong.**

The individual must submit to a soulless society in <u>THX 1138</u>.

RIGHT: Hitler's Nazi totalitarian regime imposed a rigid order on individuals.

BELOW: The Justice Tarot card symbolizes the Rebels' goal.

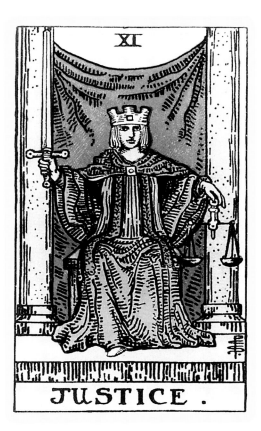

Such imaginings were vital to the growing belief in progress through technology. In these visions of an ideal future, almost all human functions would be taken over by machine, and scientific principles, which had solved so many problems, would be applied to social order and politics. The dark side of this bright progressive future, glimpsed by critics early on, was that humans would become mere servants to their technology and, worse, that in the quest for precision, order, and efficiency, they would be forced to become machine-like themselves.

In striving for utopian order, *Star Wars'* Empire does indeed want to turn people into machines. The stormtroopers are pawns, not people, and Vader eliminates without compunction any subordinates who fail to "function" properly. With intended irony, the Imperials are humans acting like machines, while Artoo-Detoo and See-Threepio are machines displaying such human traits as loyalty, concern, pride, and joy. Vader himself is made up partly of prosthetics, a symbol of how his spirit has been consumed by the Imperial machine. Yet Vader knows that machines aren't everything; early on he reminds the Imperial officers, "Don't be too proud of this technological terror."

Power abuse is a common theme in dystopian fiction. Scientific rationalism believes in order, but when taken to its extreme, it can only be achieved by a totalitarian state. When Vader tells Luke that "with our combined strength we can end this destructive conflict and bring order to the galaxy," he is not referring to the restoration of any kind of natural order but to the totalitarian order that the Empire espouses. Most evil empires in dystopian fiction give in to the temptation to abuse power in order to bring erratic humanity into an orderly structure; the hero is the one who can resist power's allure. He or she must fight against seemingly superior forces using only his or her innate strength, and the greatest

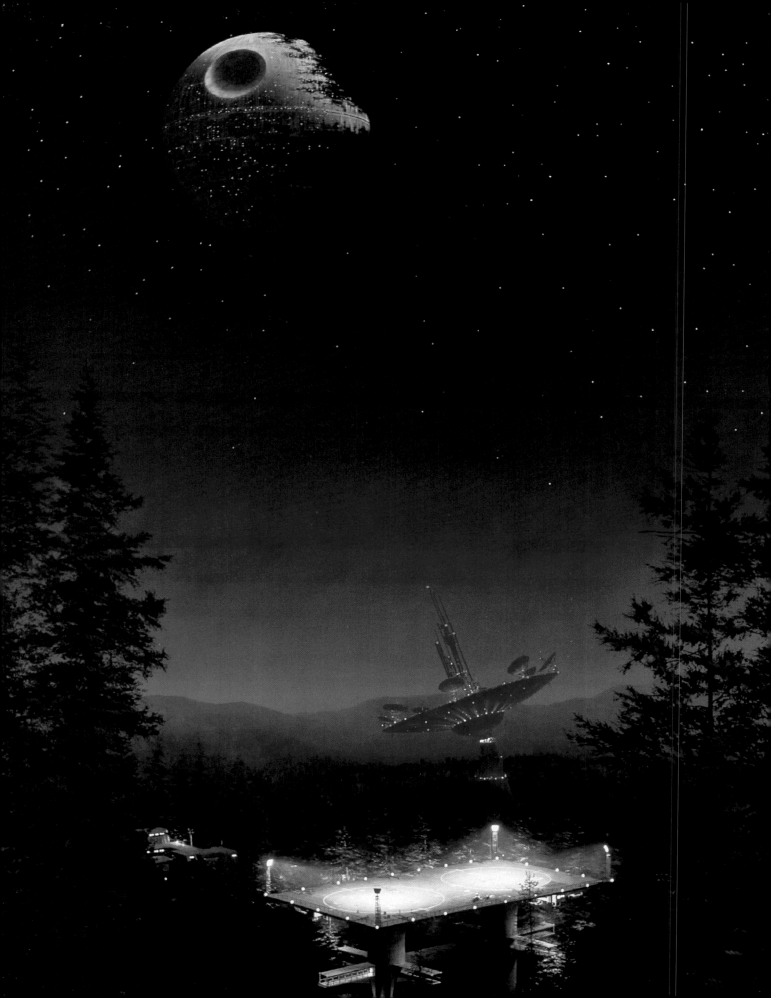

difficulty lies in distinguishing the right fight from the wrong fight. Both the Nazi regime and the Empire are examples of excessive force and violence applied to the wrong ends, ending in a loss of individual accountability and a mass psychosis. When an authority figure promotes a regime that becomes repressive and self-serving, then its overthrow requires new heroes—radicals and revolutionaries like those of the Rebel Alliance.

In a dystopia, the hero lives inside the evil empire and must find a way out, revolting against the status quo. Thus the dystopian story focuses on the individual who can recognize the spiritual and emotional emptiness of the current order. He or she may physically enter the wilderness outside the technologically controlled world in order to discover there the dark, irrational self—the human animal inside the social machine. The hero can then assert his individualism instead of becoming a servant to the machine. As Luke demonstrates at the end of the trilogy, the hero is the one who is able to resist the lure of "the system." Vader, on the other hand, is "a bureaucrat," as Joseph Campbell points out, "living not in terms of himself but in terms of an imposed system. This is the threat to our lives that we all face today. . . . How do you relate to the system so that you are not compulsively serving it?" And Campbell provides an answer: "By holding to your own ideals for yourself and, like Luke Skywalker, rejecting the system's impersonal claims upon you."[11]

Technology is an extension of humanity's power to control and manipulate itself and the world; in a dystopia humans use it as a malevolent instrument, to pervert the natural order of human life and subvert our highest longings and values.[12] Vader subverts the life-supporting qualities of the Force in order to ensure Imperial domination; he even

OPPOSITE: **The Death Star hangs over the landing platform on Endor.**

Matte painting by Chris Evans.

ABOVE: **Interrogator Droid.**

RIGHT: **Leia and Interrogator Droid.**

Concept sketch by Ralph McQuarrie.

turns against his best friend and teacher, Ben, eventually murdering him. [13] But the Death Star is the ultimate killing machine; it logically, if horribly, removes that which does not fit into the Empire's plan for complete obedience.

Buildings often reflect the principles that inform a society. The biggest human-made thing in the Empire is not a church or temple, court or administrative building, or even a place of commerce but a weapon. It is virtually empty of furniture, and relatively few people populate its vastness. The spirit of the Empire is hollow. When asked how the Emperor plans to maintain control without the bureaucracy, Tarkin replies, "Fear will keep the local systems in line."

In the early days of humanity, the hero fought hand to hand with prey, monster, or human foe. In 1430 the creation of the first cast-iron gun began to place the combatants at a distance. The magic weapon of the hero quest was superseded by the supernatural potency of technology. In T. H. White's *The Once and Future King*, King Arthur's ideals are doomed by Mordred's introduction of the cannon into battle. Honor is quickly lost in a battle of machines. In the crafting of Luke's victory over the Death Star, Lucas brought back the human-based powers of the hero; it is Luke, not his machine, who defeats the terror.

Twentieth-century myths are obliged to incorporate the machine; as Joseph Campbell states, "*Star Wars* has a valid mythological perspective. It shows the state as a machine and asks, 'Is the machine going to crush humanity or serve humanity?' Humanity comes not from the machine but from the heart." [14] Still, technology has its bright and dark sides; after all, the Rebel Alliance uses technology too, but in the service of life, not death.

This leads us to one of the great dilemmas that the *Star Wars* heroes face; indeed, throughout mythology this is a core problem of the hero quest. The Death Star has destroyed the entire planet of Alderaan and millions of innocent people. It has to be destroyed in order to save other worlds from suffering the same fate. But it is difficult to use the amount of strength and fury needed to master the terror without turning to evil oneself. Luke must destroy the Death Star, including the people in it, in order to protect and preserve the galaxy, but he must do so without turning the hero's passion for the kill into the pathological excesses shown by the Empire. When Luke turns off his targeting computer near the end of the climactic battle in *Star Wars*, he becomes the hero who values autonomy, not authority. Now he is very much involved in flesh-and-blood values, using machines yet retaining his individual integrity.

Perhaps Ellen Goodman summed it up best when she wrote her 1977 review of *Star Wars*:

Allied bombing over Vienna, March 22, 1945.

It's not just about bad guys and good guys, but about bad technology and good technology. The good guys are on the side of truth, beauty and the cosmic force, but they aren't opposed to machines. Nor do they fight missiles with stones. The real battle is between one technological society that supports a Lone Rider and praises his instinct, and a technological society that overrules individuals and suppresses instinct. . . .

Star Wars played out our own Good News and Bad News feelings about technology. We want a computer age with room for feelings. We want machines, but not the kind that run us. We want technology, but we want to be in charge of it. . . . There's no way to drop out of technology as if it were school. . . . There is our young hero in his one-man space ship, pitted against a battle station the size of the moon. He is flying his handy-dandy machine right down the narrow slot to drop-shot a bomb. . . . As he comes careering in, chased by The Bad Guy, he turns off his computer bombsight (but not his engine) and takes aim by "instinct". . . . [The] audience applauds—for the man and his instinct, in the saddle, riding technology into the sunset. The good technocrats win the day. [15]

BELOW: **The monstrous Death Star reflects the Empire's corrupted values.**

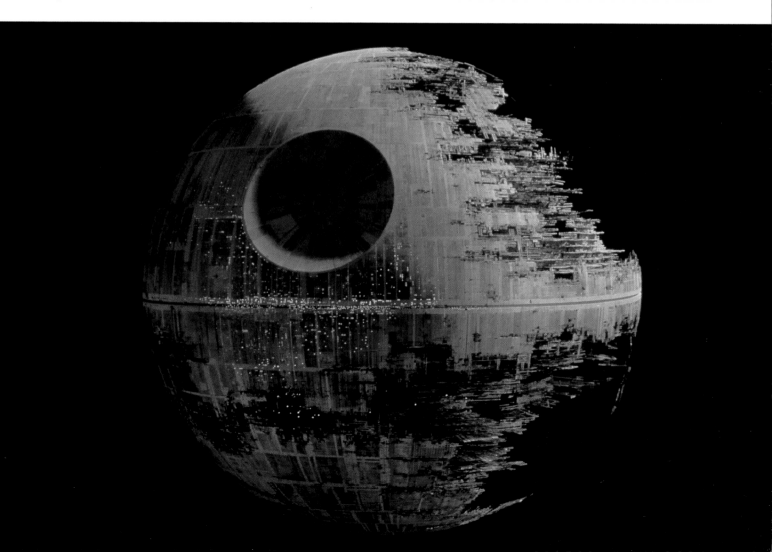

The Feminine Hero

Leia, as heroine, deserves special mention as we look at the cultural and historical roots of *Star Wars'* mythic elements. During the twenties and thirties, the "woman's film" became a genre of its own, reflecting some of the dramatic changes going on in women's lives at that time. These melodramas dealt with women's struggles with love, family, and career. Women had begun to enter the workforce in growing numbers after World War I, and in 1920 the Nineteenth Amendment granted women the right to vote.

These huge changes were reflected in new styles of dress and new attitudes toward life. This trend continued throughout the World War II years, as professional women were pushed to the fore when men left for active duty; the movie serials of the 1940s captured this evolution in women's roles. But Leia's predecessors faltered in the years after World War II, as women left their wartime jobs to return home. In many films, the professional woman reverted to a helpless nuisance.

The repressive "Feminist Mystique" era of the late forties and fifties coincided with the onslaught of alien-invasion, high-anxiety science fiction. With the exception of a few films, such as *The Day the Earth Stood Still,* women in this genre served mostly as something the hero needed to fight for or protect, or as a reward for his efforts. Finally, in the sixties, such television shows as *Lost in Space* and *Star Trek* brought women back to starflight.

Many consider 1970 to be the year that the women's liberation movement really took off in the United States, highlighted by the women's strike marking the fiftieth anniversary of the passage of the Nineteenth Amendment. In 1972 the Senate passed the Equal Rights Amendment, and the following year the Supreme Court decision in *Roe vs. Wade* gave women the right to choose on the issue of abortion. Between 1965 and 1975 about ten million women entered the

ABOVE RIGHT: Rebel leader Mon Mothma.

FROM TOP: **Leia was ahead of her time as a female hero in space.**

Lieutenant Colleen Nevius joined the ranks of groundbreaking women in military aviation.

workforce (compared to only seven million men), and by 1975 nearly half of all American women held jobs outside the home. Leia, with her take-charge attitude and gutsy, no-nonsense values, her focus on her career, and her fear of rushing into a romantic commitment, was a most appropriate heroine for her time.

Leia was also ahead of her time as a female holding a top position in the Rebel Alliance. There were no women of equal rank at that time in real-life military aviation. Women had made important gains in aviation careers before World War II, but after the war those gains almost seemed to disappear. With the seventies' emphasis on equal rights, a succession of "female firsts" occurred, as women became airline and military pilots, engineers, and corporate executives. From 1972 to 1979, the number of women in aviation increased by 50 percent, and they were often in the news. Flight attendants worked to shed old stereotypes, while the role of women in the military was debated in Congress and throughout the Department of Defense.

In the late 1950s, a number of women pilots had passed some of the grueling physical and psychological tests set up to help select U.S. astronauts. NASA, however, decided that astronaut candidates needed to have experience as jet test pilots. Since testing jets was primarily a military function and since women were not yet allowed to fly for the military, this decision effectively ruled out the possibility of female astronauts in the United States. Thus, Valentina Tereshkova of the Soviet Union became the first woman in space in 1963. Years before the first real-life U.S. women astronauts, it was up to Leia to reinvent the female hero in space.

Chapter Three

"*The* MILLENNIUM FALCON *was meant to be a well-worn, well-used relic, a bit out of date, lacking in the newest technology. It gave me, as the character who owned and inhabited it, a real base, a concrete reality. The first question I had for the production designer and George was 'How do you fly this thing?' and everybody went 'Uh, you just flip the switches.' That was a bit of fun—figuring out how to make it seem as though there was a protocol.*"

HARRISON FORD

The look
of STAR WARS
—its costumes, props, and sets—reflects the same eclectic mix of cultural, historical, and mythical sources that gives the story its rich texture. Working with concept artist Ralph McQuarrie, visual effects art director Joe Johnston, and costume designers John Mollo, Nilo Rodis-Jamero, and Aggie Guerard Rodgers, as well as a team of other artists and craftspeople, George Lucas created a universe that has the look and feel of myth. This chapter examines in detail how the unique visual style of STAR WARS came to be.

The Feel of the Past

To ensure that *Star Wars* had the look and feel of "a long time ago," Lucas asked production crews to rub dirt on the shiny new hardware and sets so that they would have a used, lived-in look. He also placed the action in ancient temples, such as the Rebel headquarters at the close of the first film. The uniforms and weapons, as we will see, were often based on those from some past era. For example, when John Mollo needed to create a rough mock-up for Darth Vader from the costume stock on hand at a costume warehouse in England, he grabbed a German helmet from the "military room," a plague mask from the "medieval room," and monk's robes from the "religious room."[1]

THIS PAGE: **Collar of charges nicknamed "the twelve Apostles" and a pair of electrobinoculars.**

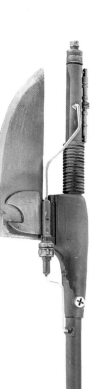

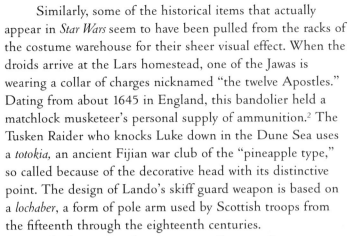

COUNTERCLOCKWISE FROM LEFT:

Lando's skiff guard weapon, based on the lochaber pole arm.

Totokia, an ancient Fijian war club.

Lochaber pole arms used by medieval Scottish troops.

Tusken Raider with gaderffii.

Similarly, some of the historical items that actually appear in *Star Wars* seem to have been pulled from the racks of the costume warehouse for their sheer visual effect. When the droids arrive at the Lars homestead, one of the Jawas is wearing a collar of charges nicknamed "the twelve Apostles." Dating from about 1645 in England, this bandolier held a matchlock musketeer's personal supply of ammunition.[2] The Tusken Raider who knocks Luke down in the Dune Sea uses a *totokia*, an ancient Fijian war club of the "pineapple type," so called because of the decorative head with its distinctive point. The design of Lando's skiff guard weapon is based on a *lochaber*, a form of pole arm used by Scottish troops from the fifteenth through the eighteenth centuries.

Whether or not the viewer actually recognizes any of these specific items, these elements combine to create a subconscious sense of a time long past.

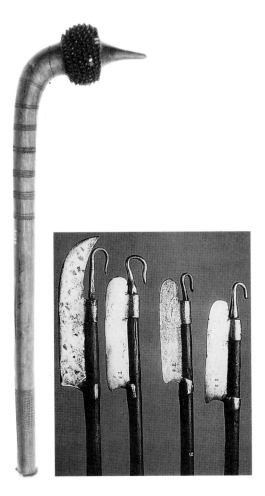

Military Costumes, Weapons, and Aviation

Needless to say, for a film trilogy with the word *war* in its title, a great deal of attention went into the creation of all the military paraphernalia. Many basic costumes, for example, were made to look more military by the addition of bandoliers, crossed belts worn over the shoulders to carry cartridges or small pouches. These accessories also gave them a romantic, frontier-America look. Parts of the Hoth costumes also suggest the frontier: the boots are similar to the mukluk worn by the Eskimo, and the shirt was based on the American frontier hunting smock.[3]

RIGHT: **Luke's boots on Hoth resemble the Eskimo's mukluks.**

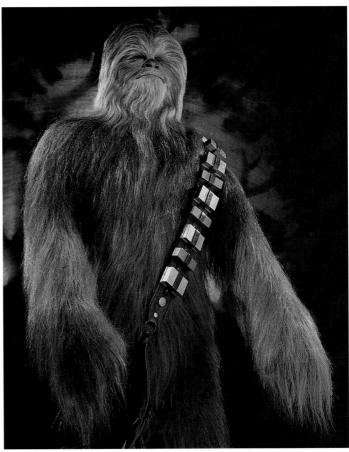

ABOVE: **Concept drawings for Imperial and Rebel helmets** by Ralph McQuarrie.

ABOVE RIGHT: **Chewie's shoulder-slung pouch is similar to the Dyer pouch from 1870.**

NEXT PAGE: **On Hoth, the Rebels use the Vickers-based tripod blaster.**

Chewie carries a pouch slung across one shoulder that is similar to the Dyer pouch developed in 1870, a combination carbine sling and cartridge pouch. But his actual weapon dates to a much earlier era, for it is based on a medieval crossbow. Luke's rifle with its extra-long barrel and crooked stock, evokes the Arab *jezail.*

Other *Star Wars* weapons were created by decorating real-life firearms with various devices to make them look futuristic. Perhaps the most notable is the blaster used by Han and carried by Luke as a sidearm on Hoth. It is a "broom-handled" 7.63-caliber Mauser; one of the earliest and most successful of all automatic pistol designs, it was used in both world wars. The prop department simply added a fancy-looking scope and an emitter nozzle at the end of the barrel. The tripod blaster is based on the 1908 Vickers Maxim Class C machine gun. This was used by both the British and Germans in World War I trench warfare. Similarly, the tripod blaster is used by both the Rebels (on Hoth) and the Empire (at Mos Eisley).

There are three main kinds of *Star Wars* blasters. One is a variation on a German MG-34 machine gun from the 1930s, with the shoulder stock removed at one end and the barrel shortened at the other. Another is the MG-42, which

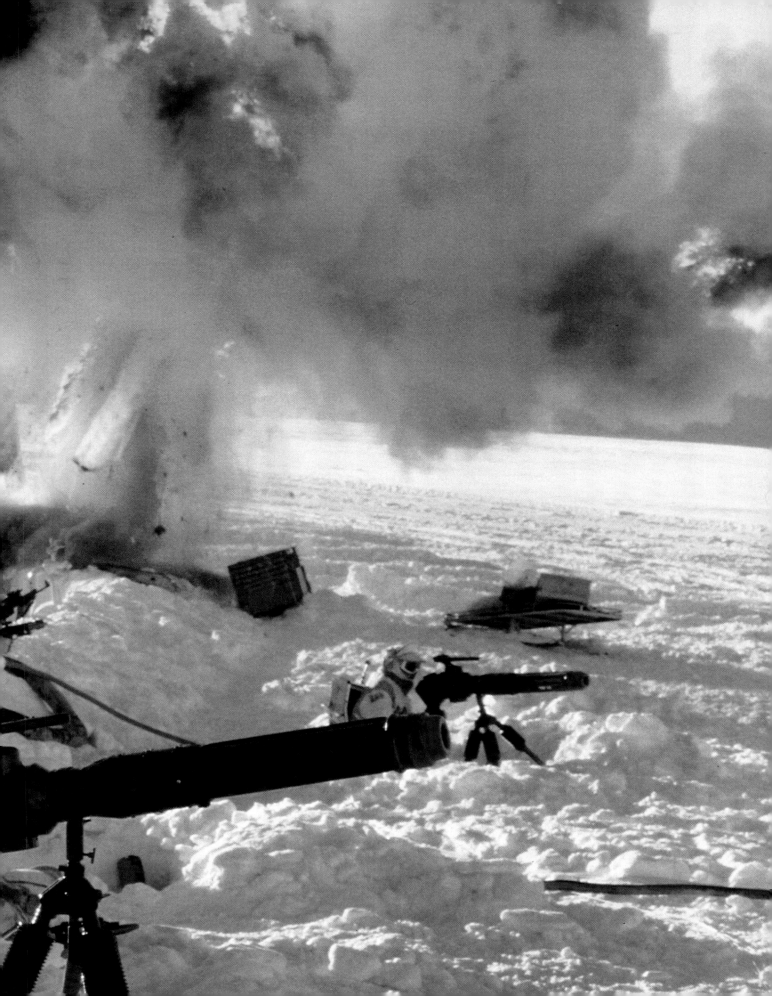

ABOVE:
"Broom-handled"
Mauser.

RIGHT: Blaster pistol.

ABOVE: Sterling
submachine gun.

RIGHT: Blaster rifle.

was mass-produced in Germany during World War II. The third is the British Sterling Mk 4 used in the 1950s, a submachine gun with an air-cooled barrel; vents, sights, and scopes were added.

World War I is again called to mind as the Rebels hunker down into the trenches in preparation for the Imperial onslaught on their base on Hoth. Here the Rebels look much like troops in World War I France preparing for a tank offensive. This suggestion is underscored by the presence of the Vickers-based tripod blaster, for the Vickers was used extensively in trench warfare. The gun turret glimpsed above the trench derives from the rotating turret of the British Saladin armored car of the 1950s, with its 76-millimeter gun.

Appropriately enough for a fantasy with flight at its heart, many of the images and events are based on the history of military aviation. Imperial TIE fighters and Rebel A, B, X-, and Y-wing fighters are designed to destroy enemy aircraft in the air and to protect bomber aircraft. The long nose and missile-tipped wings of the X-wing bear an uncanny resemblance to the formidable modern-day F-16 fighter aircraft. In *The Empire Strikes Back*, the Empire also has TIE bombers, which it uses to try to force the *Millennium Falcon* out of the asteroid field. In *Return of the Jedi* the Empire finally gets interceptors—short-range, high-acceleration craft used for point defense—in order to protect the Death Star from attack by the Rebels' X-wings.

The *Falcon* has elements of both fighter and bomber aircraft. Its armament is reminiscent of the 50-caliber

TOP TO BOTTOM: Trench warfare: the Rebels on Hoth (note the gun turret) and the British in World War I.

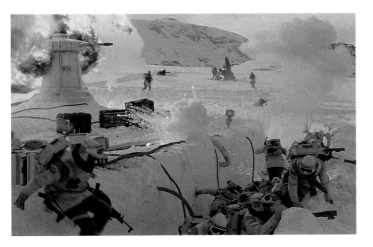

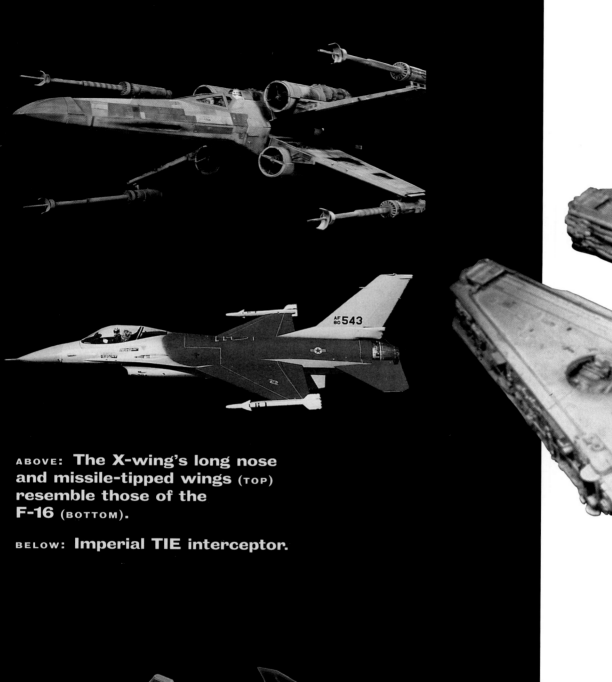

ABOVE: **The X-wing's long nose and missile-tipped wings** (TOP) **resemble those of the F-16** (BOTTOM).

BELOW: **Imperial TIE interceptor.**

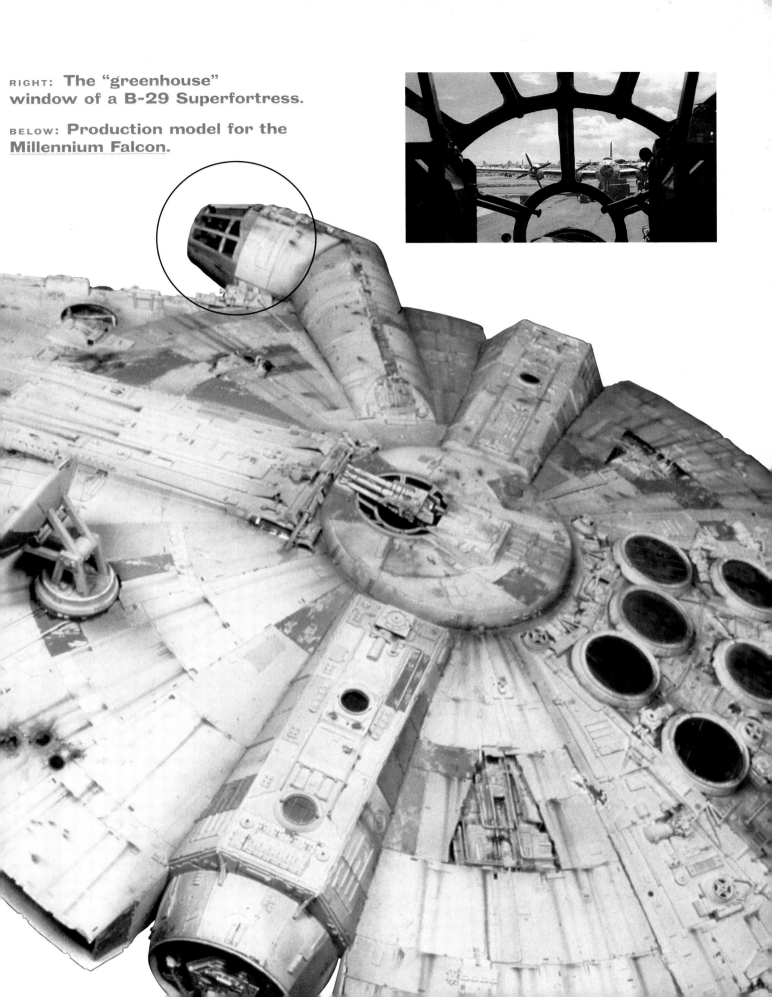

RIGHT: **The "greenhouse" window of a B-29 Superfortress.**

BELOW: **Production model for the Millennium Falcon.**

machine guns mounted in the waist of the Boeing B-17 Flying Fortress, used in the World War II European theater. The cockpit of the *Falcon* features a "greenhouse" (a large bulging window) that is very similar to those used on the Boeing B-29 Superfortress, flown in the Pacific during World War II.

For the aerial combat scenes in *Star Wars: A New Hope,* Lucas and visual effects supervisor John Dykstra spliced together a video montage of aviation combat, and used this as a reference for the action sequences.

As Vader flies in pursuit of the Rebel fighters, he is continually adjusting certain knobs on a control panel. This panel is based on the automatic computing sights developed toward the end of World War II. Previously, an operator had to put his face down into the sight to line up the target correctly. Now, the operator could simply look into the optical reflector. But accurate targeting still required a certain amount of knob turning in order to set the target dimension

RIGHT: **B-17 waist gunner.**

BELOW: **Han at the guns of the <u>Millennium Falcon</u>.**

OPPOSITE, CLOCKWISE FROM UPPER RIGHT:
Rebel troops down an AT-AT.
Storyboard by Nilo Rodis-Jamero and Joe Johnston.

<u>Douglas AD-4 Skyraider</u>,
R. G. Smith.

A P-47 Thunderbolt attacks a Nazi ammunition truck.

A TIE fighter races out of a fireball.
Storyboard by Gary Myers, Paul Huston, Steve Gawley, Ronnie Shepard under direction of Joe Johnston.

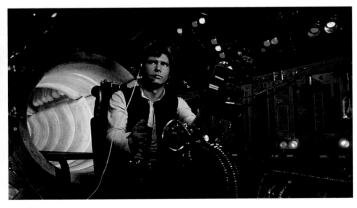

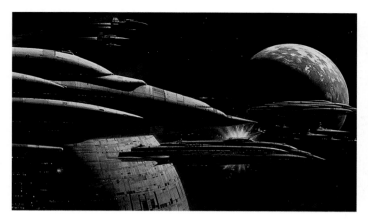

and range control and to track the target.

In another carryover from previous aviation films, the Rebels attack in combat formation, with each squadron assigned a color code name. Each craft in the squadron has an individual number; thus Luke is "Red Five" while Wedge is "Red Two." And in *Return of the Jedi,* Lando becomes the "Gold Leader" on the *Millennium Falcon.*

Star Wars costume elements were also inspired by combat flying uniforms. Around one knee, the Rebel pilots have strapped a belt of flare pistol cartridges, like that worn by the Luftwaffe during World War II. While the boots worn on Hoth are Eskimo-like mukluks, pilots also wore them; they were developed into a moccasin-type flying boot during World War I. The head gear for the Rebel foot soldier is based on the British AN-H-15 summer flying helmet. Before World War I, pilots had used football helmets as protective head coverings. Later, earphones were added for radio communication, and the AN-H-15 was standardized in 1943. The belt for the foot soldier's costume is also British standard issue; its compartments are multiple magazines for the ammunition for a 1902 Enfield 303 rifle.

From a film of Japanese World War II pilots that Lucas showed John Mollo, the Imperial TIE fighter pilots were given helmets that suggest those of the Japanese flyers.[4] The helmet crown was made from the same mold as that of the X-wing pilot, but it was expanded along a spline to make it even bigger. The face was a modified version of the stormtrooper mask, with new details added on the forehead and earpieces.

At Lucas' request, Ralph McQuarrie created "spooky white space armor" for the stormtroopers. A twentieth-century touch is the small canister clipped to the back of the belt; during World War II, troopers wore a similar canister clipped to their backpacks or slung across the lower back as part of their gas-mask equipment. But its use in *Star Wars* differs; Mollo took McQuarrie's designs and figured out how the pieces could fit together based on his knowledge of medieval armor.

CLOCKWISE FROM TOP LEFT: Rebel cruisers in formation attacking the Death Star.
Production painting by Ralph McQuarrie.

Formation for strategic bombing from World War II.

AN-H-15 summer flying helmet.

Rebel foot soldier with helmet.
Costume design by Nilo Rodis-Jamero and Aggie Guerard Rodgers.

OPPOSITE: Imperial TIE fighter pilot.

PILOT Wm. C. HOPSON
U.S. MAIL SERVICE
WINTER FLYING CLOTHING

LEFT: "Wild Bill" Hopson delivered U.S. air mail in the early days of aviation.

OPPOSITE, COUNTER-CLOCKWISE FROM UPPER RIGHT: Luke in the Rebel pilot's orange jumpsuit.

Pilot Calvin Larsen in the U.S. Navy's orange jumpsuit.

Rebel pilot uniform.

Rebel pilot helmet.

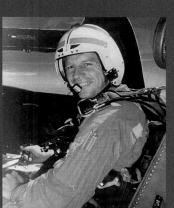

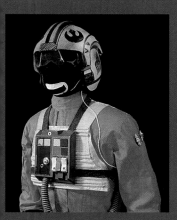

RIGHT: The Rebel docking bay on the Headquarters Frigate.
Matte painting by Michael Pangrazio.

BELOW LEFT: P-4OF fighters on the hangar deck of the USS <u>Chenango</u>.

BELOW RIGHT: Luke and other pilots scramble as Hoth is attacked.

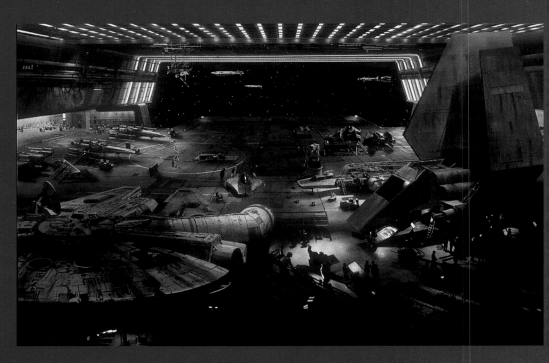

LEFT: Aircraft carriers in World War II.

ABOVE: Flight deck crew in the Gulf of Tonkin, 1972.

BELOW: **Crewman in the combat information center of a U.S. destroyer, Vietnam.**

Leia and See-Threepio in the war room on Yavin IV.

The image of the tough, rough-and-ready pilot from the early days of aviation arrives in the *Star Wars* universe almost unchanged. Perhaps in a throwback to Lucas' racing days, though, racing coveralls form the basis of several flight uniforms. The basic jumpsuits for the Rebel pilots, TIE fighters, and for Vader himself are all off-the-rack racewear.

The Rebel pilots' orange jumpsuits are also reminiscent of the "international orange" flying suits used by the U.S. Navy from 1957 to 1969. In addition, the Rebel pilots wear a configuration of webbed straps that is part of a parachute rig in real life.

Naval analogies are often found in science fiction space flight. In *Star Wars,* the Rebel cruisers and Imperial Star Destroyers operate much like aircraft carriers. Even the docking bays at the Hoth base look like those on an aircraft carrier. And the Star Destroyers themselves actually resemble aircraft carriers in their design, with their V-shaped front profile and prominent island. The geodesic deflector-shield domes and communications tower are reminiscent of an aircraft carrier's electronic array.

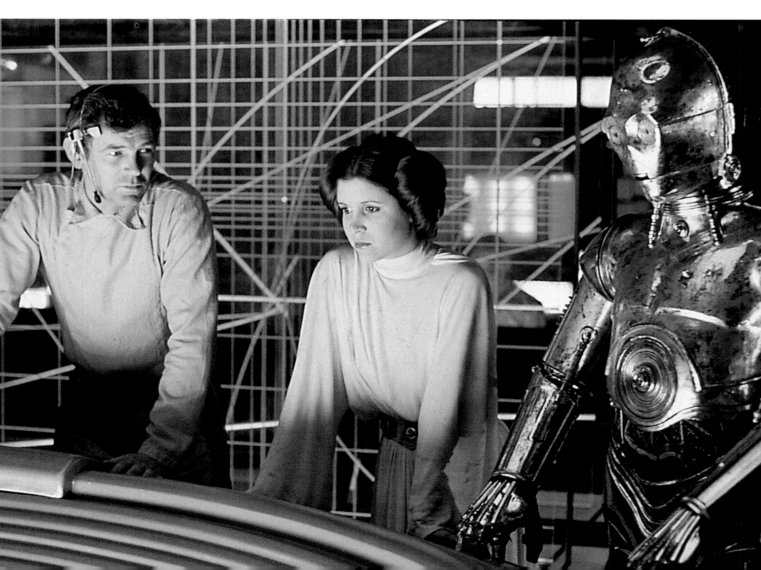

Touches of Art Deco

Not all of the imagery in *Star Wars* comes from the military, however. Several prominent visual elements derive from the 1920s and 1930s, when pulp science fiction ruled and Art Deco was in style. Chewbacca was inspired by a 1930s illustration in a science fiction magazine of a large, hairy alien. Unlike Chewie, however, that creature had six breasts—three on each side of its body. See-Threepio was inspired by the feminine-looking robot from *Metropolis*, Fritz Lang's 1926 silent film classic. Lucas wanted a droid with the almost-human feeling of Lang's robot; Ralph McQuarrie's design is definitely male and more elegant than its decorative Art Deco inspiration.

Cloud City, designed for a set for the first film but not used until *The Empire Strikes Back*, drew heavily on the Art Deco style. Here, Lucas had shown McQuarrie pictures of streamlined cities from the *Flash Gordon* comic strips of the 1930s for inspiration.[5]

THAT NIGHT---LUCO, THE FARMER, DRIVES HIS FRIENDS, WHO ARE DISGUISED AS PEASANTS, TO MINGO----

ABOVE: **The city of Mingo from Flash Gordon was an inspiration for Cloud City.**

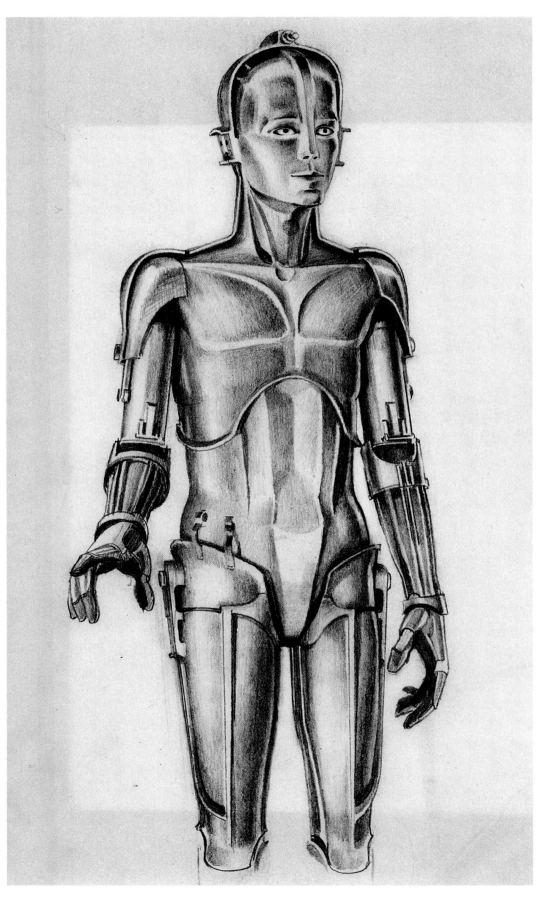

CLOCKWISE FROM LEFT:
**Concept drawing
for See-Threepio**
by Ralph McQuarrie.

**Rothwang's robot
from <u>Metropolis</u>.**

**In his final form,
See-Threepio has
become more
clearly masculine.**

Hitler's Germany

As with other aspects of the Empire, its visual trappings recall Hitler's Germany. Lucas had told costume designer and military historian John Mollo that he particularly wanted the "baddies" to look Fascist.[6] In addition, the Imperial officers wear the tunic, riding pants, and boots of the nineteenth-century German *ulans,* a division of mounted lancers. The lines of the *ulanka,* or uniform tunic, became the costume of the Imperials, without the decorative braid and buttons. The ulanka was current up through World War I; in fact, it was the costume of the famous German flying ace, the Red Baron, since he was with the cavalry prior to becoming a pilot. Finally, the Imperial officer's hat is the same field cap worn by German, Austrian, and some Italian Alpine troopers, with a milled-metal disk replacing the rosette.

ABOVE: **Costumes for Imperial officers borrow from the look of these Bavarian Chevaulagers, 1915.**

LEFT: **Flying ace Baron Manfred von Richthofen, the "Red Baron," wears the same uniform tunic.**

Far Eastern Influences

Lucas expressed his interest in feudal Japan to artist Ralph McQuarrie when he asked him to come up with the first renderings of the *Star Wars* look and even offered images of samurai warriors for inspiration.[7] Many of McQuarrie's drawings and paintings, especially for costumes, show this influence. Both McQuarrie and Mollo wanted the Jedi to have a medieval European look, and the hooded robe that Ben, Luke, and the Emperor wear is derived from a monk's garb in order to highlight the Jedi spiritual association. The under robes for the costumes of both Ben and the Emperor are elegant Japanese kimonos of raw silk, beige for Ben and

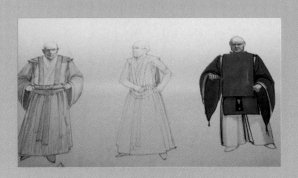

ABOVE: **The Jedi costume was inspired by Japanese clothing.**
Painting by Bunka Ku, Edo Period.

LEFT: **Obi-Wan Kenobi.**
Concept drawing by Ralph McQuarrie.

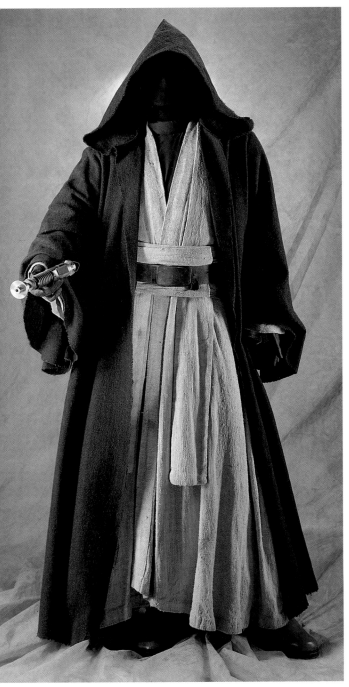

ABOVE: **Ben Kenobi's underrobe is a Japanese-style kimono.**

ABOVE RIGHT:
Portrait of an Old Man,
Kuniyoshi, c. 1850.

RIGHT: **Yoda, who has the characteristics of a Taoist sage, also wears Eastern robes.**

6

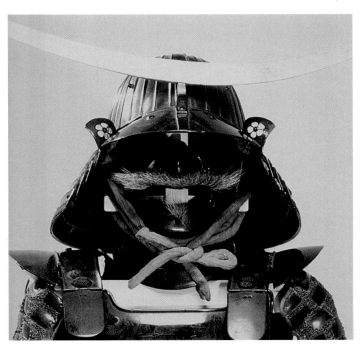

black for the Emperor. Ben, Joseph Campbell pointed out, not only has a Japanese-sounding name, Obi-Wan Kenobi, but also the look and demeanor of the Japanese sword master, a venerable teacher of the art and spirituality of swordplay.[8] Yoda's robes duplicate Ben's, while Luke's original Tatooine jacket is a short kimono; this kimono appears again in black as part of Luke's "basic Jedi" costume.

Lucas told McQuarrie that he wanted Darth Vader to look like "a dark lord riding on the wind" with black flowing robes, a large helmet like that of the Japanese samurai, and a silk mask covering his face. McQuarrie came up with a breath mask, since the dark lord was, after all, living in space, and Lucas accepted this modification. Vader's mask and helmet evoke the armor of the Japanese feudal period: the *kabuto,* or helmet, had many different designs, but most featured a bowl-like crown that flared out at the back of the neck, often in overlapping metal plates. Vader's one-piece helmet follows this same basic shape. Samurai warriors of the upper ranks usually wore a *mempo*—a mask of iron, steel, or lacquered leather to protect the face. These face masks were often molded into the visage of a demon, ghost, or animal to make them more fearsome. Vader's threatening mask, like that of the TIE fighter pilot, certainly has the same effect.

There are other Far Eastern influences besides those of feudal Japan. Costume designer John Mollo wanted to give Bespin a flavor of India, for example, so Leia's silk garments in these sequences are a nutmeg brown, and the lining of Lando's cape echoes this color in a Chinese brocade that features small dragons.

OPPOSITE AND ABOVE: Darth Vader's mask and helmet resemble the mempo mask and Kabuto helmet from the Japanese feudal period.

BELOW, FROM LEFT TO RIGHT:
Lando's Bespin robes.

Leia's Bespin gown.

Detail of Leia's gown.

Luke's Transformations

Even Luke's clothing reflects his transformations as he treads the hero's path. He changes from an uninitiated farm boy in white, to a "hot" pilot in bright orange, to a cool, calm Rebel commander in khaki. When he steps out of the mist at the beginning of *Return of the Jedi,* he has become a mysterious cloaked figure like his father. While his costume bears some resemblance to the boots, pants, and kimono jacket of his original Tatooine garb, they are now all in black. Perhaps they symbolize his growing acceptance of his shadow side and of Vader as his father.

THIS PAGE, FROM TOP: **Luke as the uninitiated farm boy...**

and as a Rebel commander.

FROM TOP: **Luke as a pilot on Hoth…**
and Luke's costume as a Jedi.

Mythic Settings

Several ideas were considered for the location of the Emperor's chambers. One had a distinctly hellish aspect: it was set in an underground cave within a lava lake and would have underscored the fact that Luke is essentially trying to bring his father back from the dead—that is, to rescue Anakin from his imprisonment within Vader. This setting was eventually transferred to a different underworld space: the interior of the Death Star.

Another idea for the Emperor's chambers consisted of a city of pyramids, which are associated with the tombs of ancient Egyptian pharaohs. Yet a third thought was a cathedral-like structure; cathedrals, too, can be the final resting place of the royal or the famous. What all these early ideas show is that the place of the final encounter between Luke and his father is sacred, even though it is an abode of evil. The word *sacred* comes from the Latin word for holy, which is in turn derived from the Sanskrit verb meaning "to be potent or full of power."

Finally, it is no accident that the concluding sequences of the trilogy contrast the lush green environment of the Ewoks with the cold unfinished technological tomb of the Death Star. The Imperial weapon floats like a skull above the Endor forest, just as death is constantly hovering over life. The Emperor calls Endor the "Sanctuary Moon," and so it is—a refuge and nature's consecrated ground.

ABOVE: The Great Pyramid and Sphinx.

ABOVE: **The Imperial palace and other pyramids on Coruscant.**
Painting by Ralph McQuarrie.

Conclusion

Furthermore, we have not even to risk the adventure alone,

for the heroes of all time have gone before us;

the labyrinth is thoroughly known; we have only to follow

the thread of the hero path.

And where we had thought to find an abomination,

we shall find a god; and where we had thought to slay another,

we shall slay ourselves; where we had thought to travel outward,

we shall come to the center of our own existence;

where we had thought to be alone, we shall be with all the world.

JOSEPH CAMPBELL, *The Hero with a Thousand Faces*

Myth is a sacred

story, and the word SACRED means "to be full of power." The original STAR WARS trilogy appeared at a time when 95 percent of Americans said that they believed in God, but only 43 percent attended religious services.[1] It is no wonder that these movies with their stories of rebirth and redemption and conquest of good over evil took on the power of myth. Values that had seemed lost to society were given new life in STAR WARS: chivalry, heroism, nobility, and valor. Luke's character, in particular, reflects the traditions of heroism from the past; these

mythological roots enrich his identity and deepen the story's meaning. As Bill Moyers summed it up in *The Power of Myth,*

> *It wasn't just the production value that made that such an exciting film to watch, it was that it came along at a time when people needed to see in recognizable images the clash of good and evil. They needed to be reminded of idealism, to see a romance based on selflessness rather than selfishness.*[2]

Luke is an ordinary character who grows to heroic stature; the supreme enemy is a destroyer who would devour all, and his malice is directed personally and specifically at the hero himself. Ultimately, the hero must face this monster alone, in a confrontation that takes place outside the organized forces for good. The ordinariness of the hero contrasts with the extraordinary destiny to which he is called; he gradually becomes a better person as brave and difficult choices stimulate his growth, until ultimately he emerges from the adventure ennobled. He is tested by the temptation to do the right deed for the wrong reason, and he demonstrates that heroism can be achieved by anyone. Fame, glory, and honor are the by-products of the journey, not his main motivation.

In his final confrontation with his father, Luke finds that the power he needs has been within him all the time. Throughout the adventure, he has been in fact the "king's son"; now he discovers the true value of his birthright. As the hero, he represents the "divine creative and redemptive image which is hidden within us all, only waiting to be known and rendered into life."[3] The hero and his presumed enemy are at last revealed as two sides of the great mystery.

Under his mask, Vader is an undeveloped person. Yet something from his past still stirs him. A fallen angel, he was once the possessor of all the powers for good, until he perverted them to corrupt ends. He is pulled back from the depths of darkness by his son, and in the end, he too is a hero. The monster mask is set aside, and he joins the Jedi triad with Obi-Wan and Yoda. Luke nods good-bye, and returns to the world.

And so *Star Wars* fulfills the basic function of myth: to open our hearts to the dimension of mystery in our lives and to give us some guidance on our own hero's journey.

CLOCKWISE FROM TOP LEFT: **Luke's training transforms him.**

In Return of the Jedi, Luke recognizes that he and Darth Vader are two sides of the same mystery.

LEFT: **The Vigil,** John Pettie, 1884.

OPPOSITE: **With Vader's unmasking, Luke sees his father's face for the first time.**

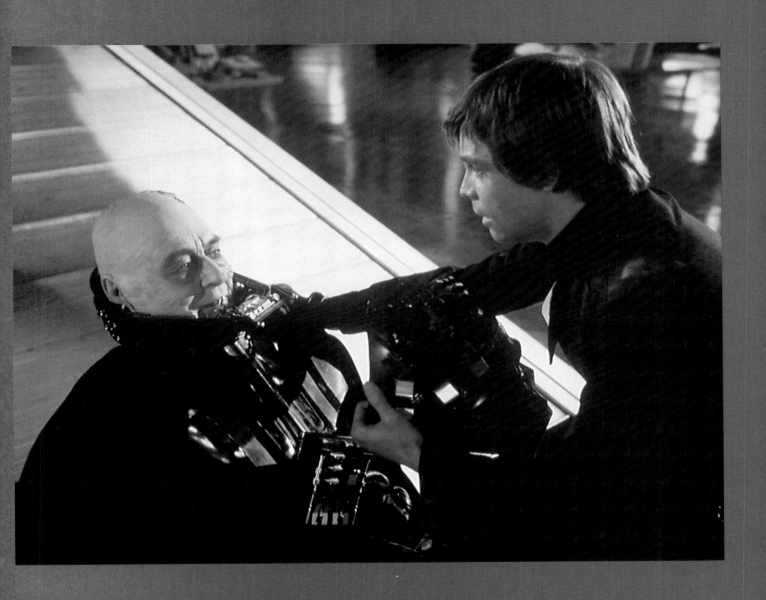

Endnotes

INTRODUCTION

[1] Joseph Campbell, *The Hero with a Thousand Faces*, 2nd ed., Bollingen Series, no. 17 (Princeton, N.J.: Princeton University Press, 1973), 11.

[2] George Lucas, from a speech in *Transformations of Myth through Time: The Hero's Journey*, produced by William Free, 57 minutes, Public Media Video, 1987, videocassette.

[3] George Lucas, in an interview with Leonard Maltin, 1995.

[4] Interview with George Lucas, Skywalker Ranch, Calif., September 27, 1996.

[5] Charles Champlin, *George Lucas: The Creative Impulse* (New York: Harry N. Abrams, Inc., 1992), 41.

[6] Mircea Eliade, *Myth of the Eternal Return*, trans. Willard R. Trask, Bollingen Series, no. 46 (Princeton, N.J.: Princeton University Press, 1991), 4.

[7] Campbell in Joseph Campbell and Bill Moyers, *The Power of Myth* (New York: Doubleday, 1988), 99.

CHAPTER ONE

[1] Carl Jung, cited in Joseph Campbell, *The Hero with a Thousand Faces*, 2nd. ed. Bollingen series, no. 17 (Princeton, N.J.: Princeton University Press, 1973), 18, n. 18.

[2] Campbell, *The Hero with a Thousand Faces*, 30.

[3] Campbell, *The Hero with a Thousand Faces*, 30.

[4] Campbell in Joseph Campbell and Bill Moyers, *The Power of Myth* (New York: Doubleday, 1988), 136.

[5] Campbell, *The Power of Myth*, 124.

[6] Campbell, *The Hero with a Thousand Faces*, 17.

[7] Throughout this book, the first movie in the trilogy will be referred to as *Star Wars*.

[8] David V. Barrett, *Tarot* (London: Dorling Kindersley, Predictions Library, 1995), 23z.

[9] *Merriam Webster's Collegiate Dictionary*, 10th ed., s.v. "herald" and "harbinger."

[10] Campbell, *The Hero with a Thousand Faces*, 72.

[11] Campbell, *The Hero with a Thousand Faces*, 59.

[12] Ovid, *Metamorphoses*, I, 504–53 (translation by Frank Justus Miller, the Loeb Classical Library), cited in Campbell, *The Hero with a Thousand Faces*, 61, n. 15.

[13] *The Art of Star Wars: A New Hope, Episode IV* (New York: Ballantine Books, 1997), 58.

[14] *The Art of Star Wars: A New Hope, Episode IV*, 59.

[15] Campbell, *The Power of Myth*, 126.

[16] The Reader's Digest Association, Inc., *The World's Religions: Understanding the Living Faiths* (Pleasantville, N.Y.: The Reader's Digest Association, Inc., 1993), 13.

[17] *The World's Religions: Understanding the Living Faiths*, 14.

[18] John Lash, *The Hero: Manhood and Power* (London: Thames and Hudson, 1995), 5.

[19] George Lucas, quoted in "Star Wars: The Making of the World's Greatest Space Adventure Movie," *Screen Superstar* no. 8, Special *Star Wars* edition, 1977, 14.

[20] Campbell, *The Power of Myth*, 129.

[21] Dante Alighieri, *The Inferno*, trans. by John Ciardi (New York: New American Library, 1982), 28.

[22] Lash, *The Hero: Manhood and Power*, 13.

[23] Campbell, *The Hero with a Thousand Faces*, 35.

[24] Campbell, *The Hero with a Thousand Faces*, 116.

[25] Timothy R. Roberts, *Myths of the World: The Celts in Myth and Legend* (New York: Metro Books, 1995), 25.

[26] Lash, *The Hero: Manhood and Power*, 24.

[27] Campbell, *The Hero with a Thousand Faces*, 95.

[28] Campbell, *The Hero with a Thousand Faces*, 108.

[29] Debra N. Mancoff, *The Return of King Arthur: The Legend through Victorian Eyes* (New York: Harry N. Abrams, Inc., 1995), 102.

[30] Mancoff, *The Return of King Arthur*, 123.

[31] *The Art of Star Wars: A New Hope, Episode IV*, 11.

[32] 1 Sam. 28:7.

[33] Recounted in Campbell, *The Hero with a Thousand Faces*, 131–33.

[34] David Fontana, *The Secret Language of Symbols* (San Francisco: Chronicle Books, 1994), 23.

[35] Campbell, *The Power of Myth*, 144.

[36] Campbell, *The Hero with a Thousand Faces*, 147–48.

[37] Walter Burkert, *Structure and History in Greek Mythology and Ritual* (Berkeley: University of California Press, 1979), 18.

[38] George Lucas, *Star Wars: From the Adventures of Luke Skywalker* (New York: Ballantine Books, 1976), 3.

[39] John R. Hinnells, *Persian Mythology* (London: The Hamlyn Publishing Group Limited, 1975), 49–68.

[40] Joseph Campbell, *The Masks of God: Oriental Mythology* (New York: Penguin Books, 1976), 81.

[41] Saint Augustine, *The City of God*, trans. Marcus Dods (New York: The Modern Library, 1993), 11.9.

[42] Campbell, *The Power of Myth*, 145.

CHAPTER TWO

[1] George Lucas, *Star Wars: From the Adventures of Luke Skywalker* (New York: Ballantine Books, 1976), photo insert.

[2] Richard Slotkin, *Gunfighter Nation: The Myth of the Frontier in Twentieth-Century America* (New York: Harper Perennial, 1993), 349.

[3] Interview with George Lucas, Skywalker Ranch, Calif., September 27, 1996.

[4] Interview with George Lucas, Skywalker Ranch, Calif., September 27, 1996.

[5] Brian Aldiss, *Space Opera* (London: Futura, 1974), 10.

[6] John Clute, *Science Fiction: The Illlustrated Encyclopedia* (London: Dorling Kindersley Publishing, Inc., 1995), 39.

[7] Martin Walker, *The Cold War* (New York: Henry Holt and Company, 1993), 226.

[8] Charles A. Reich, *The Greening of America* (New York: Crown Trade Paperbacks, 1970), 4–7.

[9] Jeffrey Goldstein, "The Spiritualization of Technology: A New Vision for the 1970s," *The Drew Gateway* vol. 48, no. 2, 1977, 28.

[10] Lucas, *Star Wars: From the Adventures of Luke Skywalker*, photo insert.

[11] Campbell, in Joseph Campbell and Bill Moyers, *The Power of Myth* (New York: Doubleday, 1988), 144.

[12] Goldstein, "The Spiritualization of Technology," 27.

[13] Denis Wood, "Growing Up Among the Stars," *Literature/Film Quarterly* 6 no. 4, Fall 1978, 329.

[14] Campbell, *The Power of Myth*, 18.

[15] Ellen Goodman, "A 'Star Wars' Fantasy Fulfillment," *Washington Post*, July 30, 1977, A15.

CHAPTER THREE

[1] Telephone interview with John Mollo, July 9, 1996.

[2] Stephen Bull, *An Historical Guide to Arms and Armor* (New York: Facts on File, 1991), 115.

[3] Telephone interview with John Mollo, July 9, 1996.

[4] Telephone interview with John Mollo, July 9, 1996.

[5] Interview with Ralph McQuarrie, Skywalker Ranch, Calif., September 25, 1996.

[6] Telephone interview with John Mollo, July 9, 1996.

[7] Interview with Ralph McQuarrie, Skywalker Ranch, Calif., September 25, 1996.

[8] Joseph Campbell with Bill Moyers, *The Power of Myth* (New York: Doubleday, 1988), 145.

CONCLUSION

[1] Gallup Survey, 1981.

[2] Moyers, in Joseph Campbell and Bill Moyers, *The Power of Myth* (New York: Doubleday, 1988), 144.

[3] Joseph Campbell, *The Hero with a Thousand Faces*, 2nd ed. Bollingen Series, no. 17 (Princeton, N.J.: Princeton University Press, 1973), 39.

Bibliography

BOOKS AND ARTICLES

Aldiss, Brian. *Space Opera*. London: Futura, 1974.

Alighieri, Dante. *The Inferno*. Translated by John Ciardi. New York: New American Library, 1982.

The Art of Star Wars: A New Hope, Episode IV. New York: Ballantine Books, 1997.

Augustine, Saint. *The City of God*. Translated by Marcus Dods. New York: The Modern Library, 1993.

Barrett, David V. *Tarot*. London: Dorling Kindersley Publishing, Inc., Predictions Library, 1995.

Bull, Stephen. *An Historical Guide to Arms and Armor*. New York: Facts on File, 1991.

Burkert, Walter. *Structure and History in Greek Mythology and Ritual*. Berkeley, Calif.: University of California Press, 1979.

Campbell, Joseph. *The Hero with a Thousand Faces*, 2nd edition. Bollingen Series no. 17. Princeton, N.J.: Princeton University Press, 1973.

———. *The Masks of God: Oriental Mythology*. New York: Penguin Books, 1976.

Campbell, Joseph, and Bill Moyers. *The Power of Myth*. New York: Doubleday, 1988.

Champlin, Charles. *George Lucas: The Creative Impulse*. New York: Harry N. Abrams, Inc., 1992.

Clute, John. *Science Fiction: The Illustrated Encyclopedia*. London: Dorling Kindersley Publishing, Inc., 1995.

Eliade, Mircea. *The Myth of the Eternal Return*. Translated by Willard R. Trask. Bollingen Series no. 46. Princeton, N.J.: Princeton University Press, 1991.

Fontana, David. *The Secret Language of Symbols*. San Francisco: Chronicle Books, 1994.

Goldstein, Jeffrey. "The Spiritualization of Technology: A New Vision for the 1970s." *The Drew Gateway* vol. 48, no. 2, 1977.

Goodman, Ellen. "A 'Star Wars' Fantasy Fulfillment." *The Washington Post*, July 30, 1977.

Hinnels, John R. *Persian Mythology*. London: The Hamlyn Publishing Group Limited, 1975.

Lash, John. *The Hero: Manhood and Power*. London: Thames and Hudson, 1995.

Lucas, George. *Star Wars: From the Adventures of Luke Skywalker*. New York: Ballantine Books, 1976.

Mancoff, Debra N. *The Return of King Arthur: The Legend through Victorian Eyes*. New York: Harry N. Abrams, Inc., 1995.

The Reader's Digest Association, Inc. *The World's Religions: Understanding the Living Faiths*. Pleasantville, N.Y.: The Reader's Digest, 1993.

Reich, Charles A. *The Greening of America*. New York: Crown Trade Paperbacks, 1970.

Roberts, Timothy R. *Myths of the World: The Celts in Myth and Legend*. New York: MetroBooks, 1995.

Slotkin, Richard. *Gunfighter Nation: The Myth of the Frontier in Twentieth-Century America*. New York: Harper Perennial, 1993.

"*Star Wars:* The Making of the World's Greatest Space Adventure Movie." *Screen Superstar* no. 8, special *Star Wars* edition, 1977.

Walker, Martin. *The Cold War*. New York: Henry Holt and Company, 1993.

Wood, Denis. "Growing Up Among the Stars." *Literature/Film Quarterly* 6 no. 4, Fall 1978.

VIDEOCASSETTE

Lucas, George. *Transformation of Myth through Time: The Hero's Journey*. Produced by William Free. 57 mins. Public Media Video, 1987. Videocassette.

INTERVIEWS

Lucas, George. Interview at Skywalker Ranch, Calif., September 27, 1996.

———. Interview with Leonard Maltin, 1995.

McQuarrie, Ralph. Interview at Skywalker Ranch, Calif., September 25, 1996.

Mollo, John. Telephone interview, July 9, 1996.

Index

Adam and Eve (biblical characters), 120
Aeneas (mythological character), 106
Alderaan (fictional planet), 36, 39, 47, 149, 156
Aldiss, Brian, 141
Alien invasions of earth, 142
American Graffiti (film), 7, 126
Anchises (mythological character), 106
Anima, 53, 102
Apollo (mythological character), 36, 102
Archetypes, 17–18
 See also *specific archetype*
Arete (excellence), 101
Ariadne (mythological character), 54
Art Deco influences, 182
Artemis (mythological character), 102
Arthurian legends, 19–20, 22, 32, 36, 56–57, 124, 156
Artoo-Detoo (fictional character), 26, 29, 30, 36, 54, 97, 153
Atonement with father, 64, 90, 106, 107, 111, 113, 120, 198
Aunt Beru Lars (fictional character), 22, 30, 129

Balder (mythological character), 78
Belly of beast, 53–54, 64–65
Ben (aka Obi-Wan Kenobi) (fictional character), 39, 68

and call to adventure, 26
costumes of, 186, 189
as guide, 32, 36, 56, 64
as hero's partner, 41, 44
and labyrinth, 47
and mystical insight, 44
slaying of, 56–57, 155–56
Vader reunited with, 113, 198
as vision, 64, 101–2
Beowulf (Anglo-Saxon poem), 97
Bespin (fictional planet), 76, 189
Betrayal, in hero's journey, 76, 78, 82, 87–90
Biggs (fictional character), 129
Boba Fett (fictional character), 82
Bounty hunters (fictional characters), 60, 82, 93, 129
Boushh the bounty hunter (fictional character), 93
Buddha (historical character), 20
Burkert, Walter, 114
Burroughs, Edgar Rice, 142

Caesar, Julius, 146
Call to adventure, 22, 26, 29, 64
 refusal of, 36, 39, 88
Calrissian, Lando (fictional character), 78, 102, 106, 165, 189
Campbell, Joseph, 36, 44, 59, 82, 113, 124
 and "creative mythology," 12
 and final victory, 113
 and functions and themes of mythology, 6, 16
 and good versus evil, 120
 and guides in mythology, 30, 32
 and hero's journey, 19, 20, 64, 196
 and humanity versus machine, 155, 156
 influence on Lucas of, 7
 and Japanese influences, 189
 and "life-potentialities," 20, 107
 and masks, 112
 Moyers' interview with, 12, 16, 44
 and Woman as complement to male heroes, 65

Carbonite tomb, 78, 93
Cathedrals, 192
Caves, 64–65, 73, 117, 192
Cerberus (mythological character), 30
Champlin, Charles, 10
Chewbacca (fictional character), 41, 56, 65, 93, 97, 106, 167, 182
Christ (biblical character), 120
Cloud City (fictional city), 76, 82, 182
Cold War, 6, 148, 149
Communism, 142
Consumption motif, 53, 54, 64–65, 97, 105
Costumes, 163, 164–65, 166–67, 171, 174, 176, 181, 186, 189
"Creative mythology," 12
Crises of 1970s, 148–59
Cronus (mythological character), 87

Dagobah (fictional planet), 64, 68, 73, 101
Damsel in distress, 26
 See also Princess, rescue of
Danaë (mythological character), 22, 82
Daphne (mythological character), 36
Dark road of trials
 in *The Empire Strikes Back*, 60–90
 as part of hero's journey, 19, 60–90, 91, 93, 97, 101
 in *Return of the Jedi*, 91, 93, 97, 101
Darth Vader. *See* Vader, Darth
David and Goliath (biblical characters), 57
Death
 Emperor as symbol of, 101
 symbolic, 64–65, 82
Death Star (Imperial space station)
 attacks on, 57, 102, 106, 171
 and call to adventure, 26
 and consumption motif, 53, 54
 and destruction of Alderaan, 47, 156
 destruction of, 60–61, 106, 108, 112, 117, 149, 156
 Emperor at, 101
 and good versus evil, 117

as guardian, 47, 57
and humanity versus machine, 155–56
interior setting of, 192
as killing machine, 155–56
Luke's trip into, 106–7
and nuclear weapons, 144, 149
as resurgence of evil, 101
second, 101, 102, 106–7, 108, 112, 117
as weapon, 192
See also Labyrinth
Demeter (mythological character), 93
Dismemberment of heroes, 64, 87–88, 105
Doyle, Arthur Conan, 142
Dragon slayers, 57, 59, 64
Dragons, 57, 65
Droids (fictional characters), 12, 26, 29, 39, 54,
152, 165.
See also specific droid
Druids, 68
Dune Sea (fictional place), 30, 97, 165
Durkheim, Emile, 44
Dykstra, John, 174
Dystopia, 152–53, 155–57

E

Egypt
mythology of, 54, 87–88, 120
pyramids of, 192
See also specific myth
Elaine (mythological character), 22
Emperor (fictional character)
back story of, 10
chambers of, 192
costumes and weapons of, 186, 189
at Death Star (second), 101
destruction of, 106, 108
and humanity versus machine, 156
in labyrinth, 106
and Luke's attack on Vader, 107–8
symbolism of, 101
and Vader, 88–89, 106, 108, 146
Empire (fictional empire)
characteristics of, 105, 106, 146, 184
costumes and weapons of, 167, 184
as evil, 117, 141
and humanity versus machine, 152, 153,
155, 156
influences on concept of, 144, 149, 184
Rebel combat with, 57, 64
as weapon, 156
See also Death Star; Emperor; Imperial
troops
The Empire Strikes Back (film)
belly of beast in, 64–65
betrayal in, 76, 78, 82, 87–90
costumes and weapons in, 171, 182
as dark road of trials, 60–90
ending of, 90
and good versus evil, 117, 120
hunt in, 60–61, 64
Leia as Luke's rescuer in, 53

as midpoint of hero's journey, 60–90
mystical marriage in, 65
sacred grove in, 68, 73
sacrifice in, 76, 78, 82, 87–90
Enchanted forest, 102, 105–6, 192.
See also Sacred grove
Endor (fictional planet), 102, 106, 192
Environmental issues, 151–52
Eurydice (mythological character), 78
Evil
alien invaders of earth as, 142
Empire as, 141
resurgence of, 101–2
Vader as representation of, 50, 53
See also Force: dark side of; Good versus evil
Ewoks (fictional characters), 102, 105–6, 192

F

Far East, 186, 189
See also Japan
Fate, 22, 26, 29, 36, 39, 89–90
Father
atonement with, 64, 90, 106, 107, 111, 113,
120, 198
of Leia, 90
sword as talisman of, 32, 36
See also Skywalker, Anakin; Vader, Darth
Fire, 113
Fool, Luke as, 22
Force
Ben introduces Luke to, 36
characteristics of, 44
dark side of, 36, 73, 106, 107, 116
as energy field for Jedi, 44
and killing of wampa, 64
and Leia, 90
as mystical insight, 44, 47
use of, 68, 76, 91
Yoda's instruction about, 68
Ford, Harrison, 162
Ford, John, 126
Forests, enchanted and sacred, 68, 73, 102,
105–6, 192
Freyia and Freyr (mythological characters), 102
Frontier, 126, 129, 166–67

G

Gagarin, Yuri, 135
Gaia (mythological character), 87
Galahad (fictional character), 22, 89
Gangster films, 133
Garden of Eden (biblical place), 30, 120
Germany, 184
See also Nazis; World War II
Gilgamesh epic, 39
God, 4, 196, 197
Golden Fleece. *See* Jason
Good versus evil, 7, 10, 18, 53, 114, 116–17, 120,
197, 198
See also Evil
Goodman, Ellen, 156–57

Gordon, Flash (fictional character), 136, 141, 182
Gorgon (mythological character), 26, 78
Greedo (fictional character), 44, 60, 129
Greek mythology, 87, 101, 102, 106
See also specific myth
The Greening of America (Reich), 151–52
Guardians, 30, 106
See also specific guardian
Guerard Rodgers, Aggie, 163
Guides, 30, 32, 36, 56–57
See also specific guide

H

Hades
as mythological character, 93, 106
as mythological place, 30
Haggard, H. Rider, 142
Han Solo (fictional character). *See* Solo, Han
Hell
carbon-freezing chamber as symbol for, 78
hero's journey through, 60–90
See also Hades
Heralds, and call to adventure, 22, 26, 29
Hercules (mythological character), 101, 106, 113
Heroes
as children, 82
dilemma of, 156–57
and discovery and assimilation of opposite,
82
dismemberment of, 64, 87–88
as dragon slayers, 57, 59
and good versus evil, 116, 198
and humanity versus machine, 156–57
individualism of, 155
making of new, 106
origins in life of, 22
partners of, 39, 41, 44
sacrifice of, 89
as sleeping, 82
symbolic death of, 64–65
tasks of, 60–61
Woman as complement to male, 65
women as, 158–59
See also Consumption motif; Hero's journey;
specific character
Hero's journey
as archetype, 18
betrayal in, 76, 78, 82, 87–90
and call to adventure, 22, 26, 29, 36, 39, 64,
88
characteristics of, 19–20, 39
and dark road of trials, 19, 60–90, 91, 93, 97,
101
and descents into underworld, 39, 41, 106–7
and dragon slayers, 57, 59
The Empire Strikes Back (film) as midpoint of,
60–90
and enchanted and sacred forests, 68, 73,
102, 105–6, 192
end of, 196, 197–98
and functions of myths, 198

goals in, 32
guardians in, 30
guides in, 30, 32, 36, 56–57
and hero's return, 91
hunt in, 60–61, 64
initiation part of, 19, 20, 54, 56, 59, 90
as journey through hell, 60–90
and labyrinth, 47, 50, 53–54, 56
and love, 65
and mystical insight, 44, 47
passing first threshold in, 39
Return of the Jedi (film) as end of, 91–120

Jawa Blaster

revenge as motive for, 129
sacrifice in, 76, 78, 82, 87–90
as self-discovery, 20, 54, 56
as spiritual, 20
Star Wars: A New Hope (film) as beginning of,
 22–59
Hitler, Adolf, 146, 184
Holy Grail
 See Arthurian legends; *specific knight*
Horus (mythological character), 120
Hoth (fictional planet), 61, 64, 166, 167, 171,
 176, 181
Humanity versus machine, 151–53, 155–57
Hunt motif, 60–61, 64
Hydra (mythological character), 101

Idealism, 198
Imperial Star Destroyers (fictional fleet), 64–65,
 181
Imperial troops (fictional military)
 costumes and weapons of, 171, 176, 181, 184
 and good versus evil, 117
 and humanity versus machine, 153
 naval, 64–65, 181
 as Nazis, 144, 146, 184
Individual, importance of, 44, 47
Individualism, 155
Individuals, power of, 44, 47
Initiation, and hero's journey, 20, 54, 56, 59, 90
Inkidu (mythological character), 39
Innocence, 20, 22, 29, 89–90
Iolaus (mythological character), 101
Isis (mythological character), 87–88

Jabba the Hutt (fictional character), 44, 78, 91,
 93, 97, 101, 102
Japan, 133, 176, 186, 189
Jason (mythological character), 19, 30, 39, 124
Jawa scavengers (fictional characters), 26, 129, 165
Jedi (fictional characters)
 costumes and weapons of, 186, 189
 Force as energy field for, 44
 knights of, 32, 113
 See also specific character

Jesus (biblical character), 20, 78
Joan of Arc, 53
Johnston, Joe, 163
Jonah and the whale (biblical story), 65
Judas Iscariot (biblical character), 78
Jung, Carl, 17–18, 53

Kissinger, Henry, 149
Knights (mythological characters), 47.
 See also Arthurian legends; Jedi: knights of;
 specific knight
Kurosawa, Akira, 133

Labyrinth, 47, 50, 53–54, 56, 73, 106
Lancelot (mythological character), 22
Lando Calrissian (fictional character), 78, 102,
 106, 165, 189
Lang, Fritz, 182
Lars, Aunt Beru (fictional character), 22, 30, 129
Lars, Uncle Owen (fictional character), 22, 29,
 30, 32, 129
Leap into abyss, of Skywalker, 89–90
Leia Organa (fictional character).
 See Organa, Leia
"Life-potentialities," 20, 107
Lightsaber (fictional saber), 32, 36, 44, 64, 97,
 107
Loki (mythological character), 76, 78
"Lost world" fantasies, 141–42
Lot (biblical character), 78
Love, 50, 65, 78, 90
 See also Romantic love

Lucas, George
 Campbell's influence on, 7
 and consumption motif, 64–65
 and costumes and props of *Star Wars*, 164,
 176, 181, 182, 184, 189
 cultural and historical influences on, 125,
 126, 129, 133, 135, 136, 144, 151, 152,
 156, 163, 182, 184, 189
 and good versus evil, 120
 personal and professional background of,
 7, 10
 and writing of *Star Wars* trilogy, 7, 10, 163
 See also THX 1138
Lucian of Samosata, 142

Machine versus humanity, 151–53, 155–57
McQuarrie, Ralph, 163, 176, 182, 186, 189
Marriage, mystical, 65
Masks, 111–12, 198
Medusa (mythological character), 22, 26
Merlin (mythological character), 32, 57
Metropolis (film), 182
Middle Ages, 30, 65, 78
 See also Arthurian legends
Military costumes and props, 166–67, 171, 174,
 176, 181
Millennium Falcon (fictional spaceship), 41, 44, 47,
 56, 64–65, 90, 162, 171, 174, 176
Minotaur (mythological character), 54, 106
Mollo, John, 163, 164, 176, 184, 186, 189
Monster combat (fictional battle), 97, 101
Moon, American landing on, 135–36, 151
Mos Eisley (fictional cantina), 39, 41, 60, 129
Moses (biblical character), 20, 82
Moyers, Bill, 12, 16, 44, 124, 198
Muhammad (historical character), 20
Mystic tree cave, 117
Mystical marriage, 64, 65
Mythic settings, 192
Mythology
 and archetypes, 17–18
 characteristics and functions of, 3–4, 6, 198
 "creative," 12
 cultural and historical influences on modern,
 123–60
 Egyptian, 54, 87–88, 120
 Greek, 87, 101, 102, 106
 impact on modern life of, 124
 irrelevancy of ancient, 6
 of Middle Ages, 30
 narrative structure in Western, 114
 Navaho, 107
 Norse, 76, 78, 102
 Roman, 101–2, 106
 as sacred, 197
 Star Wars trilogy as new type of,
 6–7, 10, 12
 themes of, 10, 16, 17–18
 See also Arthurian legends; *specific myth,
 archetype, or theme*

Narrative structure, 114
Navaho myths, 107
Naval analogies, 181
Nazis, 144, **155**, 184
"Night-sea journey," 82
1970s, crises of, 148–49
Norse mythology, 76, 78, 102
Nuclear/atomic weapons, 142, 144, 149
Nut (mythological character), 54

Obi-Wan Kenobi. *See* Ben
Odysseus (mythological character), 39
Organa, Leia (fictional character), 36, 39, 76, 106
 as archetype, 50, 53
 in belly of beast, 64–65
 as Boushh the bounty hunter, 93
 and call to adventure, 26
 costumes of, 189
 and Ewoks, 105
 and Force, 90
 and good versus evil, 116
 and Han, 50, 65, 78, 90, 93
 as heir to father's gifts, 90
 as hero, 20, 50, 158–59
 hero's journey of, 53, 64
 and Jabba, 93, 101
 Luke's first meeting with, 47, 50
 as Luke's rescuer, 53, 90
 as Luke's twin sister, 101–2
 rescue of, 47, 50
 unmasking of, 111
 as Vader's daughter, 90, 116
Orpheus (mythological character), 78
Osiris (mythological character), 87–88

Palpatine, Senator (fictional character), 146
Partners, of heroes, 39, 41, 44
Peckinpah, Sam, 133
Peneus (mythological character), 36
Persephone (mythological character), 93
Perseus (mythological character), 22, 26, 78, 82
Pirsig, Robert, 152
Power
 abuse of, 153, 155
 and dragon slayers, 57
 of individuals, 44, 47
 of labyrinth, 54
 as means to right the wrongs of world, 88
 mystical insight as, 44, 47
 and separation from world, 64
 spiritual, 44
 supernatural, 136, 142
 See also Force; Forests; Lightsaber
"Pre-hero" archetypes, 68
Princess, rescue of, 47, 50, 53–54, 56
Progress, Western belief in, 152–53

Prometheus (mythological character), 19
Psyche, droids compared with, 26, 29
Pyramids, 192

Racism, 142
Rancor (fictional character), 93, 97
Rebel Alliance
 combat between Empire and, 57, 64
 costumes and weapons of, 164, 167, 171, 174, 176, 181
 and good versus evil, 53
 and humanity versus machine, 155, 156
 Luke and Han as leaders of, 59
 and women as heroes, 159
Rebirth, 54, 56, 65, 82, 93, 105, 197
Redemption, 120, 197, 198
Refusal of call, 36, 39, 88
Reich, Charles, 151–52
Religion, 44, 197
Remus (mythological character), 22, 101–2
Resurrection. *See* Rebirth
Return of the Jedi (film)
 costumes and weapons in, 171, 176, 190
 dark road of trials in, 91, 93, 97, 101
 and descent into underworld, 106–7
 enchanted forest in, 102, 105–6
 final victory in, 113
 and good versus evil, 120
 as hero's return, 91–120
 Lando's journey in, 78
 monster combat in, 97, 101
 and resurgence of evil, 101–2
 resurrection in, 93
 and Skywalker's name, 29
 unmasking in, 111–12
 Western films' influence in, 129, 133
Rodis-Jamero, Nilo, 163
Rogers, Buck (fictional character), 136, 142
Roman mythology, 101–2, 106
Romantic love, 50, 65, 141, 198
Rome, ancient, 146
Romulus (mythological character), 22, 101–2

Sacred
 definition of, 197
 grove as, 68, 73
 and Luke and Vader's final encounter, 192
 marriage, 64, 65
 myth as, 197
Sacrifice, in hero's journey, 76, 78, 82, 87–90
Saint Augustine, 120
Sand People (fictional characters), 30, 129, 165
Sarlacc (fictional shark), 97
Satan (biblical character), 120
Saul (biblical character), 102
Saviors. *See* Good versus evil; *specific character*
Science fiction, 135–36, 141–42
See-Threepio (fictional character), 20, 26, 29, 54, 65, 105–6, 153, 182

Self-annihilation, 64–65
Self-discovery, 20, 54, 56, 65, 155, 196
Set (mythological character), 87–88, 120
Settings, mythic, 192
Seven Samurai (film), 133
Shamans, 61, 64, 68
Shepard, Alan, 135
Siegfried (mythological character), 36, 59
Skywalker, Anakin (fictional character)
 Ben tells Luke story of, 32
 "life-potentialities" of, 107
 sword of, 32, 36
 Vader as, 82, 106, 113, 192
 See also Atonement with father
Skywalker, Luke (fictional character), 59, 106, 198
 aspires to be like Anakin, 32
 and atonement with father, 64, 90, 106, 107, 111, 113, 120, 198
 and Ben, 26, 32, 39, 57, 59, 64, 101–2
 call to adventure of, 22, 26, 29, 36, 39
 childhood of, 22, 129
 costumes and weapons of, 167, 176, 186, 189, 190
 dark side of, 73, 90, 106, 107, 117, 190
 destruction of childhood home of, 39, 129
 dismemberment of, 87–88
 and Emperor, 107–8
 and Ewoks, 105
 and Force, 44, 64, 68, 76, 91
 and good versus evil, 114, 116, 117, 120, 198
 guide for, 32
 hero's journey of, 20, 22, 29, 32, 36, 39, 60–61, 64, 113, 129
 and humanity versus machine, 155, 156
 integration of opposites within, 102
 Jabba's capture of, 93, 97, 101
 in labyrinth, 106
 leap into abyss of, 89–90
 Leia as twin sister of, 101–2
 Leia's first meeting with, 47, 50
 Leia's rescue of, 53, 90
 "life-potentialities" of, 107–8
 and monster combat, 97, 101
 in mystic tree cave, 117
 mythic settings for, 192
 name of, 29
 redemption of, 120
 return to Dagobah of, 101
 in sacred grove, 68, 73
 sacrifice of, 87, 89
 self-discovery of, 107–8
 as "Sir Luke," 29
 spiritual quest and conflict of, 44, 64, 106
 as "town tamer," 133
 transformations of, 20, 29, 56, 68, 73, 102, 190, 198
 in underworld, 82, 87–90, 106–7
 Vader as father of, 82, 90, 106, 107, 120, 190, 192
 Vader as shadow side of, 73

Vader's battle with, 59, 87–89, 107–8
Vader's final encounter with, 107–8, 112, 192, 198
and Vader's funeral, 113
as Vader's savior, 112
Vader's seduction of, 88–89
Vader's telepathic communication to, 90
and wampa, 64
See also Lightsaber
Skywalker Ranch,
 Moyers-Campbell interview at, 12
"Sleeping Beauty" (fairy tale), 47, 50
Solo, Han (fictional character), 64, 76, 106
 in belly of beast, 64–65
 betrayal of, 78
 in carbonite tomb, 78, 82, 93
 Chewie's reunion with, 93
 costumes and weapons of, 167
 and dragon slayers, 57, 59
 as gunfighter, 44, 129
 as hero, 20
 hero's journey of, 44, 64
 as hero's partner, 41, 44
 Jabba's capture of, 93, 97
 Lando helps, 102
 and Leia, 50, 65, 78, 90, 93
 and mystical insight, 44
 mystical marriage of, 65
 rescue of, 78, 93
 and rescue of the princess, 47
 transformation of, 44, 56, 59, 65
 and Vader, 78
Soviet Union, 135, 148, 149, 159
Space program, 6, 135–36, 141–42, 159
Space travel, 136, 142
SS (Schutzstaffel) troops, 146.
 See also Stormtroopers
Star Wars: A New Hope (film)
 and call to adventure, 22, 26, 29, 36, 39
 costumes and weapons in, 174
 and descent into underworld, 39, 41
 and dragon slayers, 57, 59
 ending of, 59
 and good versus evil, 116
 guardians in, 30
 guides in, 30, 32, 36, 56–57
 labyrinth in, 47, 50, 53–54, 56
 and mystical insight, 44, 47
 passing first threshold in, 39
 Western films' influence in, 129, 133
Star Wars: From the Adventures of Luke Skywalker
 (novel), 146
Star Wars trilogy
 costumes and props in, 12, 161–92
 and functions of myths, 198
 and good versus evil, 114, 116–17, 120
 impact of, 7, 12, 197–98
 as middle of nine-part project, 7, 10
 as new type of mythology, 6–7, 10, 12
 writing of, 7, 10
 See also Star Wars: A New Hope; The Empire
 Strikes Back; Return of the Jedi

Stone, turning people to, 78
Stormtroopers (fictional characters), 47, 152, 153, 176
Sturges, John, 133
Supernatural powers. *See* Power
Swords, magic, 32, 36
 See also Lightsaber

Talisman, and hero's journey, 32, 36
Tarkin, Grand Moff (fictional character), 146, 156
Tatooine (fictional planet), 22, 26, 39, 190
Technology, 105, 106, 141, 151–53, 155–57
Tennyson, Alfred Lord, 89
Tereshkova, Valentina, 159
Theseus (mythological character), 30, 54, 106
Threshold guardians, 30, 106.
 See also specific guardian
THX 1138 (film), 7, 47, 152
"Town tamer," 133
Transubstantiation, 60
"Traveler's tales," and "lost world" fantasies,
 141–42
Triangle, traditional, 47
Tristan and Iseult (fictional characters), 65
Tusken Raiders. *See* Sand People
Twin Warriors (Navaho myth), 107
Twins, 101–2, 107

Uncle Owen Lars (fictional character), 22, 29,
 30, 32, 129
Underworld, descents into, 39, 41, 78, 82,
 87–90, 106–7
Unmasking, 111–12

Vader, Darth (fictional character)
 as Anakin Skywalker, 82, 106, 113, 192
 back story about, 7, 10
 and Ben, 56–57, 113, 155–56, 198
 costumes and weapons of, 50, 53, 164, 174,
 181, 189
 and Emperor, 88–89, 106, 108, 146
 funeral of, 113
 and good versus evil, 53, 114, 116, 117, 120
 as guardian of labyrinth, 106
 and Han, 78
 as hero and savior, 20, 107
 hero's journey of, 108
 and humanity versus machine, 106, 153,
 155–56
 and Leia, 47, 116
 "life-potentialities" of, 107
 Luke as savior of, 112
 Luke's battle with, 59, 87–89, 107–8
 as Luke's father, 82, 90, 106, 107, 120, 190, 192
 Luke's final encounter with, 107–8, 112, 192,
 198
 Luke's seduction by, 88–89
 as Luke's shadow side, 73
 Luke's telepathic communication from, 90

mask of, 112, 189, 198
Nazi influence on, 146
redemption of, 120
reunification of Ben, Yoda, and, 113, 198
as shadow figure, 50, 53, 73
as tragedy, 108
transformation of, 90
 See also Atonement with father
Verne, Jules, 142
Victims, shamans as, 61, 64
Vietnam War, 6, 149, 151

Wampa (fictional ice creature), 64
Weapons, 156, 163, 164, 165, 167, 171
 See also Nuclear/atomic weapons
Wedge (fictional character), 106, 176
Wells, H. G., 142
Western films, 44, 124, 126, 129, 133, 136
White, T. H., 156
Woman, as complement to male hero, 65
Womb, return to, 53–54
Women
 as aviators, 159
 as deliverance, 78
 as heroes, 158–59
 transformation of role in Middle Ages
 of, 78
Wookiee (fictional character), 41
World War I, 171, 176
World War II, 144, 146, 158, 174, 176
 See also Nazis

X-wing pilots (fictional characters), 12, 57, 102,
 171, 176, 181

Y-wing pilots (fictional characters), 171
Yahweh (Jewish God), 120
Yoda (fictional character), 53, 64, 68, 73, 107,
 113, 189, 198

Zen and the Art of Motorcycle Maintenance
 (Pirsig), 152
Zen Buddhism, 68, 73
Zeus (mythological character), 22, 87
Zoroastrianism, 116–17

Permissions

PAGE 37

LOWER LEFT: *Apollo and Daphne*; sculpture by Gian Lorenzo Bernini, 1622–23, collection of the Galleria Borghese, Rome, Italy (Courtesy of Alinari/Art Resource, NY)

PAGE 38

LOWER: *Ulysses and the Sirens*; oil on canvas by John William Waterhouse (1849–1917, English), 1891 (100 x 201.7 cm, purchased 1891) (National Gallery of Victoria, Melbourne, Australia)

PAGE 40

Chewbacca (Courtesy of the Smithsonian Institution; photograph by Eric Long and Mark Avino)

PAGE 41

UPPER LEFT: *The Argonauts with Athene*; large two-handled bowl, collection of the Louvre, Paris, France (Photo courtesy of the Mansell Collection/Time Inc.)

LOWER RIGHT: *John Oxenham*. Illustration by N. C. Wyeth, for *Westward Ho!* by Charles Kingsley, 1920 (Collection of Joseph L. Soley, Portland, Maine; photograph courtesy of the Brandywine River Museum)

PAGE 46

LOWER: Floor of Chartres Cathedral: The Labyrinth. Cathedral, Chartres, France (Courtesy of Foto Marburg/Art Resource, NY)

PAGE 47

LOWER LEFT: *The Prince Awakens Sleeping Beauty*. Illustration by Donn P. Crane, "The Sleeping Beauty," 1936 (©The United Educators, Inc.)

PAGE 50

LOWER LEFT: *Itha Rode Away with Her Lord*. Illustration by Thomas Heath Robinson, for *A Child's Book of Saints* by W. Canton, 1898 (Courtesy of Chris Beetles Ltd., St. James's, London)

MIDDLE RIGHT: *Dante and Beatrice*. Illustration by Donn P. Crane, for "The Divine Comedy," 1936 (©The United Educators, Inc.)

PAGE 51

The Horseman of Night. Illustration by Ivan I. Bilibin, for *Vassilisa the Beautiful* by Irina Zheleznova, 1976 (Goznak)

PAGE 52

Leia and Vader (Courtesy of the Smithsonian Institution; photograph by Eric Long and Mark Avino)

PAGE 53

MIDDLE LEFT: *Joan of Arc at Orléans*. Illustration by Martin, for "Joan of Arc," 1936 (©The United Educators, Inc.)

PAGE 54

LOWER LEFT: *Legend of Theseus: Theseus, Ariadne and the Minotaur*; Italian School, 15th century, Avignon, France (Courtesy of Giraudon/Art Resource, NY)

MIDDLE RIGHT: *Garden Maze*; drawing by Hans Puec, 1592 (Courtesy of Dumbarton Oaks, Studies in Landscape Architecture, Photo Archive)

PAGE 56

UPPER RIGHT: *Sir Kay Overthroweth His Enemies*. Illustration by Howard Pyle, for *The Story of King Arthur and His Knights* by Howard Pyle, 1903 (Courtesy of the Howard Pyle Collection of the Delaware Art Museum, Wilmington, Delaware)

PAGE 57

MIDDLE LEFT: *David and Goliath*. Illustration by Gustave Doré, for *The Holy Bible*, 1866

PAGE 60

RIGHT: *The Forest*. Illustration by Gustav Doré, for *Divine Comedy* by Dante Alighieri

PAGE 64

LOWER RIGHT: Jonah and the whale (Courtesy of CULVER PICTURES, Inc. New York)

PAGE 67

"*Oh, gentle knight*," said la Belle Isolde, "*Full of woe am I of Thy departing*." Illustration by N. C. Wyeth, for *The Boy's King Arthur* edited by Sidney Lanier, 1917 (Collection of the Brandywine River Museum; gift of Mrs. Gertrude Mellon)

PAGE 68

LOWER RIGHT: *Grove of the Druids*. Illustration for *The Story of the Greatest Nations* by Edward S. Ellis and Charles F. Horne, 1901 (Courtesy of North Wind Picture Archives)

PAGE 73

LOWER RIGHT: *Gama Sennin, a Taoist Sage*; ink on paper by Soga Shohaku, 18th century [04.192] (Courtesy of the Freer Gallery of Art, Smithsonian Institution, Washington, D.C.)

PAGE 78

UPPER RIGHT: *The Flight of Lot*. Illustration by Gustave Dore, for *The Holy Bible*, 1866

UPPER LEFT: "*Behold it then!*" cried Perseus... Illustration by Mary Hamilton Frye, for *Myths Every Child Should Know* edited by Hamilton Wright Mabie, 1905

PAGE 82

UPPER LEFT: *Danaë*; painting by J. W. Waterhouse, 1892

PAGE 83

UPPER LEFT: Boba Fett (Courtesy of the Smithsonian Institution; photograph by Eric Long and Mark Avino)

PAGE 87

LOWER LEFT (LEFT): "Death" Tarot Card (Illustrations from the Rider-Waite Tarot Deck®, known also as the Rider Tarot and the Waite Tarot, reproduced by permission of U.S. Games Systems, Inc., Stamford, CT 06902 USA. Copyright ©1971 by U.S. Games Systems, Inc. Further reproduction prohibited. The Rider-Waite Tarot Deck® is a registered trademark of U.S. Games Systems, Inc.)

LOWER LEFT (RIGHT): *Saturn Devouring His Children*; painting by Francisco de Goya y Lucientes, 1819–23, collection of the Museo del Prado, Madrid, Spain (Courtesy Giraudon/Art Resource, NY)

PAGE 89

MIDDLE LEFT: *Sir Galahad*; painting by Arthur Hughes, 1870 (Courtesy of the Board of Trustees, National Museums and Galleries on Merseyside, Walker Art Gallery, Liverpool)

PAGE 91

MIDDLE LEFT: *Joseph Makes Himself Known to His Brethren*. Illustration by Gustav Doré, for *The Holy Bible*, 1866

PAGE 92

The Return of Persephone; painting by Frederic, Lord Leighton, 1891 (Courtesy of Leeds Museum and Galleries, City Art Gallery)

PAGE 93

MIDDLE LEFT: Princess Leia as Boushh (Courtesy of the Smithsonian Institution; photograph by Eric Long and Mark Avino)

PAGE 94

LEFT: Lando as Jabba's Palace Guard (Courtesy of the Smithsonian Institution; photograph by Eric Long and Mark Avino)

PAGE 94–95

LOWER: Sy Snootles and Salacious Crumb (Courtesy of the Smithsonian Institution; photograph by Eric Long and Mark Avino)

PAGE 95

RIGHT: Princess Leia's slave girl costume (Ibid.)

PAGE 96

LOWER LEFT: Road Creature (Ibid.)

RIGHT: *Beowulf Fights Grendel*. Illustration by Donn P. Crane, for "Beowulf the Great," 1936 (©The United Educators, Inc.)

PAGE 98

MIDDLE RIGHT: *Cervantes Brought Before the Pasha*. Illustration by Donn P. Crane, for "A Spanish Hero," 1936 (©The United Educators, Inc.)

PAGE 99

UPPER LEFT: *Walking the Plank*. Illustration by Howard Pyle, for *Howard Pyle's Book of Pirates*, 1921

PAGE 100

The Emperor (Courtesy of the Smithsonian Institution; photograph by Eric Long and Mark Avino)

PAGE 101

UPPER LEFT: *The Hydra*; from a seventeenth-century etching

PAGE 104

LOWER LEFT: An Ewok warrior (Courtesy of the Smithsonian Institution; photograph by Eric Long and Mark Avino)

PAGE 106

LOWER RIGHT: *Orphee et Eurydice* (Courtesy North Wind Picture Archives)

PAGE 111

UPPER LEFT: Navaho sand painting to a Blessing Chant; New Mexico, c. 1950 (Courtesy of the Joseph Campbell Foundation)

PAGE 112

LOWER RIGHT: *Gela Mask (The Ancient One)*; mask of the Wee peoples, Côte d'Ivoire, Liberia [81.17.193] (Courtesy of The Seattle Art Museum, Washington; gift of Katherine White and the Boeing Company)

PAGE 113

MIDDLE LEFT: *Heracles Rises to Olympus*. Illustration from *D'Aulaire's Book of Greek Myths* by Ingri & Edgar Parin D'Aulaire (Copyright ©1962 by Ingri and Edgar Parin D'Aulaire. Used by permission of Bantam Doubleday Dell Books for Young Readers)

PAGE 116

MIDDLE RIGHT: *Chaos Monster and Sun God*; engraving by Austin Henry Layard of an Assyrian wall panel, 885–860 B.C. (From *Hero with a Thousand Faces* by Joseph Campbell ©1949, Renewed 1976 by Princeton University Press. Reprinted by permission of Princeton University Press.)

PAGE 124

Scene from Fritz Lang's *Metropolis*, 1926

PAGE 126

MIDDLE RIGHT: *Sitting Up Cross-Legged with Each Hand Holding a Gun...* Illustration by N. C. Wyeth, for "Bar 20 Range Yarns" by Clarence E. Mulford, *The Outing Magazine*, May 1906 (Courtesy of Wells Fargo Bank, Arizona)

PAGE 127

LEFT: Han Solo's gunslinger costume (Courtesy of the Smithsonian Institution; photograph by Eric Long and Mark Avino)

LOWER RIGHT: *A Fight in the Street*. Illustration by Frederic Remington, for *Ranch Life in the Far West* by Theodore Roosevelt, 1902 (Courtesy of the Frederic Remington Art Museum, Ogdensburg, NY)

PAGE 128

The Pay Stage. Illustration by N. C. Wyeth, for *Scribner's Magazine*, August 1910 (Courtesy of Wells Fargo Bank, Arizona)

PAGE 132

UPPER LEFT: *The Thirty-six Master Poets*; ink and color on silk by Sakai Hoitsu, Edo period [70.22] (Courtesy of the Freer Gallery of Art, Smithsonian Institution, Washington, D.C.)

LOWER LEFT: *The Kusazuribiki Scene from the Play Hobashira Taiheiki*; color and ink on paper by the Torii School, Edo period [02.251] (Courtesy of the Freer Gallery of Art, Smithsonian Institution, Washington, D.C.)

PAGE 133

UPPER LEFT: *Fan Print with Actor*; print by Katsukawa Shunsho, 1726–92 [21.4296] (William S. and John T. Spaulding Collection. Courtesy of the Museum of Fine Arts, Boston)

LOWER LEFT: *Samurai*. Illustration for *Secrets of the Samurai: A Survey of the Martial Arts of Feudal Japan* by Oscar Ratti and Adele Westbrook, 1973 (Courtesy of Charles E. Tuttle Co., Inc.)

PAGE 134

Astronaut Edwin E. "Buzz" Aldrin begins his walk on the moon, July 1969 (Courtesy of the National Aeronautics and Space Administration)

PAGE 135

LOWER RIGHT: Astronaut Thomas P. Stafford and Cosmonaut Aleksey A. Leonov meet during Apollo-Soyuz Test Project (Ibid.)

PAGE 136

UPPER RIGHT: Weequay and Wooof (Courtesy of the Smithsonian Institution; photograph by Eric Long and Mark Avino)

PAGE 137

Gamorrean Guard (Ibid.)

PAGE 138–39

Rancor (Ibid.)

PAGE 140

Flash Gordon; comic strip by Alex Raymond, 1935 (©King Features Syndicate, Inc.)

PAGE 141

UPPER LEFT: *As they prepare to enter the somber structure...*; Flash Gordon comic strip by Alex Raymond, 1935 (©King Features Syndicate, Inc.)

UPPER RIGHT: *Buck Rogers* memorabilia from the collection of the National Air and Space Museum (Photograph by Ross Chapple. Courtesy of the Smithsonian Institution)

PAGE 142

UPPER RIGHT: Capt. Laska (William Gould), Prince Tallen (Philson Ahn), Buck Rogers (Larry "Buster" Crabbe), and Wilma Deering (Constance Moore) from *Buck Rogers in the 25th Century*, (Copyright ©1939 by Universal Studios, Inc. Courtesy of Universal Studios Publishing Rights. All Rights Reserved.)

MIDDLE RIGHT: Queen Azura (Beatrice Roberts), Flash Gordon (Larry "Buster" Crabbe), and Emperor Ming (Charles Middleton), from *Flash Gordon's Trip to Mars*, 1938 (©King Features Syndicate, Inc.)

PAGE 143

Queen Fria and Flash Gordon; comic strip by Alex Raymond, 1935 (©King Features Syndicate, Inc.)

PAGE 144

LOWER RIGHT: Hitler and storm troops honor Nazi dead (Courtesy of UPI/Corbis-Bettmann)

PAGE 145

LOWER: The SS unit "Leibstandarte des Fuehrer," 1935 (Courtesy of the United States Holocaust Memorial Museum, Washington, D.C.)

PAGE 146

TOP RIGHT: Imperial Royal Guard (Courtesy of the Smithsonian Institution; photograph by Eric Long and Mark Avino)

LOWER RIGHT (RIGHT): Hitler; from the photo albums of Eva Braun (Courtesy of the National Archives, Washington, D.C.)

PAGE 147

UPPER LEFT: Police officer on the streets of Berlin with SS auxiliary police, 1933 [102/14381] (Courtesy of the Bundesarchiv)

LOWER RIGHT: Imperial officer's uniform (Courtesy of the Smithsonian Institution; photograph by Eric Long and Mark Avino)

PAGE 148

LOWER RIGHT: Nuclear explosion [U.S. Air Force Photo Collection, USAF Neg. No. K 6761] (Courtesy of the National Air and Space Museum, Smithsonian Institution)

PAGE 152

UPPER LEFT: Devastated rainforest in the Darien region of Panama (Courtesy of the Smithsonian Institution's Tropical Research Institute; photograph by Carl C. Hansen)

PAGE 153

UPPER RIGHT: The SS goose-step in a parade, c. 1933–39 (Courtesy of the United States Holocaust Memorial Museum, Washington, D.C.)

MIDDLE LEFT: "Justice" Tarot Card (Illustrations from the Rider-Waite Tarot Deck®, known also as the Rider Tarot and the Waite Tarot, reproduced by permission of U.S. Games Systems, Inc., Stamford, CT 06902 USA. Copyright ©1971 by U.S. Games Systems, Inc. Further reproduction prohibited. The Rider-Waite Tarot Deck® is a registered trademark of U.S. Games Systems, Inc.)

PAGE 155

MIDDLE LEFT: Death Star Interrogator Droid (Courtesy of the Smithsonian Institution; photograph by Eric Long and Mark Avino)

PAGE 156

MIDDLE RIGHT: Allied bombing over Vienna, March 22, 1945 [U.S. Air Force Photo Collection, USAF Neg. No. 61597 AC] (Courtesy of the National Air and Space Museum, Smithsonian Institution)

PAGE 159

MIDDLE LEFT: Lt. Colleen Nevius [SI Neg. No. 86-12200] (Courtesy of the National Air and Space Museum, Smithsonian Institution)

PAGE 164

LOWER LEFT: "Bandoleer" or "collar of charges," English, c. 1645 [XIII.916] (Courtesy of The Board of Trustees of the Armouries, Royal Armouries, Leeds)

UPPER RIGHT: Electrobinoculars; production prop (Courtesy of the Smithsonian Institution; photograph by Eric Long and Mark Avino)

PAGE 165

FAR LEFT: Lando's skiff guard weapon (Ibid.)

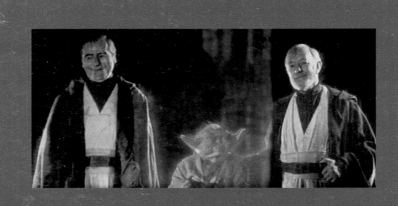